The Art of Photography

Life World Library
Life Nature Library
Time Reading Program
The Life History of the United States
Life Science Library
Great Ages of Man
Time-Life Library of Art
Time-Life Library of America
Foods of the World
This Fabulous Century
Life Library of Photography
The Time-Life Encyclopedia of Gardening
The American Wilderness
Family Library
 The Time-Life Book of Family Finance
 The Time-Life Family Legal Guide

LIFE LIBRARY OF PHOTOGRAPHY

The Art of Photography

BY THE EDITORS OF TIME-LIFE BOOKS

TIME-LIFE BOOKS, NEW YORK

ON THE COVER: Looking through a camera's lens and visualizing in his mind's eye a picture (also reproduced on page 133), the photographer himself —not his equipment—is the most important element in the art of photography. His unique vision of the world, his experiences and memories, as much as his skills, are his real creative tools. With them he selects and organizes the raw materials before him, creating a picture to which others can respond.

Contents

TIME-LIFE BOOKS

Founder: Henry R. Luce 1898-1967

Editor-in-Chief: Hedley Donovan
Chairman of the Board: Andrew Heiskell
President: James R. Shepley
Chairman, Executive Committee:
James A. Linen
Editorial Director: Louis Banks

Vice Chairman: Roy E. Larsen

Editor: Jerry Korn
Executive Editor: A. B. C. Whipple
Planning Director: Oliver E. Allen
Text Director: Martin Mann
Art Director: Sheldon Cotler
Chief of Research: Beatrice T. Dobie
Director of Photography: Melvin L. Scott
Assistant Text Directors:
Ogden Tanner, Diana Hirsh
Assistant Art Director:
Arnold C. Holeywell
Assistant Chief of Research:
Martha T. Goolrick

Publisher: Joan D. Manley
General Manager: John D. McSweeney
Business Manager: John Steven Maxwell
Sales Director: Carl G. Jaeger
Promotion Director: Paul R. Stewart
Public Relations Director: Nicholas Benton

LIFE LIBRARY OF PHOTOGRAPHY
Series Editor: Richard L. Williams

Editorial Staff for
The Art of Photography:
Picture Editor: Carole Kismaric
Text Editor: Jay Brennan
Designers: Sheldon Cotler, Ray Ripper
Assistant Designer:
Herbert H. Quarmby
Staff Writers: George Constable,
John von Hartz, Bryce S. Walker
Chief Researcher: Peggy Bushong
Researchers: Sondra Albert,
Frances Gardner, Kathryn Ritchell
Art Assistants: Patricia Byrne, Lee Wilfert

Editorial Production
Production Editor: Douglas B. Graham
Quality Director: Robert L. Young
Assistant: James J. Cox
Copy Staff: Rosalind Stubenberg,
Barbara Fairchild, Ruth Kelton,
Florence Keith
Picture Department: Dolores A. Littles,
Catherine Ireys

LIFE STAFF PHOTOGRAPHERS
Carlo Bavagnoli
Ralph Crane
John Dominis
Bill Eppridge
Henry Groskinsky
Yale Joel
John Loengard
Michael Mauney
Leonard McCombe
Vernon Merritt III
Ralph Morse
Carl Mydans
John Olson
Bill Ray
Co Rentmeester
Michael Rougier
John Shearer
George Silk
Grey Villet
Stan Wayman

Director of Photography:
Richard Pollard
TIME-LIFE Photo Lab Chief:
George Karas
Deputy Chief: Herbert Orth

Valuable aid was provided by these individuals
and departments of Time Inc.: Editorial
Production, Norman Airey, Nicholas Costino Jr.;
Library, Peter Draz; Picture Collection, Doris O'Neil;
TIME-LIFE News Service, Murray J. Gart;
Correspondents Elisabeth Kraemer (Bonn),
Margot Hapgood (London), Maria Vincenza
Aloisi (Paris), Ann Natanson (Rome), Jesse
Birnbaum (San Francisco), James Shepherd
(New Delhi), Eva Stichova (Prague) and
Mary Johnson (Stockholm).

There is no question that photography is a popular hobby, a craft, a trade for many, a profession for some, a tool of science and very likely a science in itself. Whether it is also an art used to be a question, but that argument is over. The use of a camera does not disqualify a photographer from being taken seriously as an artist, any more than the use of a typewriter disqualifies a poet, playwright or novelist.

Neither does the camera or typewriter, however expensive, make the artist; they are conveniences. Sophisticated equipment, as Carl Mydans once observed, simply "frees all of us from the tyranny of technique and enables us to turn to what photography is all about —creating a picture."

That is also what this book is about: creativity and esthetics, not metering and f-stops. The vocabulary of esthetics is different from the vocabulary of technology, and both take getting used to, but one is no more mysterious than the other. In this volume there is a good deal of material, both visual and verbal, that seeks to explain how some of the fundamental principles of esthetics apply to photography. The principles are not confining but liberating; they allow for countless individual approaches to art, from the dutifully conventional to the convention-defying. Learning about them and seeing how they operate will not assure you a place among great artists, but, by showing you why good pictures are good, the information will free you to make better pictures of your own. As Carl Mydans also put it, "one is not really a photographer until preoccupation with learning has been outgrown and the camera in his hands is an extension of himself. There is where creativity begins."

The Editors

What the Camera Sees 1

Ralph Weiss made his close-up of oyster ▶ mushrooms rich with sensuous detail by his manipulation of visual characteristics that are inherent in the things we see. The graceful shapes, rounded forms and soft, spongy texture of the fungi, growing out of the jagged bark of a tree stump, all combine to strengthen the viewer's appreciation of a miniature scene on the floor of the woods in Inwood Hill Park in New York City.

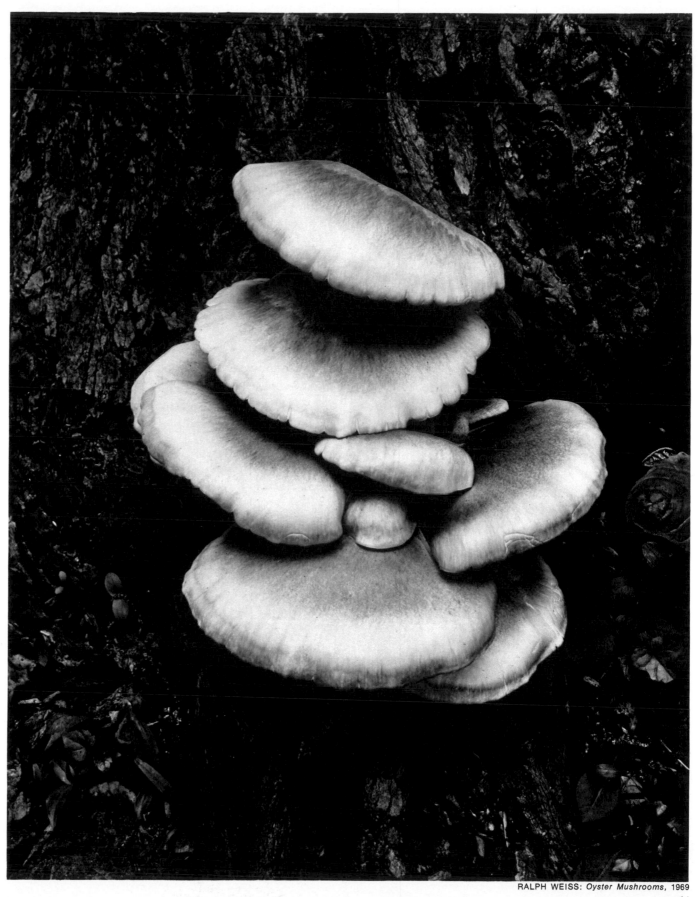

RALPH WEISS: *Oyster Mushrooms,* 1969

The Making of a Fine Photograph

Scenario 1: A businessman is half a continent from home, walking through a city with a camera in his hand. His appointments for the day are over. Rather than sit in his hotel room and read until dinnertime, he has decided to devote the rest of the afternoon to his new hobby—photography. On this crisp afternoon, the city is even more photogenic than he had expected. Sunlight is sparking off cars and buildings, and a gentle wind is riffling flags and coats.

Strolling toward the heart of the business district, he keeps his eyes alert for promising subjects. Many sights tempt him: a cluster of street signs mounted on a single pole; a newspaper vendor with narrowed, cynical eyes; a moving van debouching desks and chairs; a helicopter clattering over the roof of the city. But each of these subjects seems too limited.

His attention is arrested by one huge new office building. Gleaming and stark, it looks more like a machine than a place where human beings spend their days. At the ground level is a long, empty arcade, bordered on one side by black marble columns and on the other by a glass-walled lobby. The building strongly appeals to him. But how should he photograph it? He could aim his camera upward or he could shoot down the long arcade. Either of these approaches would express the great scale of the office building, but he is after something more original and meaningful.

Suddenly he spies a possible solution. Inside the glass-enclosed lobby are small potted trees. Several people are sitting on a bench nearby, but it is the trees that interest him. Surrounded by the stern, rectilinear strength of the building, they seem very frail. There is something both touching and a bit ridiculous about them. Why, he wonders, do architects construct cold edifices of glass, steel and concrete, then feel compelled to import a bit of nature into their shining technological world? He suspects that these potted trees are going to help him make an extraordinary picture.

His first impulse is to go inside the lobby and take the photograph from there. Then he decides that the trees would look much more interesting if seen from outside the glass walls. An exterior vantage point would give a clear indication of their setting, which is crucial to the point he wants to get across. A picture that displays the building as well as the trees will communicate the irony of outdoor organisms surviving in an air-conditioned, hermetically sealed environment in which nighttime and daytime arrive at the flick of a switch.

Having decided to shoot from the outside in, he must now cope with the problem of reflections in the glass walls of the lobby. These mirrored images, if picked up by his camera, are likely to obscure the view of the trees on the other side of the glass; they could be eliminated with a special polarizing filter, but he does not have one with him. Just as he is beginning to taste disappointment, an answer presents itself. All he has to do is make sure that

ANSEL ADAMS: *I have often thought that if photography were difficult in the true sense of the term—meaning that the creation of a simple photograph would entail as much time and effort as the production of a good watercolor or etching —there would be a vast improvement in total output. The sheer ease with which we can produce a superficial image often leads to creative disaster. We must remember that a photograph can hold just as much as we put into it, and no one has ever approached the full possibilities of the medium.*

the glass is reflecting some dark, featureless object. This kind of reflection will be virtually invisible, and the camera will be able to peer through the glass at the trees. Happily, just such a dark background is readily available to him: he will stand in a position where the glass walls reflect one of the huge black marble columns.

When he steps between one column and the glass and raises the viewfinder to his eye, he sees that his picture will include a view of the arcade. Stretching into the distance, it gives a sense of the building's size. He also notices that at this angle the column does not block all the reflections from across the street. The viewfinder shows that the reflection of an office building will appear in the right-hand portion of the picture. But the more reflections the merrier, he thinks, as long as the potted trees are still visible. The added images will make the picture more interesting. Satisfied, he adjusts the focus and exposure and shoots the picture, certain that it will be one of the best he has ever taken. He is mistaken.

When he sees the print *(page 14)* several days later, he cannot help wincing. The result is not at all what he had in mind. The picture seems muddled and pointless. For one thing, the trees—prime objects of his attention—are barely visible through the glass. In the shadowed lobby, they have practically no dramatic impact; they are upstaged by the more brightly lit arcade and the reflections of the outdoors. And these reflections are confusing. Cars and trucks that he failed to see when he looked through the viewfinder appear to be driving right through the lobby. There is a reflection of another tree—outdoors—that blunts his point about the irony of importing nature into the alien world of a modern building. This outdoor tree is leafless, setting up distracting questions about the season and the requirements for growth.

The list of defects seems endless. He wonders why he tripped the shutter just when the woman in the lobby turned her head away. He wonders why he did not notice the dim reflection of another building at the far right-hand side of the picture, or why he did not spot the reflection of the strange sack lying at the foot of the marble column. How could he have chosen a horizontal format for the picture, instead of a vertical one more suited to skyscraper verticality? The failure of his picture is obvious. Instead of according it honor in his collection, he throws it in the wastebasket.

Scenario 2: Late in the afternoon a second photographer wanders by. He, too, observes the potted trees and is intrigued for many of the same reasons as the first photographer. By now the sun is lower in the sky, and a shaft of light is streaming into the lobby, setting the leaves ablaze. However, the tops of the trees are still in shadow. He decides to postpone photographing the scene until the sun has descended a few more degrees, fully illuminating the

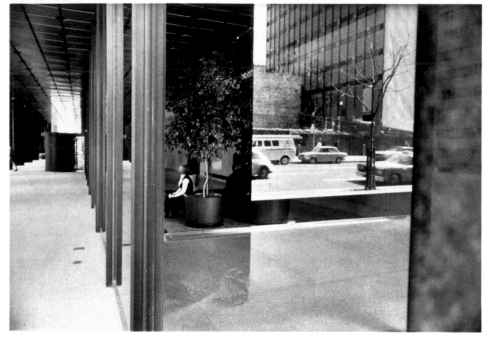

The amateur who took this picture hoped to suggest the irony of decorating the glass-walled lobby of a skyscraper with potted trees—but ended up with a confused array of visual elements that is almost impossible to interpret.

trees. He does not want to waste film on a shot that he knows he will be dissatisfied with later and so he continues his walk.

Half an hour later he returns and finds that the illumination is just right. The shaft of sunshine is a powerful spotlight piercing the dimness of the lobby and singling out the trees. A woman is now sitting near the trees, as if their living greenery were offering her comfort in this cold, modern skyscraper.

Before he even begins to consider how the picture should be composed, he tries to clarify his feelings about the scene. Like the first photographer, he is struck by the incongruity of nature in a glass-and-steel office building. It occurs to him that the conflict is not just between this building and these trees, but between any modern urban architecture and any trees. There is some essential opposition to be communicated here, something that transcends the specific ingredients of this scene and makes a broad statement about cities and nature.

How can he communicate his sense of transcendent meaning? Standing at the same spot where the first photographer stood, he considers every element that might appear in the picture. He knows that he will have to stay at this position between the glass wall and the black marble column, so that the dark reflection of the column will enable the camera to see the trees beyond the glass. This necessary location narrows his options, but there are still a number of pictorial ingredients to be handled: the reflections of cars, a leaf-

Given the same subject matter, Tony Ray-Jones selected some of the available visual elements, discarded others and transformed still others to produce the picture at right—a strong comment on the relationship of nature and cities.

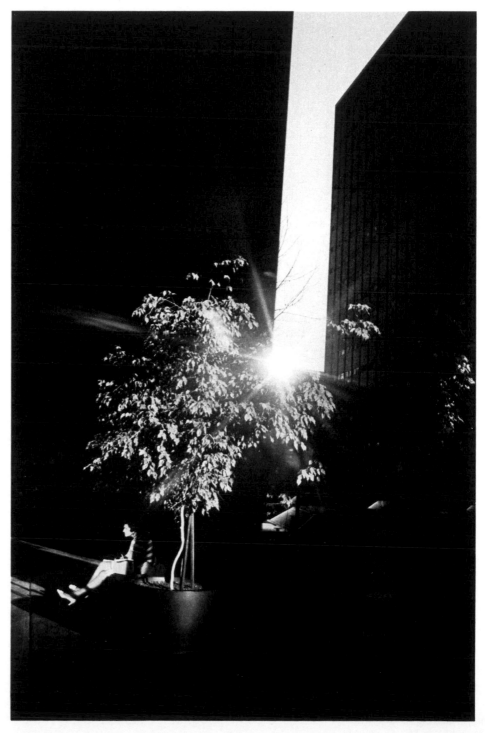

less tree and an office building across the street; the long view of the arcade; the reflection of the column; and the glass wall itself.

Shall he include all these ingredients or pare away some? The arcade conveys the look of ultramodern urban architecture, but seems wrong for his purpose. It leads the eye away from the trees, which are central characters in the picture he wants to make. But if he does not show the arcade, how can he express the flavor of urban architecture? The answer comes at once: the reflection of the office building across the street will communicate the look of the cityscape. He does not need the arcade at all. By eliminating it, he gains, for now the specific location of these trees is obscured. They could be anywhere, in any city—a valuable ambiguity because it broadens the meaning of his picture.

Assessing the other reflections, he decides that the leafless, outdoor tree should be eliminated too. It strikes him as confusing and inappropriate. He is concerned with a conflict between living plants and inanimate buildings. The thrust of his theme would be blunted by a leafless tree suggesting some state of half-death. He decides to skip that tree and the arcade.

The reflected cars, on the other hand, are pertinent to his statement about natural versus man-made things, and he decides to include them in the picture. Finally there is the reflection of the black column itself. It would be possible to reveal the column for what it is by aiming the camera slightly downward to show the base reflected in the glass. But identifying the column would serve no purpose, and he decides not to. However, while he can conceal the column's reality, he cannot eliminate its reflection, for this dark image allows the trees behind the glass to be visible. Then he notices a resemblance between the vertical edge of the column reflection and the shape of the building across the street. Musing on this similarity of shape, a bold idea comes to him. If the interior of the lobby (except for the trees and woman) is pitch black in the picture, the straight edge of the column reflection might produce the illusion of a huge black skyscraper looming up behind the indoor trees. To pull off this illusion, he will have to position himself fairly close to the glass, excluding both the reflected base of the column and the roof of the arcade; only if these visual clues are missing will the viewer be unable to tell that dark, straight-edged shape from a skyscraper.

Now he realizes that if everything in the scene, except the trees and woman, is rendered in a very dark tone, the viewer will have no way of knowing that reflections make up crucial elements of the picture. The glass wall of the lobby will disappear. And this suits his purpose perfectly, because he wants trees and city to be in direct opposition, with nothing between them.

He steps toward the glass and peers through his viewfinder to see how this scheme will work. With a horizontal format it does not work at all; the strong

EDWARD WESTON: The photographer's most important and likewise most difficult task is not learning to manage his camera, or to develop, or to print. It is learning to see photographically —that is, learning to see his subject matter in terms of the capacities of his tools and processes, so that he can instantaneously translate the elements and values in a scene before him into the photograph he wants to make.

vertical elements demand a vertical frame for the picture, and he turns his camera. Next, he moves around and tries different camera angles, seeking the best arrangement of the various parts in the scene. He tries centering the trees in the frame, but this placement seems to spoil the illusion of a looming black skyscraper behind the trees. He decides to put the trees in the bottom of the frame. This shift in camera angle yields an extra dividend: it allows the top of the building across the street to be seen, so that the viewer's attention will be held within the picture.

Correct exposure will make or break this photograph, and he plans to bracket with enough shots at different apertures and shutter settings to be sure that he will get great tonal range. The trees and woman must be very bright, as if they alone, in this cold urban world, were touched with the fire of life. Everything else must be dark, brooding and impossible to locate with any degree of sureness. His greatest asset, he realizes, is the brilliant sunlight on the trees. They will remain lightly visible even if he underexposes to make the reflections dark and the interior of the lobby pitch black.

All this time, the photographer has been assuming that he will shoot from a position where the column will cut off the mirror image of the sun in the glass wall, since strong rays reflected from the sun would produce flare, streaking the image with a star pattern of light. But now he steps a few inches to the right to see what might happen to his pictorial scheme if a bit of the reflected image of the sun were included. The effect is both interesting and disconcerting. Because he intends to obscure the fact that reflections are present in the picture, the sun will appear to be behind the trees. Yet this apparent position will be impossible to reconcile with the way that light is falling on the trees—from the front.

At once, he realizes that this "impossibility" is the ingredient that will make the picture complete. The mystery of the scene will be deepened by the paradox of light that seems to be coming from two directions at once. It will build conflict into the frame—a shiver of illogic to heighten the clash between nature and the city. And yet, because the sun's image will be located near the center of the picture, it will be a force for visual stability—a bright central point around which everything else is organized.

At last he is ready to shoot. Since the exposure is tricky and he is not sure how much flare will be caused by the rays of the sun, he takes a number of pictures, moving his position slightly so that greater and lesser amounts of mirrored sunlight reach the camera, and bracketing his exposures at each position. This effort is a gamble, and the photographer wants to give himself every chance for success.

His diligence pays off. When he examines his prints, he finds one picture that more than lives up to his hopes (page 15). It presents a dreamlike vision

pinioned on the spokes of a sunburst. In the midst of a brooding, gloomy city-scape, a little clump of trees offers its scrap of shade to a solitary woman. Here is a world of powerfully opposed tones, ghostly shapes, stray floating leaves and strange-looking lighting phenomena. And yet every ingredient that has been used is cemented into a compelling whole.

The difference between the two photographers need not be ascribed to intellect, sensitivity or any other vague requisite for success in photography. The first photographer was a man of imagination and intelligence. He had excellent equipment, good intentions and strong feelings about his subject matter. Yet he produced a picture that looks boring, confused and pointless.

His failure—and the second photographer's success—ultimately depended on one vital factor: intelligibility. The second picture is much clearer and more comprehensible than the first. The first picture is a babble of many meanings that drown one another out. The viewer is unsure what to respond to and can only guess at the photographer's intention. What went wrong?

The photographer started out with a good idea: to convey the incongruity of trees growing in a modern office building. But he indiscriminately piled all sorts of ingredients together and hoped that the camera would automatically extract the meaning he sensed was there. He did not forge visual or thematic links to connect one ingredient to another and unify them. The picture accords about the same amount of importance (or unimportance) to arcade, glass, lobby, woman, trees and reflections. The arcade was included because he realized that it made the building look big. The reflection of the office building across the street was included because he vaguely felt it would make the picture more interesting. The reflections of the cars and the leafless tree were included because he never saw them in the first place—and he also missed the dim reflection of still another office building that showed up in the shiny marble of the column. In short, he never really figured out how to integrate all the elements of the scene, and the result is incoherence.

What was the secret of the second photographer's success? He did what his predecessor did not: he clarified his thoughts and feelings about the subject. He, too, was intrigued by the incongruity of trees in a modern office building. But instead of snapping a picture on the basis of this twinge of interest, he analyzed the meaning of the scene, and set out to trace its appeal to the source. He realized that *these* trees and *this* office building were not his real concern. At stake was a fundamental incompatibility between nature and urban architecture. And the more he looked at the scene, the more he detected a definite bias within himself. Cities, in his view, are grim and heartless, whereas nature is luminous and quick with life. Like the sunlit woman sitting near the trees, he cast his lot with nature.

> *AARON SISKIND: As the saying goes, we see in terms of our education. We look at the world and see what we have learned to believe is there. We have been conditioned to expect. And indeed it is socially useful that we agree on the function of objects. But, as photographers, we must learn to relax our beliefs. Move on objects with your eye straight on, to the left, around on the right. Watch them grow large as you approach, group and regroup as you shift your position. Relationships gradually emerge and sometimes assert themselves with finality. And that's your picture.*

The working method of the second photographer was a complex process of exploration and selection. He examined all the objects before his camera —the building, its contents and its surroundings—and explored the meanings that might be attached to them. During this period of observation, many potential pictures beckoned—the trees, the arcade, the woman, the reflections. Then one idea—the paradox of life within a sterile skyscraper —seemed richer and more compelling than any other. Whatever was irrelevant or distracting he excluded. What remained was carefully positioned in his viewfinder so that its importance was evident. He tuned the mix of these elements, like a musician seeking a chord whose notes blend perfectly. And when he was sure that every part would fit together and contribute to the whole, he took the picture.

This analytical approach is not unique to photography, but it is applicable. Photography is a special art in that the exploration and selection must be done either in advance of picture taking, before the shutter is tripped, or afterward in the darkroom. It is as though a composer were to conceive a symphony complete from beginning to end, push a button, and presto! An orchestra would play the music. The very ease with which film can generate an entire picture hinders many photographers from developing their skills. They may be misled into believing that all they have to do to guarantee at least one good picture is take a great number of shots of a subject, and they concentrate on the act of image-recording rather than on the process of picture creation. In many cases, a large number of shots are advisable, but quantity alone cannot assure success. It is the carefully thought-out photograph that communicates its maker's message.

In analyzing a picture, the skillful photographer performs three different sorts of exploration. He examines his feelings and thoughts about the subject—in short, its meaning to him. He examines all the visual attributes of the scene, seeking those that will best convey his sense of the meaning. And he considers various ways in which the chosen visual elements can be arranged in the picture, so that the meaning can be efficiently grasped. In practice, these three sorts of exploration go on simultaneously, each influencing the others. Noticing a particular shape might suggest a new meaning and the need for a certain design. The explorations may be quick or even intuitive; some photographers speak of instantaneous "recognition" of what to shoot and how to shoot it. Conversely, many fine photographers spend a great deal of time contemplating their subjects and adjusting the tiniest details.

Breaking up the creative process into three areas of exploration and selection is only the first step, of course. Each area—meaning, visual characteristics, arrangement—is itself subject to further exploration and selection. Meaning, for example, depends on the memories, cravings,

aversions, training and intelligence of the beholder. Most people looking at a certain round, red object will identify it as an apple. At this first level of meaning, they simply recognize the object for what it is. Looking closer, they ascertain its state of ripeness, and they relate the object to their memories of eating apples and their current degree of appetite. Emotions such as happiness, worry or disgust might come into play. And some people might grasp subtler meanings: the way the apple grew, the symbolism of the intricate shades of its red skin, the uses that an apple might be put to, and so on.

As this apple example demonstrates, the exploration of meaning is guided by the visual characteristics of the subject. These characteristics, in turn, can be explored in a very direct way because they are fundamentally objective. The roundness and smoothness of apples are facts—measurable ones if need be. Similar attributes are identifiable in every object, so that the appearance of a subject can be classified in an orderly manner *(pages 22-58)*. The arrangement of objects within the picture is also subject to direct analysis, for every arrangement can be gauged according to widely accepted standards. We say that a picture seems balanced or unbalanced, for example, but balance is only one of the attributes influencing human perception; many others are discussed in Chapter 2.

These techniques of exploration confront the photographer with choice after choice. Should he emphasize the bright texture of leaves on the potted trees? Or the hard line of a reflection in the glass? Should the trees be centered in his frame or placed to one side? His choice seems to be intuitive: if he is pressed to rationalize, he is likely to say only, "It looks better this way." But intuition is shaped by experience—by lifelong exposure to the responses that are common to the human race. And it can be sharpened by studying photographs that are acknowledged to be successful. Not that the techniques and styles of great photographers should be copied. Rather they should be analyzed for the underlying principles that helped the pictures communicate meanings so effectively.

This emphasis on meaning is justified even though the photographer cannot be sure his viewers will share his own responses to his subject. A photographer who perceives an apple as delectable may depict that meaning of deliciousness with great success for most viewers. Yet a person who hates apples will have a different response when he looks at the picture. He will probably see the apple as an undesirable object, since his attitudes and emotions play as large a role in perception as his eyes. Nevertheless, if the photograph is successful, the apple-hating viewer will recognize its intended meaning—and he will appreciate its expressive power, if only because his negative response is so strong.

Such personal differences are, in fact, the lifeblood of photography. The

BERENICE ABBOTT: A photograph is or should be a significant document, a penetrating statement, which can be described in a very simple term—selectivity. To define selection, one may say that it should be focused on the kind of subject matter which hits you hard with its impact and excites your imagination to the extent that you are forced to take it. Pictures are wasted unless the motive power which impelled you to action is strong and stirring. The motives or points of view are bound to differ with each photographer, and herein lies the important difference which separates one approach from another. Selection of proper picture content comes from a fine union of trained eye and imaginative mind.

people who take pictures are as idiosyncratic in their response to a subject as are those who view pictures—perhaps more so, because good photographers try harder to strip away familiar, predictable meanings in order to reveal their personal ideas. Different photographers might have depicted the potted trees and the city in totally dissimilar ways. One might have expressed joy in the play of colors; another might have celebrated the achievements of human ingenuity by showing the trees as dull and earthbound amid sparkling, soaring architecture; still another might have suggested calm by presenting the trees and bench as an island of repose.

But if any interpretation is legitimate, what makes one picture a work of art and another one not? This question is a philosophical tar pit wherein may be found the fossils of many once-glorious theories. Plato said that art springs from a "divine madness" that seizes the artist. Aristotle, trying to keep his feet on the ground, described art as a means of inducing psychological reactions in the beholder. Other philosophers have tried to define a common denominator for all art in terms of "beauty," "ideal form," "spiritual harmony," "intensified reality" and other vague concepts that might drive a purely practical mind to despair.

Even though the essence of art may never be pinned down, there are some broad guidelines to creative photography. They stem from the analytical approach described above. The photographer must consider the meaning of his subject, its visual attributes, and various schemes for organizing its elements. There are no absolute laws of esthetics to bind him, aside from the one requirement that these three considerations contribute to an intelligible whole. If this requirement is fulfilled, the picture will do honor to its creator —and may even qualify as a work of art. □

The Visual Elements: Shape

The art of photography, being a visual art, depends on the act of seeing raised to a high level of acuteness and discrimination. Ordinarily, people skim-read the everyday world with their eyes and minds, using only a minimum of clues to identify and assess what they see. A certain shape instantly denotes a pair of pliers; a certain glittery surface indicates ice; a red light means "stop." In daily life, there usually is no time to linger over such seemingly nonessential matters as the color of the pliers, the reflections in the ice or the dimensions of the traffic light. As long as the viewer does not mistake the pliers for a hammer, slip on the ice or have an automobile accident, his perceptual faculties have done their job.

A good photographer must train himself to do a more penetrating kind of seeing, to catch the meaning of a subject (that is, its meaning to him). Since this meaning may be extremely subtle and complex, he often must postpone any conclusions about it until all of the visual evidence is in. While there are innumerable ways of organizing that evidence, in the case of most seeing there are four traditionally useful approaches to visual information. In the terminology of the artist, they are defined as: shape, that is, the two-dimensional outline of an object; texture, its surface characteristics; form, its three-dimensional aspect; and color. The photographer considers all four.

Photographer Sebastian Milito has demonstrated this in the exercise on the opposite and following pages, systematically exploring the various visual characteristics of a single object.

Of the four elements, shape is the logical starting point because it is, for the photographer's purpose, the simplest component, suggesting only vertical and horizontal dimensions.

Not only are shapes different, but various lenses can make still other differences. A wide-angle lens, if aimed from a low angle, will turn a tall building into a pyramid; a long lens, by diminishing the effects of converging lines, may produce an image whose shape conforms more closely to mental expectations of the same building. By forgetting about its "normal" appearance altogether, the photographer may be able to find many nonrepresentational shapes in a scene. This is because anything that appears in a photograph —whether it is a fishing rod, an apple or a human being—not only produces a shape on the two-dimensional surface of the picture, but also acts as a boundary, creating shapes on either side of it.

How should the photographer use shape? He can shoot at an unexpected angle to make the viewer look twice at the subject (a pair of pliers, seen nose-on, may be a tantalizing mystery). He can create several shapes that echo one another, linking parts of a complex scene into a whole. He can display his subject as a construction of diverse geometric figures. If he knows how to see shape as an independent component, every scene will offer innumerable creative options. Yet he will have just begun to tap the visual riches of the world, for at least three other visual ingredients remain to be explored.

These photographs show four strikingly different views of the same object. The photographer chose to present the object as a riddle, hiding its identity for a time so as to present the various versions of its shape without being bound by preconceptions as to how it "should" look. Each of the pictures actually shows two shapes, of course—one dark, one light—a further dividend derived from an analytical approach to vision.

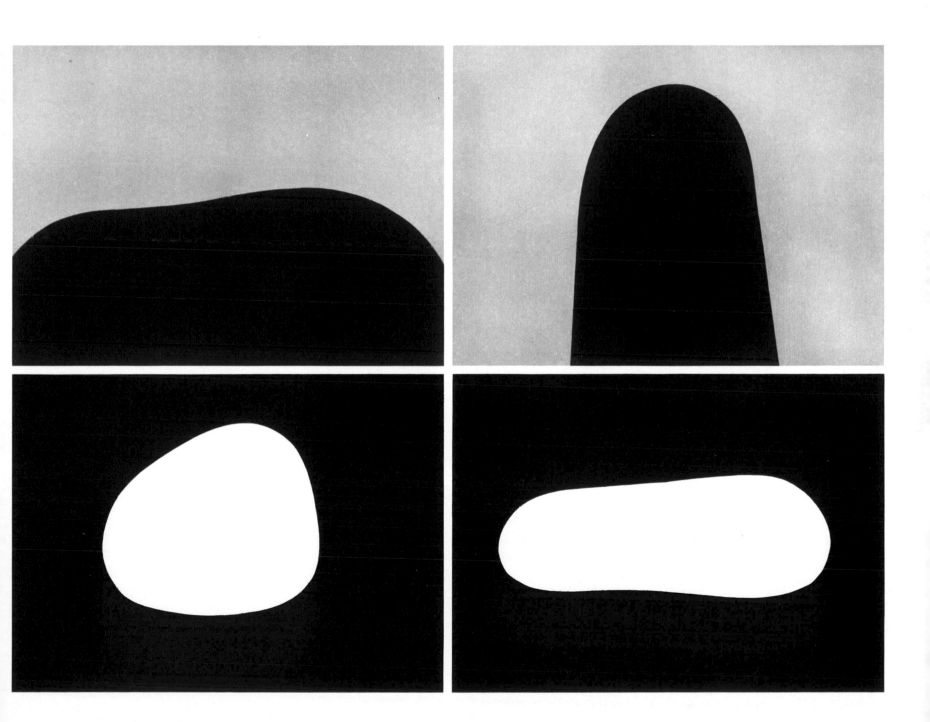

The Visual Elements: Texture

Once he has defined a subject's shape, the photographer—much like an explorer who has merely sailed around the coasts of a new continent—may next consider what lies within that shape, what textural details it holds. To allow the surface of an object to remain terra Incognita sounds inconceivable, and yet day-by-day human perception often does exactly that. For texture usually becomes crucial only when something must be held, walked on, slept on, eaten—in short, whenever it must be touched. The textures of billboards, rain gutters or suspension bridges are not of pressing concern, so they usually go unnoticed, although they may be very interesting if one bothers to notice them. But photography cannot afford such oversights if all its possibilities of perception are to be realized.

Even though photographic images are flat, they can evoke texture, which is by its nature three dimensional, with remarkable success. Modern lenses and film can capture the finest details of a surface, and a variety of lighting techniques can exploit, or even simulate, any sort of textural quality—jagged, glossy or anything in between. For the picture at right of the same object whose shape was explored on the preceding page, the photographer has employed sidelighting to rake across its surface, emphasizing its pitted texture. He could have chosen to use other methods, either increasing the magnification to achieve an extremely craggy effect, or using frontlighting to make the surface look like polished metal. As is the case with shape, the discovery of texture as a distinct visual aspect of every object presents a greatly enhanced range of creative opportunities.

The same still-unidentified object whose shape was explored on the previous pages is now studied for its texture. A light placed off to one side throws shadows on the surface, showing its irregularly pitted character. The photographer has as yet presented no clue to the object's distance or size; and this sort of texture could belong to anything from a moonscape to an orange peel.

The Visual Elements: Form

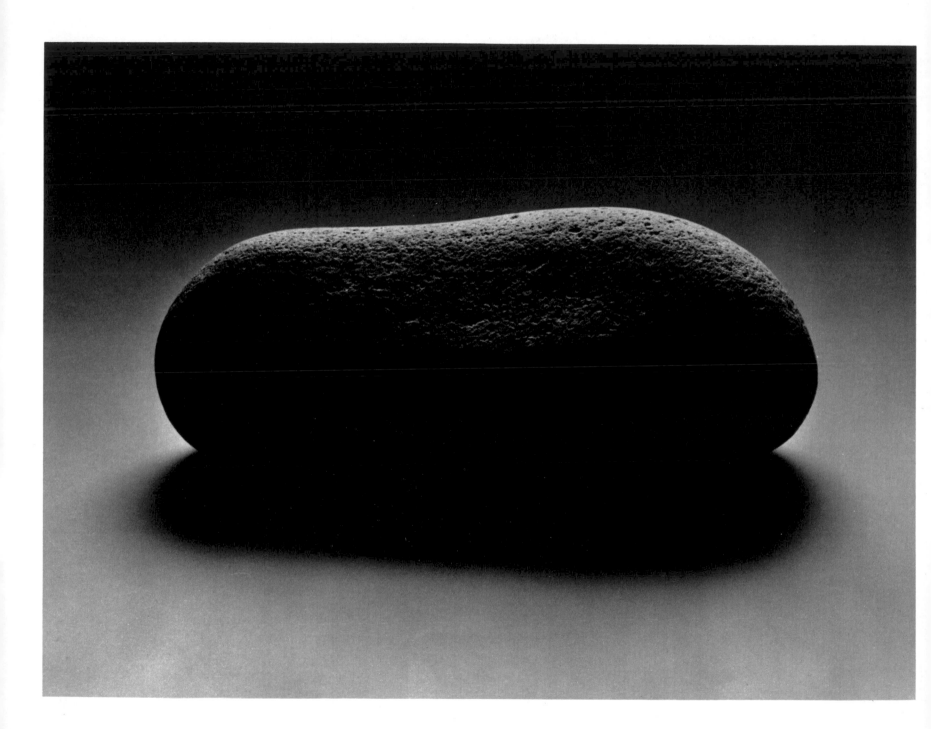

In art, form is distinguished from shape as the three-dimensional aspect of an object—it describes the way the object occupies space. Like texture, which also implies a third dimension, form might seem to be beyond the natural powers of photography. A camera, being one-eyed and not binocular, cannot perceive depth as well as human vision can. Happily, there are a number of two-dimensional clues to the third dimension: the manner in which shadows are cast, the effects of perspective, the overlapping of far objects by near ones. The photographer must be aware of such clues if he is to control the way his two-dimensional pictures transmit an impression of space and substance.

On these pages, only light and shadow have been employed to show the form of the object. Now, for the first time, the object's identity is clear: it is a rock, whose sculpted roundness is almost palpable. The two pictures not only reveal its form, or volume, but also give conflicting hints about the density of the object. The photograph opposite makes the rock ponderous; the lighter-toned version at right presents a rock that appears almost to float.

A gradual progression of tones (right), from dark to light, leaves no doubt as to the roundness of the rock, and even suggests the way it was formed —by centuries of slow, steady abrasion at the seashore. Much lighter than the background, the rock seems in this portrait an object that could easily be hefted, as if made of pumice.

◄ *Illuminated by an overhead light, the same rock displays few intermediate tones, and its volume is proclaimed emphatically. Here it looks weighty; predominantly dark, it seems to be sinking heavily into the soft-edged shadow at its base.*

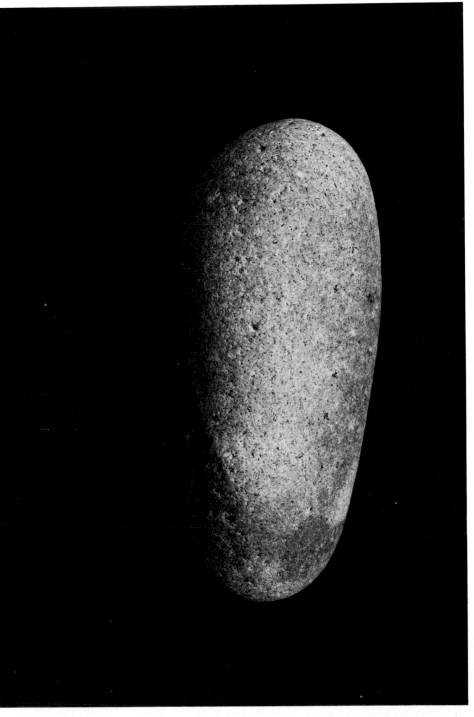

The Visual Elements: Color

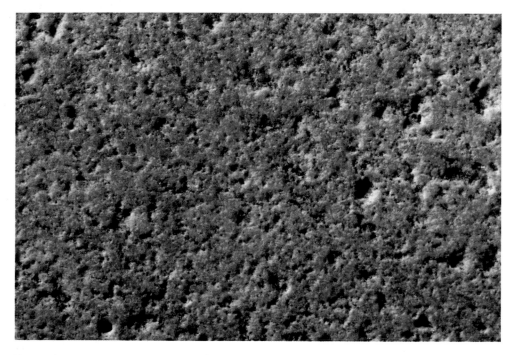

To see what a difference color can make in the perception of an object, compare the photograph above with the black-and-white close-up of the rock's texture on pages 24-25. In the picture opposite the color view brings out a richness of tone that sets this rock apart as a unique object.

Color might seem to be the most immediately evident of all the components of seeing: Who, except the blind and the color-blind, does not see the green of leaves, the red of valentines or the ever-changing tints of the ocean? But the fact is that colors are carelessly perceived a great deal of the time, because people generally see the colors that they expect to see. An object that is usually pink is only more or less pink—or not pink at all—under a tree, where it may assume a greenish cast; in the blue glow of a fluorescent light; or placed next to a yellow wall, where it picks up a reflection of the wall's color. A camera, which labors under no preconceptions, may record all such subtle color changes.

Take Milito's rock, for instance. It was picked up on an island off the coast of Rhode Island; most such rocks, worn by the glacial ice that deposited them and by millennia of friction, appear to be colorless at first glance—mostly white, or perhaps a little yellowish. But the textured close-up at left and the highlighted picture opposite reveal that the rock's visual assets include striking rust-red flecks and stains on its subtle beige background. It is not, then, to be regarded solely as an object of shape, texture and form; it exhibits another aspect of vision that is detectable by the seeing eye: color. □

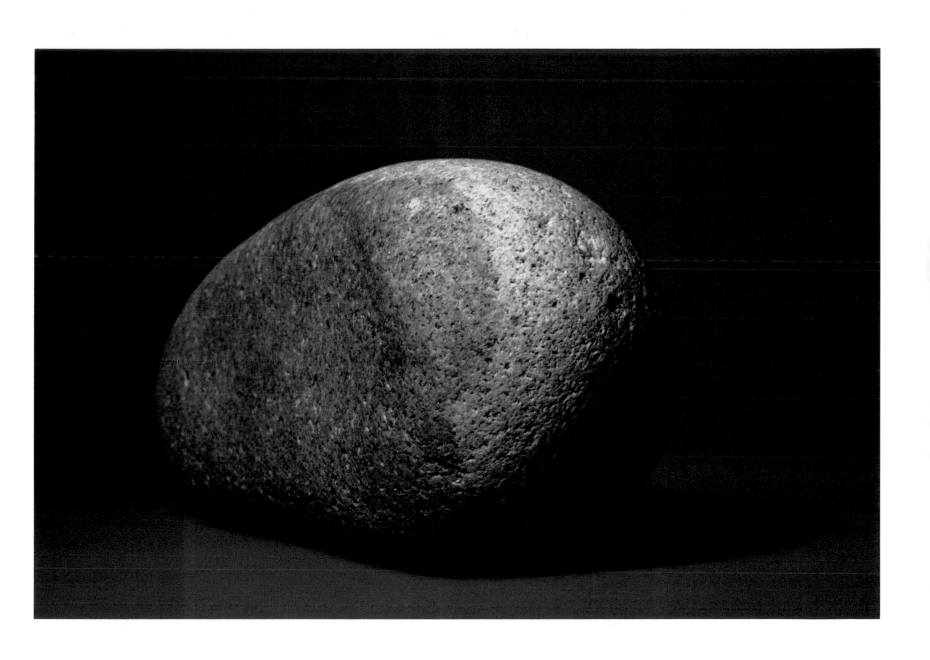

Shape on Display

For the photographer, *seeing* shape, texture, form and color is only the first step. He must now suppress, emphasize or otherwise manipulate all these elements according to his own view of the object he is looking at. No law dictates that all of these approaches to seeing must be acknowledged in one picture—any more than all the instruments in an orchestra must play during every moment of a symphony. The photographer refines ordinary perception, disregarding all superfluous aspects of his subject matter—much like Michelangelo, who, it was once said, freed the form that lay within a block of marble.

The pipes in the photograph opposite offered a wide choice of temptations to Sebastian Milito: their shapes, their machined texture, their rounded forms, their blue-black color. He settled for shape, dispensing with everything else. "I saw the pipes," Milito says, "as gun barrels against the sky." A rendition of all four visual elements might have weakened the intended analogy by too explicitly identifying the ominous shapes and thus distracting the viewer's attention from the photographer's purpose.

The photographs on the following pages show how any one of these approaches to seeing can be the principal way of inferring a meaning from an object or producing a reaction to it. In each case, the choice seems almost obvious. Yet this only indicates how hard the photographer worked at seeing his subject; truly cogent selection of one visual mode depends upon careful consideration of them all—if only in order to reject all but one.

Silhouetted against the sky, circular rims just
visible as they rise from a black mass, these
pipes stacked on the Brooklyn waterfront bear a
resemblance in shape to cannon arrayed for
attack. A heavy red filter blocked the blue light
from the sky, as well as the light bouncing off the
blue-black surface of the metal, but it allowed
the film to record the light reflecting off
the clouds and the unpainted rims of the pipes.

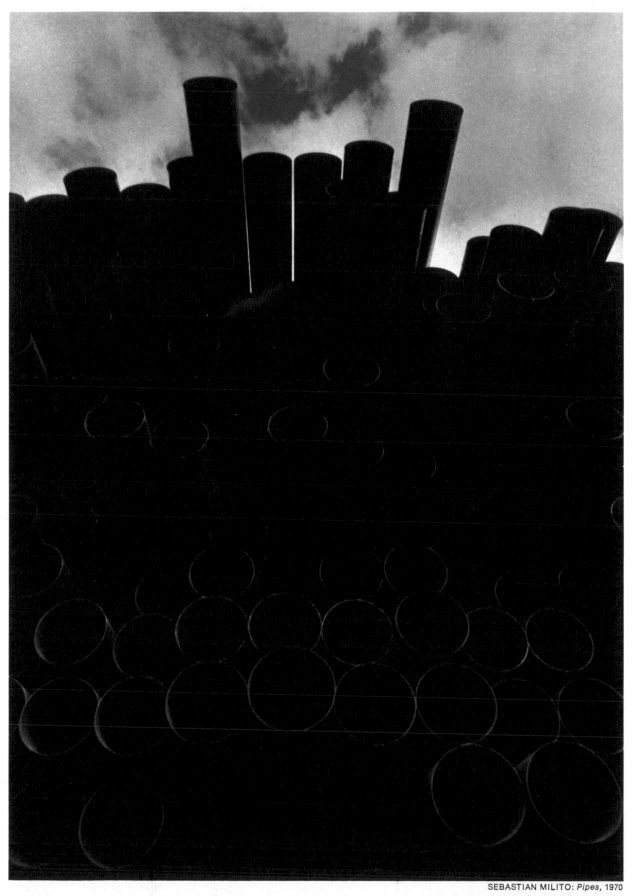

SEBASTIAN MILITO: *Pipes*, 1970

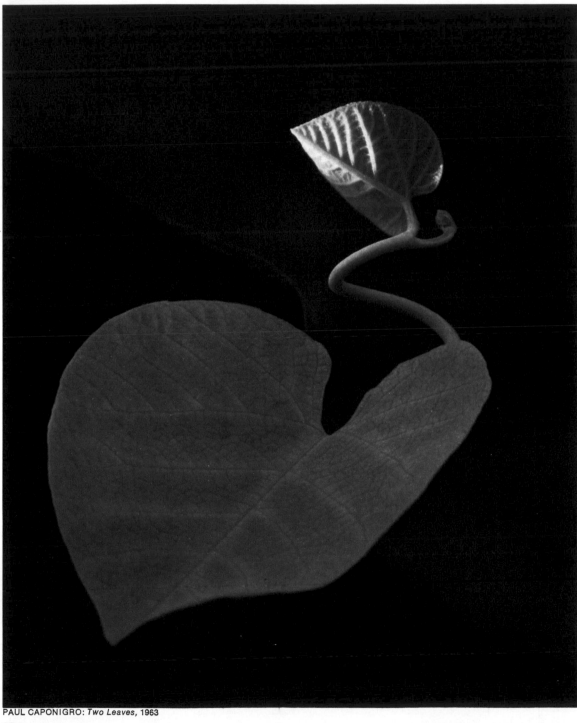

PAUL CAPONIGRO: *Two Leaves*, 1963

Soft natural light caresses the tilted-valentine shape of a Dutchman's-pipe leaf at left. The area within the leaf's sinuous boundaries, depicted in a subtle play of low-key tones, seems essentially flat, but the smaller, highlighted leaf and spiraling stem lend the suggestion of a third dimension.

The contours of a woman's nose are repeatedly ▶ amplified in the high-contrast photograph opposite, first by the similarly shaped crook of her arm, then by the outer edge of the arm, which extends beyond the picture frame. Using harsh lighting and printing for sharp contrast, the photographer excluded all but the face and arm, letting the eye and mouth help explain what otherwise would have remained a minor mystery.

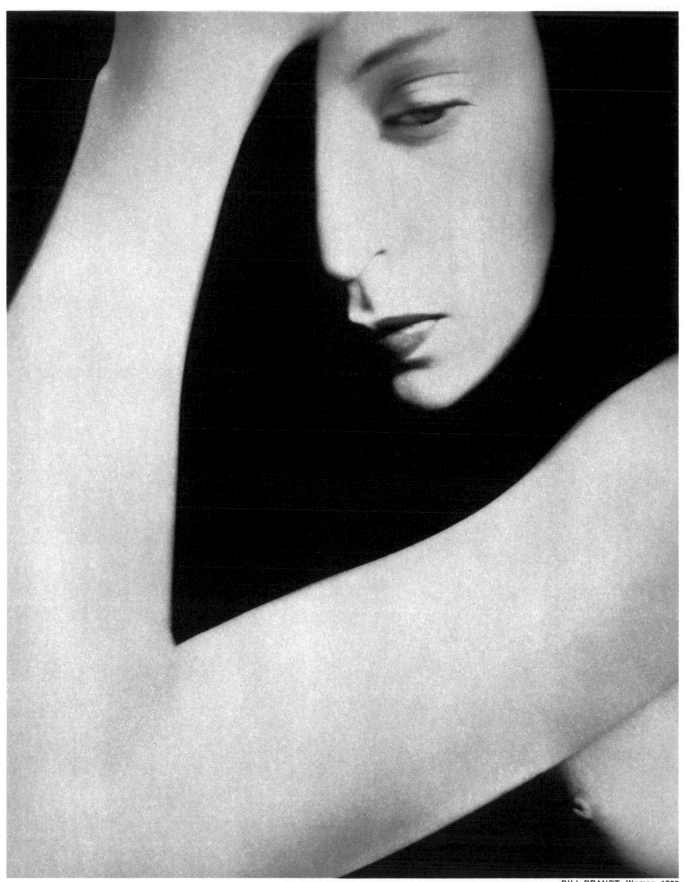

Pattern on Display

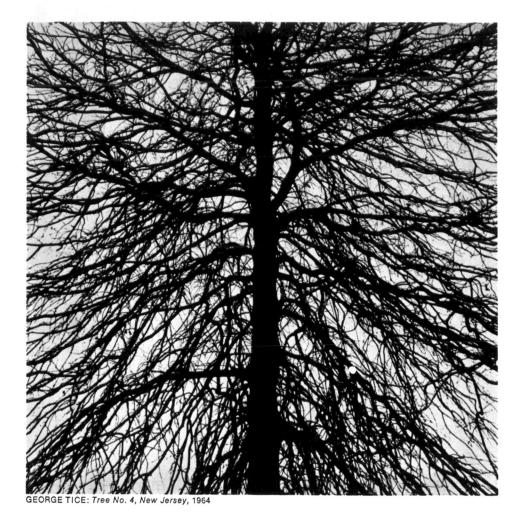

GEORGE TICE: *Tree No. 4, New Jersey, 1964*

In the natural and man-made world, shapes often repeat themselves and produce a pattern—the windows of a skyscraper, the lines on a printed page, or the leaves shown opposite in silhouette. Pattern differs from texture, which also displays repetition, because pattern does not necessarily imply a third dimension, as texture does.

Order exists in every pattern. If a single shape has been multiplied many times, the pattern's regularity is immediately apparent. If the shapes are similar but not identical, as in the branches at left, the order may be less obvious—but the discerning photographer who detects the underlying unity can employ that fact to create pictures replete with subtle rhythms.

Even though the branches of a tree are of different sizes and point in different directions, they form a pattern based on the repetition of long, twisting shapes. Here, the photographer concentrated on this underlying orderliness by underexposing to avoid catching confusing detail. He then overdeveloped his film and printed his picture on contrasty paper to obtain the silhouette effect.

A strongly ordered pattern is exhibited in this photograph of leaves, also created by underexposing, overdeveloping and printing on contrasty paper. One slight deviation from symmetry enhances the pattern's organization: the stems are not perfectly opposed, but take turns, as it were, as they emerge from the branch.

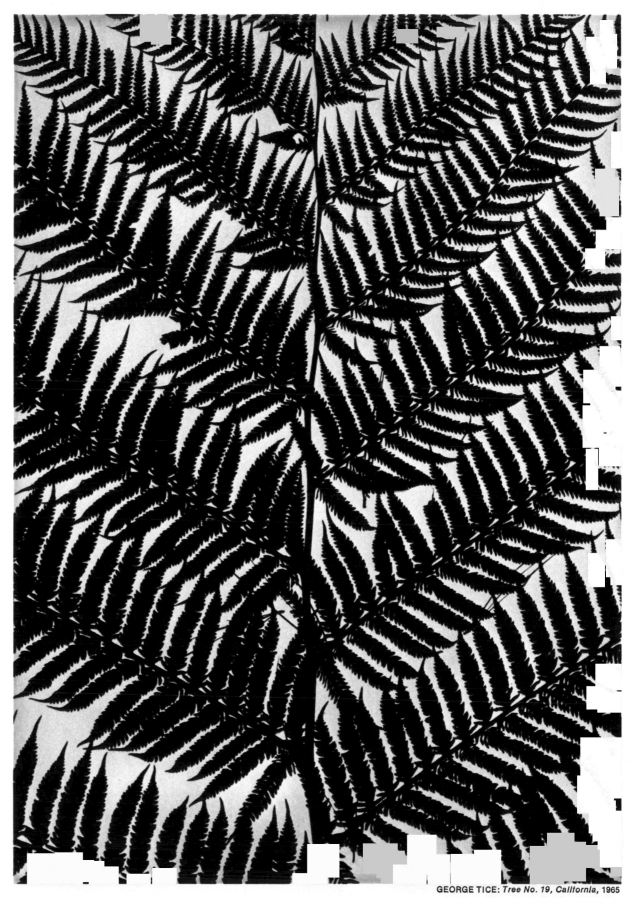

GEORGE TICE: *Tree No. 19, California,* 1965

Texture on Display

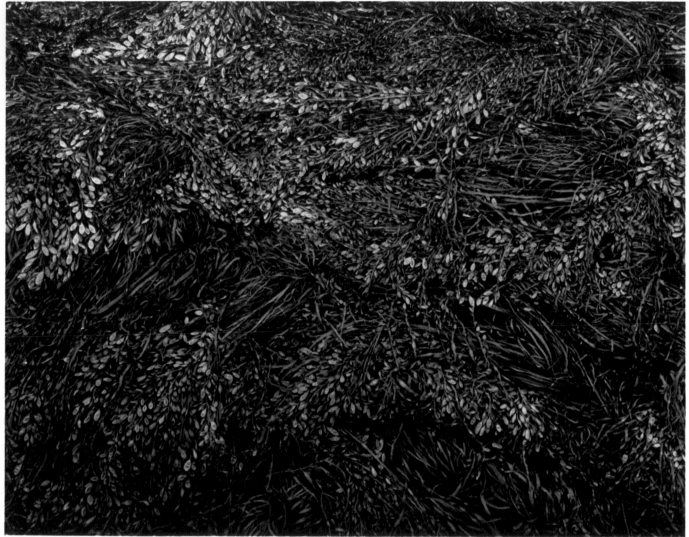

PAUL CAPONIGRO: *Tidepool,* 1966

A tangled mass with a texture of great density, this pile of eelgrass awaits the loosening flood of the tide in a marsh near Nahant, Massachusetts. Using natural light and a view camera loaded with fast film, the photographer moved in close to concentrate on the thickly matted vegetation.

On a slightly overcast morning the bark of a wild ▶ cherry tree, photographed with a long lens from only a few feet away, becomes a magnified, textured conundrum of overlapping scales, indeterminate in size and substance but like a craggy cliff inviting the touch of a hand.

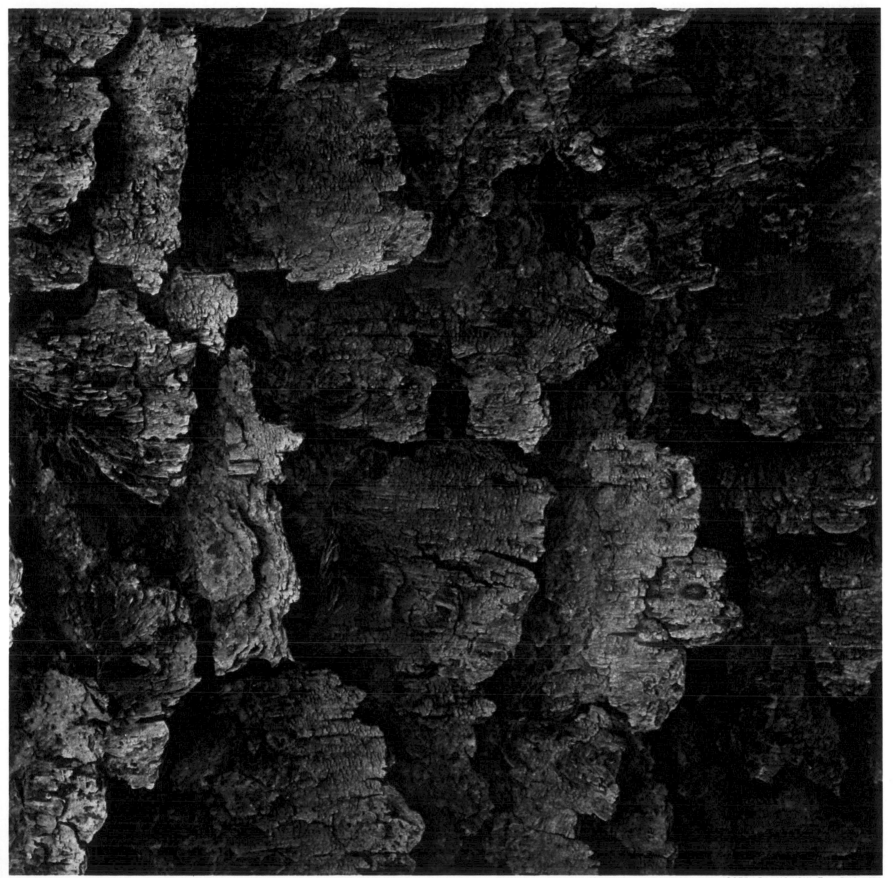

JOSEPH DANKOWSKI: *Tree Bark*, 1970

37

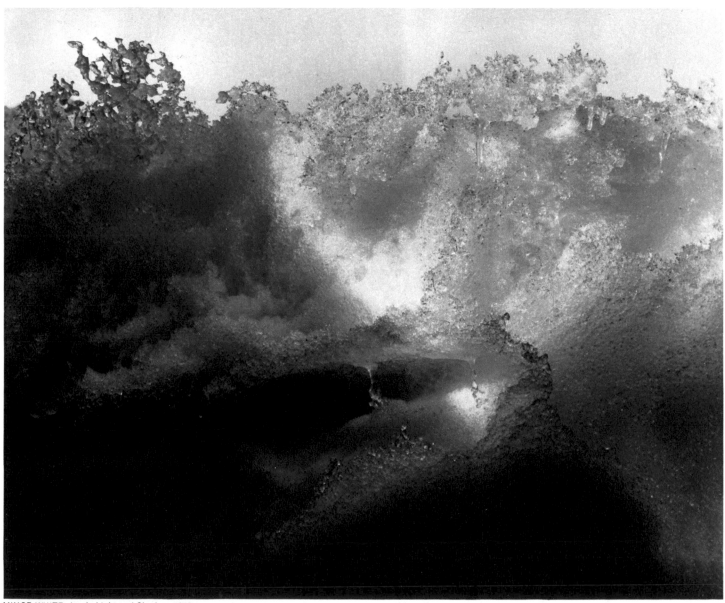

MINOR WHITE: *Ice in Light and Shadow,* 1960

Shooting through a window of his home, Minor
White caught a rich blend of crystalline textures in
one picture: soft, white snow at the center;
brittle, granular ice where the snow has melted
and then refrozen; and tiny, glass-smooth icicles
that seem about to return to the liquid state.

The crinkly, involuted texture of kale is ►
repetitively displayed in the picture opposite,
whose right half exactly matches the left. No
kale plant ever grew this way—the photographer
created the symmetrical image to emphasize
texture. Mounting the negative in her enlarger,
she exposed half of the printing paper, then
flopped the negative and exposed the other half.

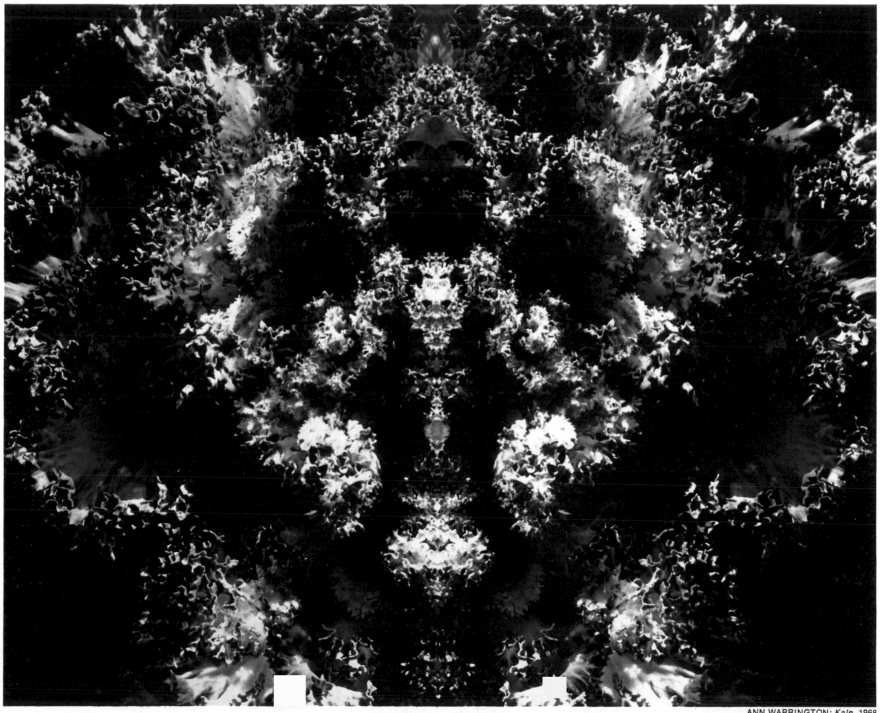

ANN WARRINGTON: *Kale,* 1968

Form on Display

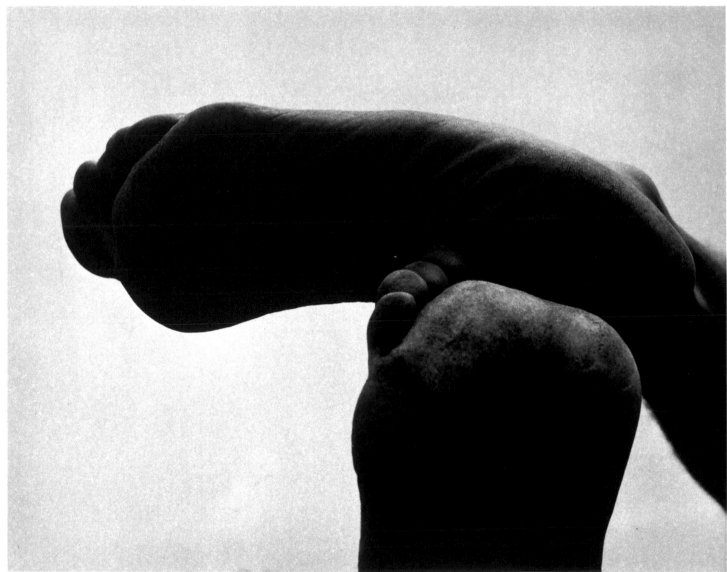

AARON SISKIND: *Feet,* 1957

Framing his subject against the sky to emphasize
its form, Aaron Siskind converts a pair of feet
into an intricately balanced sculpture that might
have been carved by wind or water. In making a
picture, Siskind says, *"I want it to be an altogether
new object—complete and self-contained."*

Sculpted by soft daylight and slight additional ▶
floodlighting, the swollen form of a pregnant
woman becomes a compelling symbol of the
fruitfulness of life. Barbara Morgan gave the final
print a predominantly dark tone to create a sense
of the *"mystery and beauty of childbearing."*

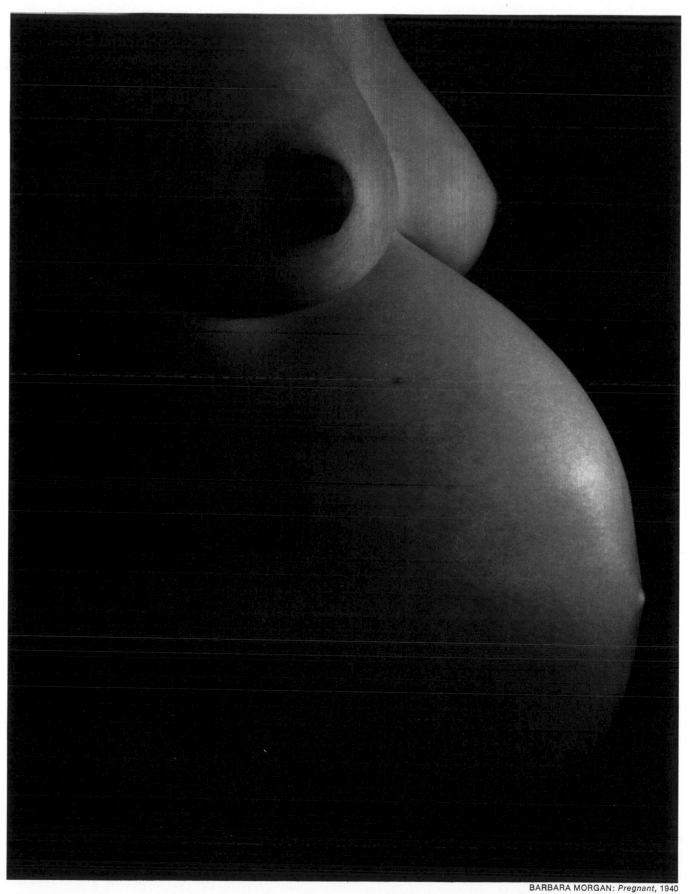

BARBARA MORGAN: *Pregnant,* 1940

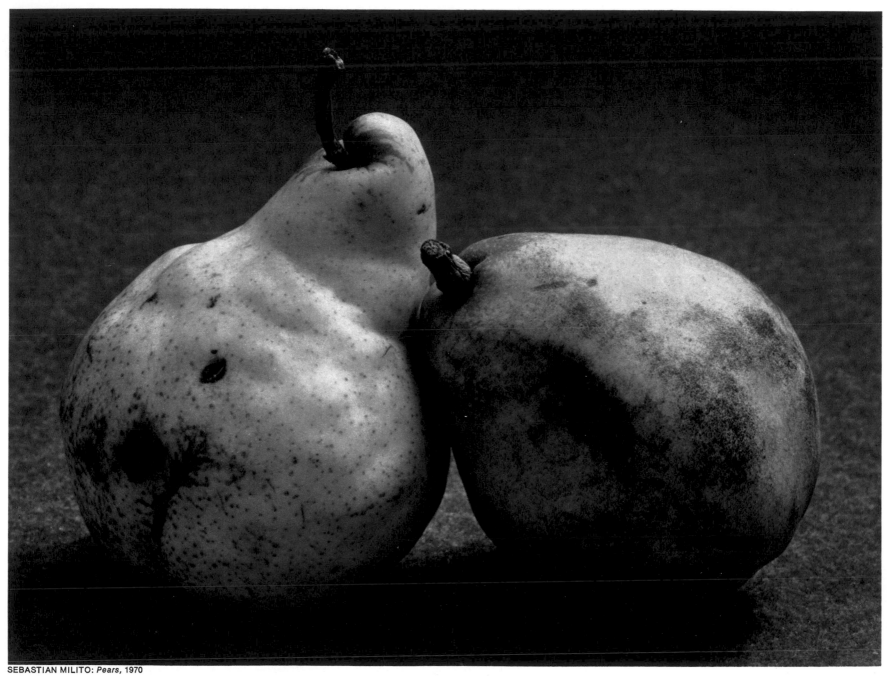

SEBASTIAN MILITO: *Pears,* 1970

◀ *Two pears, so ripe as to be reminiscent of the pregnant form on the previous page, strongly evoke the third dimension. The photographer emphasized their plumpness by backlighting them with one light and highlighting them from above.*

While the ripe pears opposite seem to press outward against empty space, the bell-like centers of the lilies at right lure the attention from the surrounding space into their mysterious interiors. Shot on a slightly overcast day, their form is expressed by the deepening shadows that lead almost imperceptibly into the dark centers.

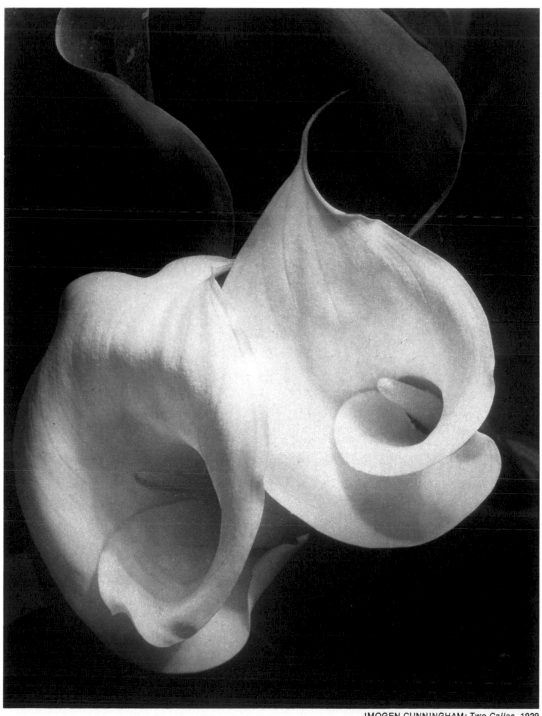

IMOGEN CUNNINGHAM: *Two Callas,* 1929

The Visual Elements in Combination

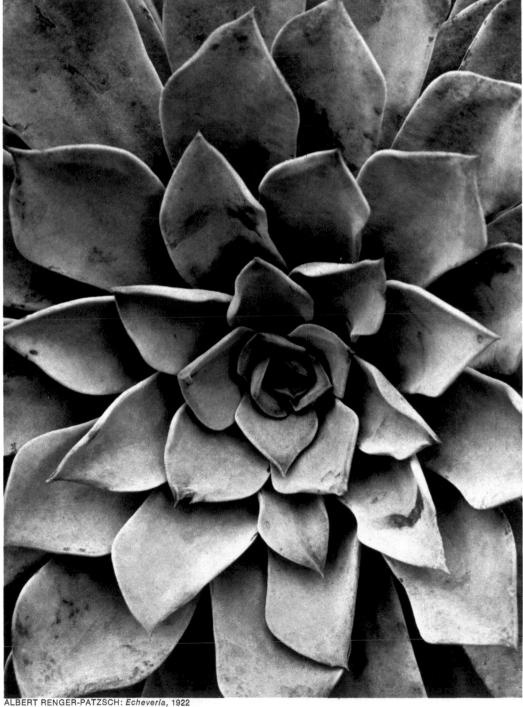

ALBERT RENGER-PATZSCH: *Echeveria*, 1922

The photographer who isolates and examines the four visual approaches explained on the previous pages has actually earned himself many more than four options, because a camera not only can isolate any one of the four, but can record various combinations of them—any two, any three or all four.

In gaining these options, the photographer has made his work potentially more rewarding, but more complex. He now must decide: Should he emphasize only the shape of his subject? Should he concentrate on texture and color while forgetting about form? Should he employ shape, form and color while leaving out texture?

He may, of course, decide on any combination of elements rather than a single one. But the best combination will be irreducible—the minimum that will express his sense of the subject. Each of the pictures here and on the following pages evinces such a combination—one that respects the possible visual complexities, yet at the same time pares away all but the essentials.

While paying attention to the pattern and three-dimensional aspect of the petals of a Mexican cactus, the photographer moved in close in order to withhold any suggestion of the plant's total shape. The viewer can speculate on the unlikely possibility that the petals radiate to infinity.

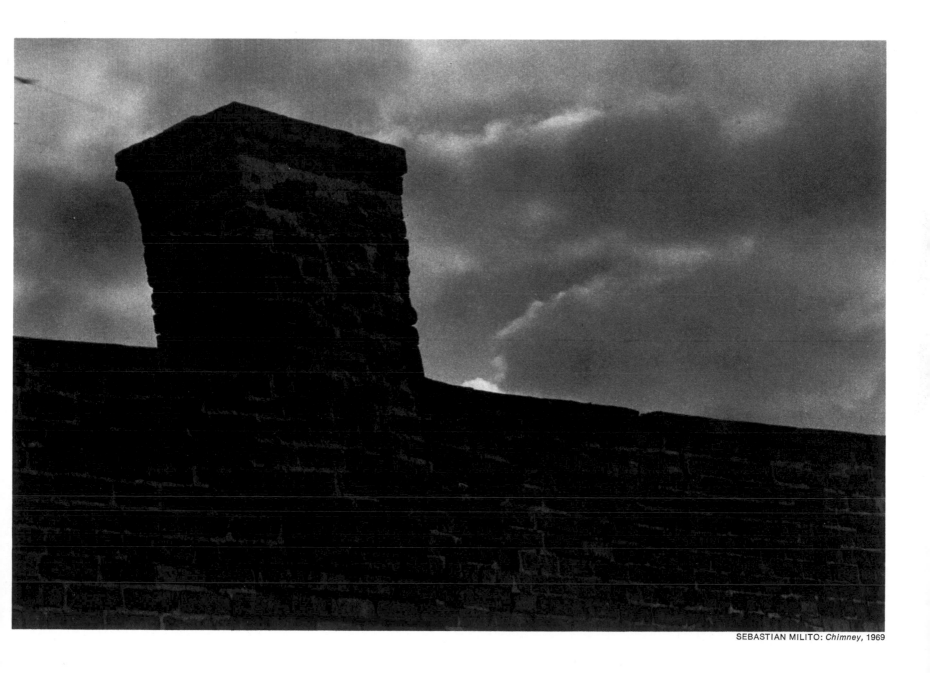

SEBASTIAN MILITO: *Chimney*, 1969

From his own window, Sebastian Milito photographed an oddly tilted chimney protruding from a brick wall and created an image that is economical yet as full of expression as a human gesture. The visual attributes necessary to his picture were pattern and shape. Without the pattern (and, to some degree, the texture) of the bricks, the chimney would be merely a cryptic interruption in a line; and without its shape, it would be any not-quite-straight chimney.

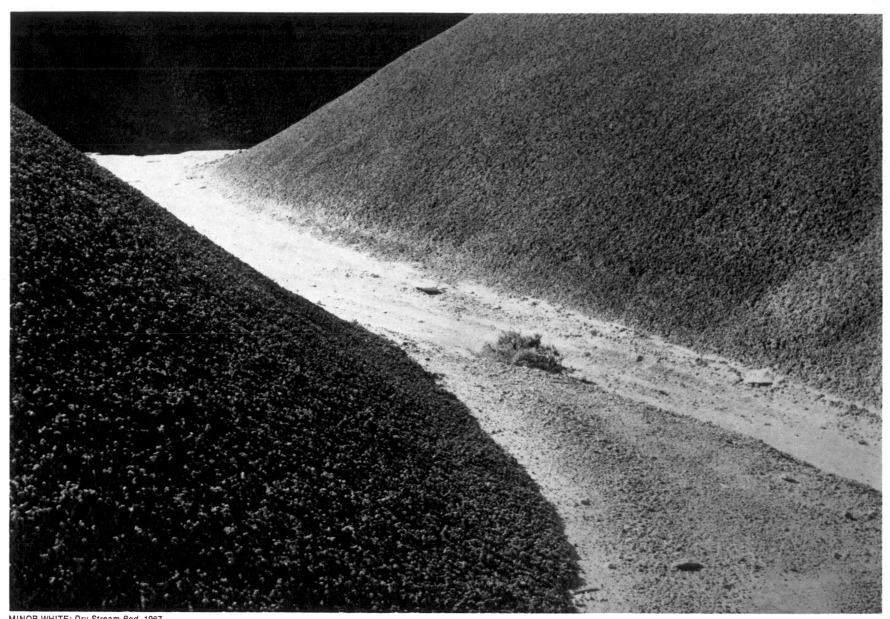

MINOR WHITE: *Dry Stream Bed*, 1967

A dry stream bed in Utah has become an abstraction of texture and shape in this picture, taken with a portable view camera and printed on high-contrast paper. One component of seeing has brought another into being: the soil texture, darkened in different ways by the angle of the sunlight, forms a rich variety of shapes.

A tree trunk near Dark Canyon Lake in Utah,
photographed from inches away, needs no
suggestion of a third dimension; it is a visual feast
of splintery texture and a pattern that might
have been wrought by magnetic lines of force.

MINOR WHITE: *Knothole*, 1967

MINOR WHITE: *Long Form Moving Away,* 1950

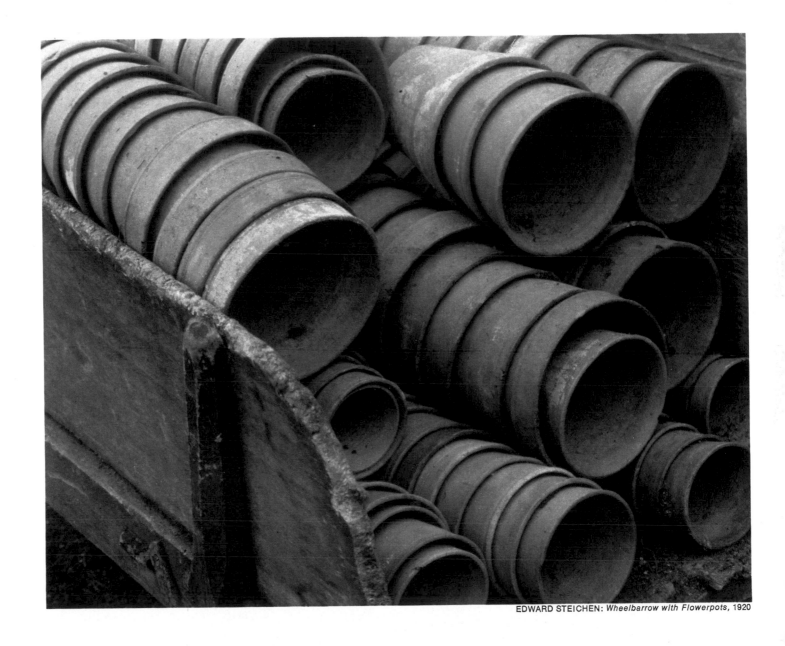

EDWARD STEICHEN: *Wheelbarrow with Flowerpots, 1920*

◄ *Sensuous texture and complex, shadowed forms dominate this picture of sandstone at Point Lobos, California, whose water-sculpted rocks have fascinated countless photographers. Here the photographer has produced a study in high contrasts, ignoring the overall shape of the rock.*

In this study of flowerpots in a wheelbarrow, strong contrast serves to deepen the shadows, emphasizing the pattern of the rims, while modeling the cylindrical pots. Edward Steichen thought the picture realistic and was surprised when friends saw it as an abstraction.

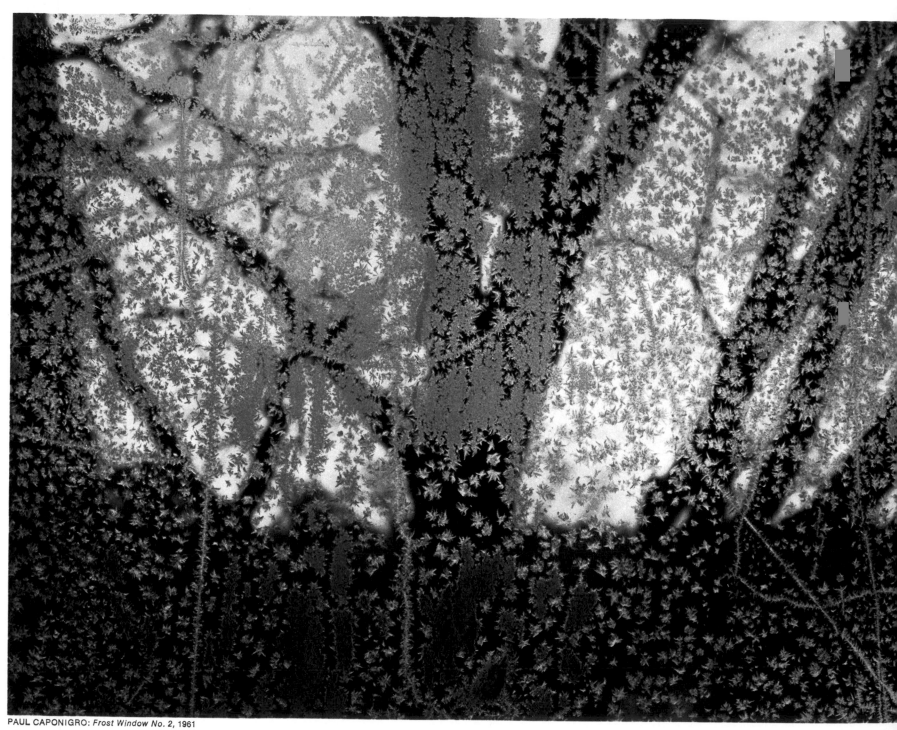

PAUL CAPONIGRO: *Frost Window No. 2,* 1961

◄ *A picture of frost crystals on a bedroom window (opposite) makes a tapestry out of a mixture of pattern and texture. Positioning his view camera about a foot from the glass, the photographer stopped the lens all the way down to f/32 so as not to lose the dark trees in the background.*

Straight-edged except for its single curving boundary, this combination of patterns and shapes of shadows comprises an intricate visual fugue in the study at right. Counterbalancing designs make a mystery of the subject's identity.

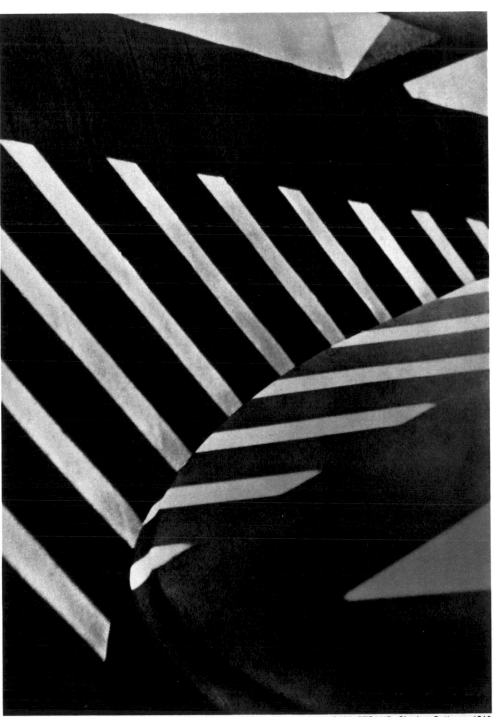

PAUL STRAND: *Shadow Patterns*, 1916

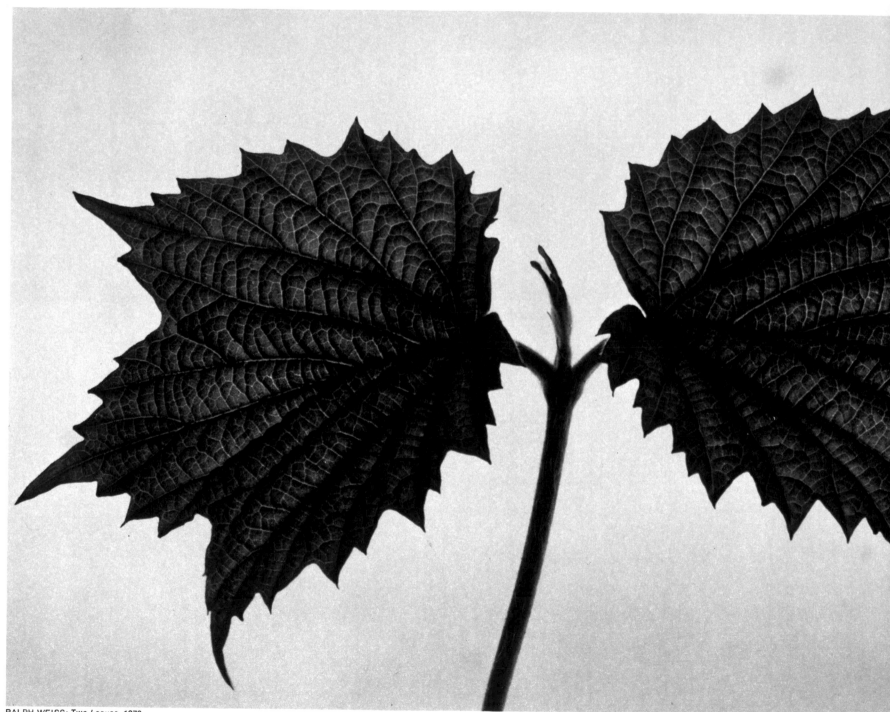

RALPH WEISS: *Two Leaves*, 1970

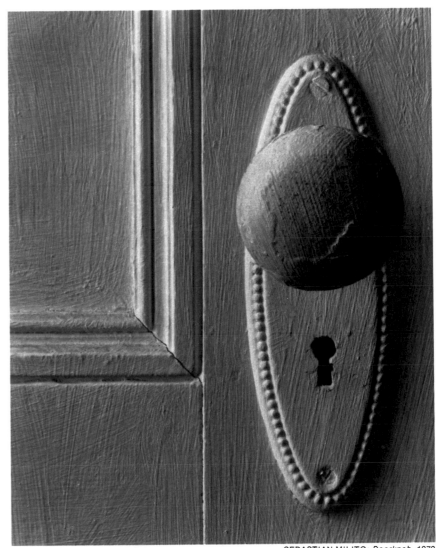

SEBASTIAN MILITO: *Doorknob*, 1970

*Sidelighting a door with a common incandescent
bulb summons up three of the visual approaches,
all but color: rectangular, oval and circular
shapes; the texture of paint applied by a coarse
brush; and the rounded form of the doorknob.*

◄ *A pair of maple leaves, stretched out like the
wings of a bird, clearly manifest their shape and
texture—and their third dimension is implied by
the half-hidden stems that seem to thrust the vein-
patterned leaves toward the eyes of the viewer.*

When Color Dominates

Color film gave photography a second life. In the 19th Century, photographers had to be satisfied with translating their subjects into the confined tonal language of blacks, whites and grays. Early color-creating processes were crude, and color retouching was never very convincing.

When color film became generally available in the mid-1930s, it naturally brought with it a sense of release and renewal. But it also presented a major challenge, because a new need for discipline soon became apparent. Color that is indiscriminately recorded does not confer automatic worth on each and every image. Too much color, inappropriate color or unsuitable color relationships can all do violence to a photographer's intention.

Yet once the challenge is understood and met, color film adds another dimension in visual boldness. The colors of real life can be selected, concentrated or muted to make possible a degree of perception scarcely available to the eye in its routine scanning of the world. Further, these available colors can be heightened, muted or completely transformed by many means—color filters, special lights, techniques of exposure, development and printing. Like the other qualities of vision, color requires careful esthetic control. It disappoints only when it is ignored, mismanaged or taken for granted. □

In an arresting mix of normal and artificial colors, a model's purple make-up and her cap of steel-gray gravel are counterweighted by the healthy red of her tongue. The photographer lighted his picture by bouncing an electronic flash into a diffusing umbrella held directly above the model's head. The startling redness of the tongue tip was brought out by a color-correction filter.

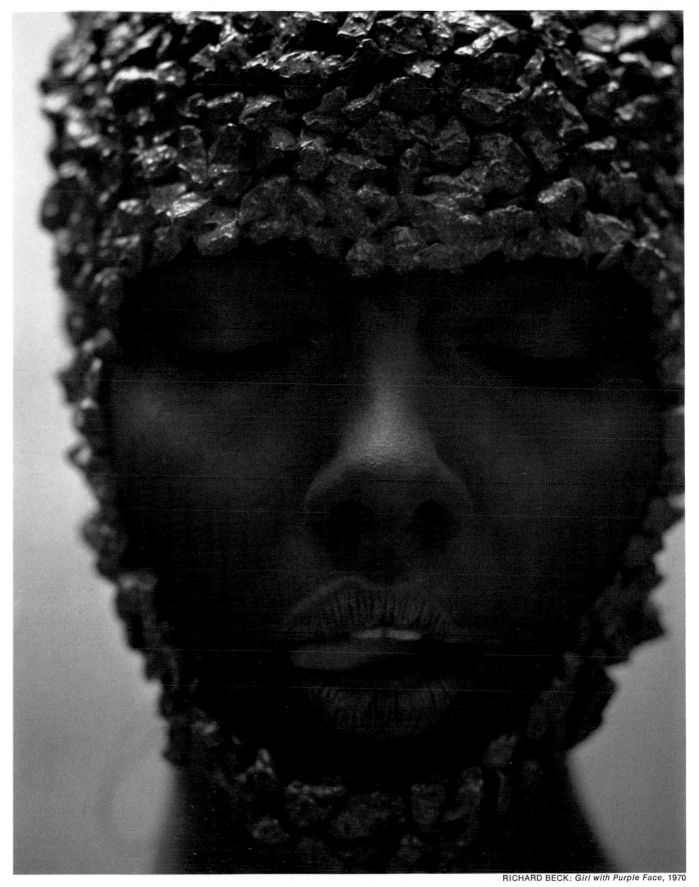

RICHARD BECK: *Girl with Purple Face,* 1970

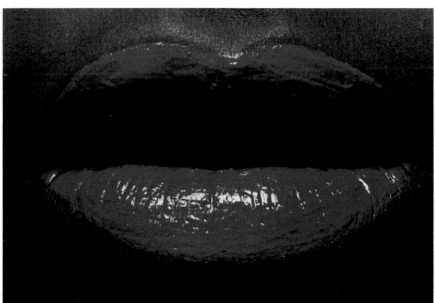

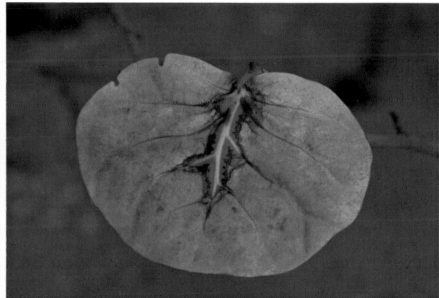

PETE TURNER: *Hot Lips*, 1966

LILO RAYMOND: *Leaf*, 1965

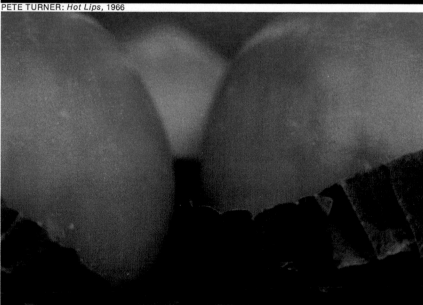

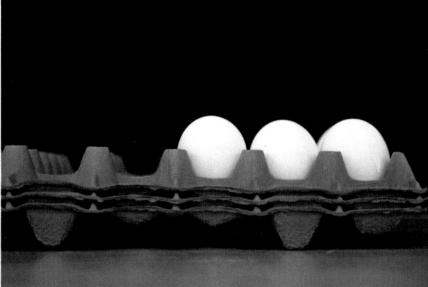

MARTIN SCHWEITZER: *Persimmons*, 1959

MARTIN SCHWEITZER: *Eggs and Cartons*, 1968

At top, a frontally placed electronic flash makes a vibrant combination of colors: bright red lips, muted brown skin, dark mouth and chin.

Below, a trio of persimmons, photographed through a grocery window, offers a triple play of color, in which the orange fruit and the purple wrapping contrast with the green background.

In the photograph of the sea-grape leaf at top, color is the dominant attribute. The mauve color of the leaf blends subtly with the blue background of the Florida shore where the plant flourishes.

The cartoned eggs might have been successful even in black and white; here the purplish gray of the cartons provides a third dimension of color.

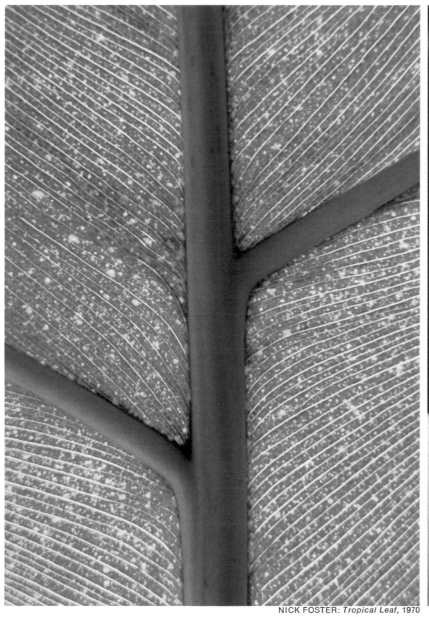

NICK FOSTER: *Tropical Leaf,* 1970

*All our elements but texture are present in this
picture of a tropical leaf made at the New
York Botanical Garden: pattern in the arcing
veins, shape and form in the stem and, above all,
riotous color in the bright greens and yellows
dancing across the delicate surface of the leaf.*

NICK FOSTER: *Orchid,* 1970

*What the photographer calls "the sensual
landscape of a flower" is enhanced by this
picture's opulent colors. Infrared film was used,
changing the green of the orchid's leaf to
magenta, and emphasizing the shimmering white
radiance of the column at the center of the flower.*

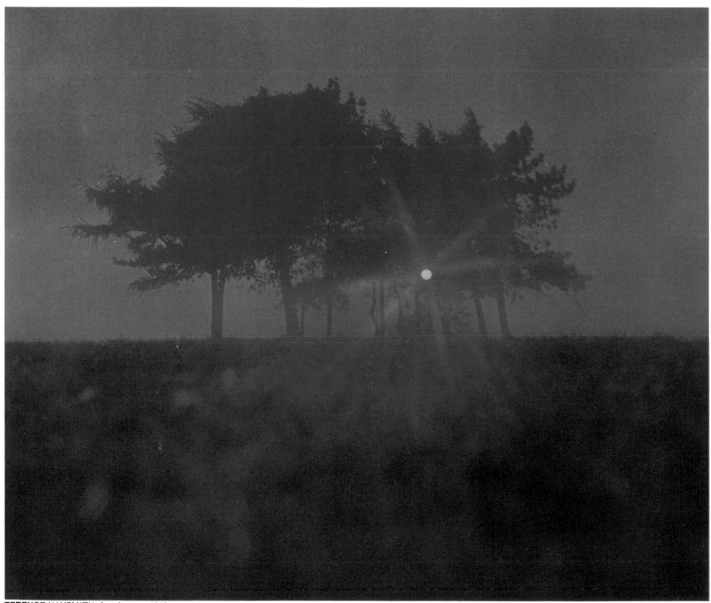

TERENCE NAYSMITH: *Landscape,* 1969

A composition that looks like a landscape at dawn is not that at all. The photographer has conveyed the idea of daybreak artificially, by blending colors and without shooting an actual sunrise. The picture is a triple exposure made in early afternoon. Aiming his camera in a different direction each time, he first used a yellow filter to shoot the grass, changed to a cyan filter, and finally switched to a magenta filter to get the end product of blue trees, pink light and lavender sky.

Principles of Design 2

The subject is a not-so-blank brick wall; the ▶
photograph itself is a bridge between the
preceding chapter and the chapter that follows.
Shapes, patterns and textures—some of the vital
"building block" elements of perception—are
made into a superb picture by the application
of fundamental design principles that are
discussed and illustrated on the ensuing pages.

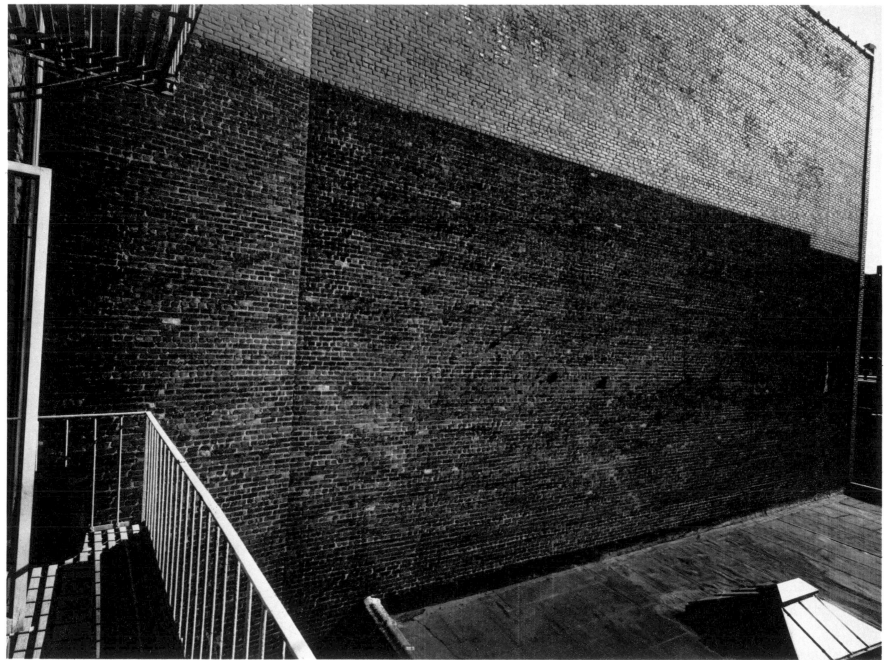

WOLF von dem BUSSCHE: *Untitled*, 1971

Making Design Work

Design in photography is sometimes thought of, mistakenly, as a repertoire of tricks for beautifying pictures. That idea is as false as considering architecture to be merely the embellishment of the outsides of buildings. In photography—as in every art and craft—design is the process of organizing ingredients so that they achieve a purpose. A teapot, for example, is a device that must be light enough to be picked up in one hand, that must contain a liquid, keep it warm, pour it without spillage, and satisfy a number of other requirements as well. The design of a teapot reconciles all these requirements through a particular choice of material, shape, thickness and other qualities. It makes the teapot work.

What makes a photograph work is also complicated. A picture is something that works by being perceived. It is usually (not always) a flat object that is meant to communicate something to a viewer. More often than not, that "something" is quite complex—a blend of feeling, information, insight and idea that would be difficult to sum up in words. Good design in photography is any structure—any organization of visual elements—that enables the beholder to grasp all that the photographer wanted to communicate.

Assuming that every picture needs some sort of structure to achieve its purpose, how does the photographer bring about this organization? Most likely he will make a number of broad design decisions without even being aware of it. Simply using a camera is one such decision: it will form an image in perspective—that is, it will make distant objects appear smaller than near ones, and it will make parallel lines seem to come together as they recede from the camera. Most photographers take the perspective-rendering camera for granted. But there are design alternatives, such as montages, in which distance need influence neither the size of objects nor the convergence of lines in the way we have come to expect. Film and printing paper —as well as exposure and development—also help design a photograph by responding to light in a characteristic way, each material and each technique for using it introducing its own qualities—contrast, color rendition, graininess and so on. The photographer may want to venture beyond the ordinary uses of film and printing paper by sandwiching negatives for composite pictures, creating photograms without camera or lens, or imposing various other sorts of organization on his work.

Such basic matters establish the broad framework of design in photography. They, like the painter's palette and canvas, determine what can be done next in creating a picture. Within this framework, the photographer still has an enormous number of design options for organizing the visual components to produce the effect he wants.

By changing his camera angle or walking around a subject, he can exercise great control over what will appear in the picture and how it will be ar-

ranged—choosing a background, for instance, or establishing a new relationship between two objects by making them look closer together than they really are. The selection of a lens allows him to control the effect of perspective and alter the relative sizes of near and far objects, as well as the amount of material included in the picture. (A wide-angle lens might be placed close to a piano player's hands to make them seem disproportionately large; a long lens can make cars in a traffic jam seem crammed together by rendering them almost the same size.) By adjusting the lens aperture, the photographer can either keep almost every part of a picture in sharp focus or extinguish some unwanted element in a vaporous blur. By choosing the appropriate shutter speed, he can freeze a moving object in one spot or cause it to draw a streak of color across the picture. Through his choice of lighting, he can control the brightness of a scene, its shadows, and what is disclosed or obscured. Each of these decisions helps determine which components the viewer will see in a situation and how important they will seem to him. They help set the design.

This list of techniques (by no means exhaustive) indicates only how a photographer can impose a structure on his image—and immediately raises the question of *what* that arrangement should be. There is no all-purpose answer, for the deployment of elements in a picture depends on the intention of the photographer and on the techniques that are available to him. But in striving for effective communication, he can exploit certain design principles that have been known to artists for centuries and are still useful guides. Familiarity with these principles helps determine the way the viewer interprets relationships between the visual ingredients in a picture. It is the relationships, rather than the separate ingredients, that mainly influence the way the viewer perceives the picture and determine its success as a design.

Viewing a picture, people will note differences or similarities among its parts—variations in shape, texture, form, color, size, orientation and perhaps a number of other characteristics, depending on the training and patience of each viewer. Due to the differences or similarities that are perceived, the parts seem to gain a visual equivalent of weight, and they make the picture seem balanced or unbalanced. One part may appear to be dominant and the others subordinate. Their relative amounts—the proportions—of color, bulk or any other characteristic may seem familiar or surprising. The separate parts of the image might appear to group themselves into a single configuration, such as a triangle or circle. Or they might set up a visual counterpart of the rhythm that is associated with motion and sound. And even if there were only one element in the photograph, its size, tone and position in the frame would stir some associations and comparisons in the viewer and evoke mental relationships.

Why are human beings so responsive to such visual forces and relationships? Many explanations have been offered. The impulse to interconnect visual ingredients so that they will have meaning is, perhaps, a basic function of intelligence. We survive by constantly trying to organize and make sense out of what we see, identifying and assessing visual data for dangers, food or whatever. When we see a man running in the street we may merely be curious; but if we relate him to a following runner dressed in a blue uniform, the visual data acquire new meaning, and curiosity may change to alarm. Why we seek certain meanings, searching a picture for particular relationships such as balance or rhythm, has been explained to a degree in physiological terms. As two-footed creatures who have to go through a tricky period of learning to stand upright and walk, humans might well be expected to react to balance, feeling comfortable when it is present and disturbed when it is absent. Men appreciate regular rhythm, perhaps because of the inspiration of the countless rhythms that appear in nature—the heartbeat, the alternation of night and day, the pulse of the waves and the phases of the moon. But these physiological preferences may be less explanatory, many psychologists believe, than the general method of operation of the human brain, which seems always to seek to organize visual data into the most simple, regular and symmetrical configurations possible.

All these theories may possess a measure of truth. And they pose an intriguing possibility in the matter of design. If the brain, for whatever reasons, likes unity, regularity, good balance and steady rhythms, why not arrange the ingredients in every picture in a way that provides these relationships and nothing else? The answer usually given is obvious: In addition to the need for clarity, order and balance, there is also a need for stimulation —which can be supplied in pictures by elements of variety and tension. By this reasoning, the ideal design is one that is clear, orderly and balanced —but not in too obvious a way. It should be precarious and varied enough to be interesting, but not so precarious as to be irritating. Yet even this more complex formula fails on close inspection. It would sacrifice a great deal of the expressive power of design. For instance, an unbalanced structure might well be the best design for a picture whose intent is to disturb. Strange proportions can be extremely revealing—as in the example of the pianist's hands made to look unnaturally large. No other familiar relationship need be present: a photograph that is all color or pattern, with no dominant element, may be just as effective in communicating a creative intent as one with a more conventional scheme.

The effort to find an ideal design scheme has a long history. The Greeks, believing that certain proportions had divine significance, considered the so-called Golden Section rectangle, with a ratio of roughly 5 to 8, to be per-

fect. From Classical times to the present day, artists have devised formulas for relating design to the proportions of the human body. And some manuals of photography have listed rules prescribing, for example, that a horizon line must never divide a picture into equal halves, but ideally into two thirds/one third. Yet for every allegedly ideal arrangement, innumerable fascinating exceptions can be cited. It is safer to say that good design is any organizational scheme that communicates effectively.

For a beginner, good design usually requires cautious, conscious decision making. As he grows more experienced, he will learn to organize the elements as efficiently and perhaps as automatically as shifting gears in an automobile. This was the case with the photographs on the following pages, taken by Wolf von dem Bussche. His fundamental design decisions remained more or less constant throughout: he used a 4 x 5 view camera equipped with a 65mm wide-angle lens; he chose black-and-white film; he printed on medium-contrast paper. But within the various pictures, he deftly exploited a number of different kinds of pictorial arrangements to strike sparks of comprehension and interest in the viewer's mind.

The Dominant Feature

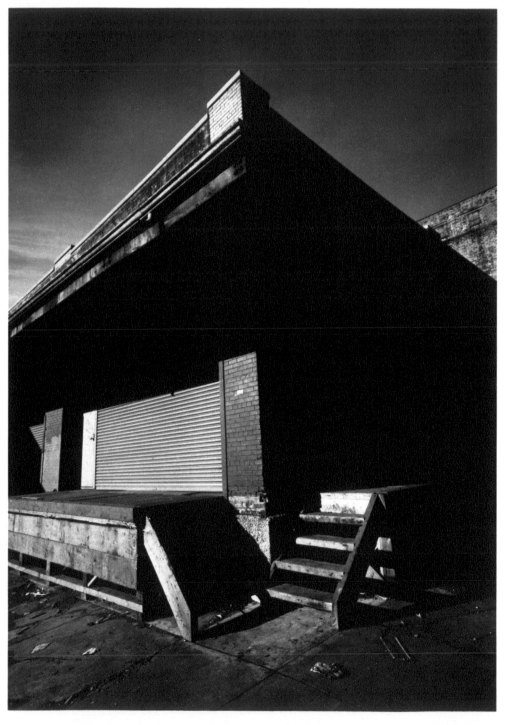

The design that lends organization to a picture can be talked about in a number of ways—put in terms of balance, proportion, rhythm and so on—but frequently there will be one mode of organization that is more appropriate than the others. In both of the photographs that appear on these pages, the visual components are chiefly linked to one another by dominance and subordination, and this relationship yields a powerful sense of unity.

The subject at left is a loading dock. It is, on the face of it, an uninspiring subject; if it were depicted from another angle or with less contrast, it would probably bore the viewer. But Wolf von dem Bussche chose his vantage point near a corner and used a wide-angle lens to make the lines of roof and platforms converge sharply, revealing the building as a kind of jigsaw puzzle of irregular polygons. He then emphasized these polygons by setting his exposure so that the shadowed areas within them came out very dark. Because the shadow under the roof is the largest and darkest of the polygons, it is dominant, and all the other polygon shapes are subordinate to it.

In the cityscape at right, another technique for generating dominance has been used: convergence of lines. The viewer's eye cannot resist looking at the top of the telephone pole because the telephone wires and the lines of the buildings lead right to it. The subject is a cityscape, of course—not the top of a telephone pole. But by providing a single point from which everything else in the scene appears to radiate, the photographer has unified his visual material and made it interesting to explore.

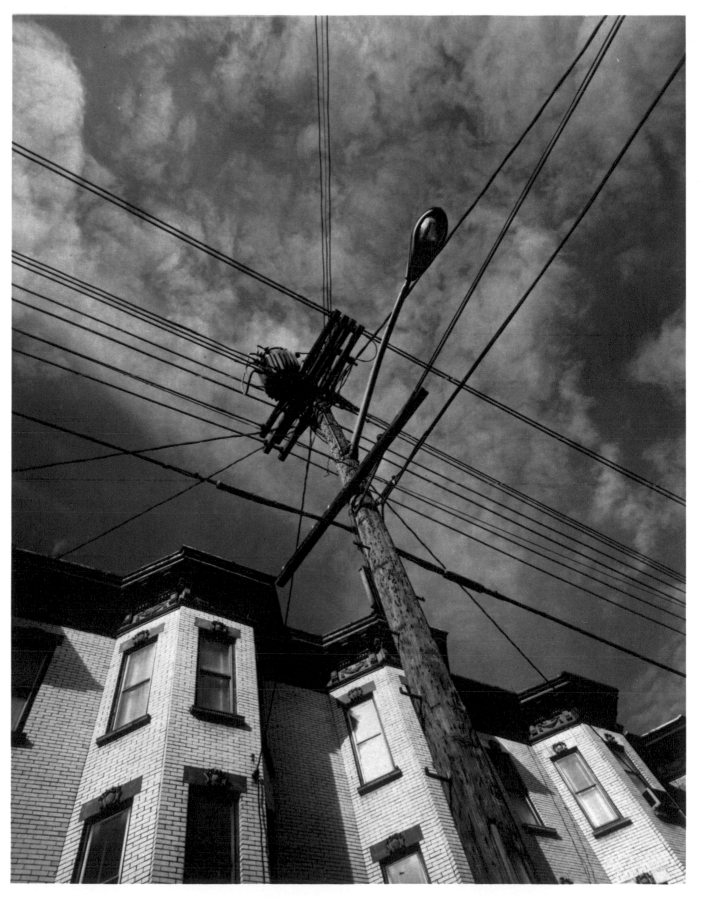

Balance

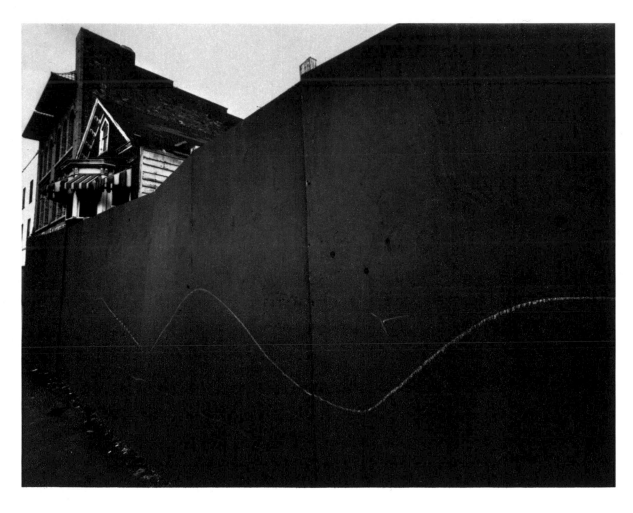

Some designs achieve their effects with very formal and obvious balances—an image with two identical halves, for instance. Other pictures have a subtle, asymmetrical balance that is produced by interactions of visual components.

Balance need not depend on matching sizes or shapes. Instead it may depend on the relative "weight" the viewer assigns to each pictorial ingredient. Pictorial elements will demand varying amounts of the viewer's attention according to size, color, location or even "interestingness"—and all these demands may add up to equilibrium by perceptual calculations almost impossible to explain in words. But no matter how balance is achieved, it evokes a sensation of stability and comfort in the viewer—and this response may well suit the photographer's purposes.

Both of the pictures on these pages are asymmetrically balanced. In the photograph of the house behind the fence at left, equipoise has been established by ingeniously playing off size against visual interest. Almost all of the picture is taken up by the fence. But the old-fashioned, angular house is much more intriguing than the fence, which is blank except for a wavelike chalk line. This size-versus-interest rivalry for the viewer's attention ends in a stand-off —and a definite feeling of stability.

The dreamlike scene at the right achieves balance by using a small area of blackness to offset a large white area. The design is analogous to a lever that is at rest. On one end is the pitch-black dog; the fulcrum is neutral white space; on the other end is the expansive but dull-toned landscape. If either dog or landscape were left out, the picture would seem distinctly precarious.

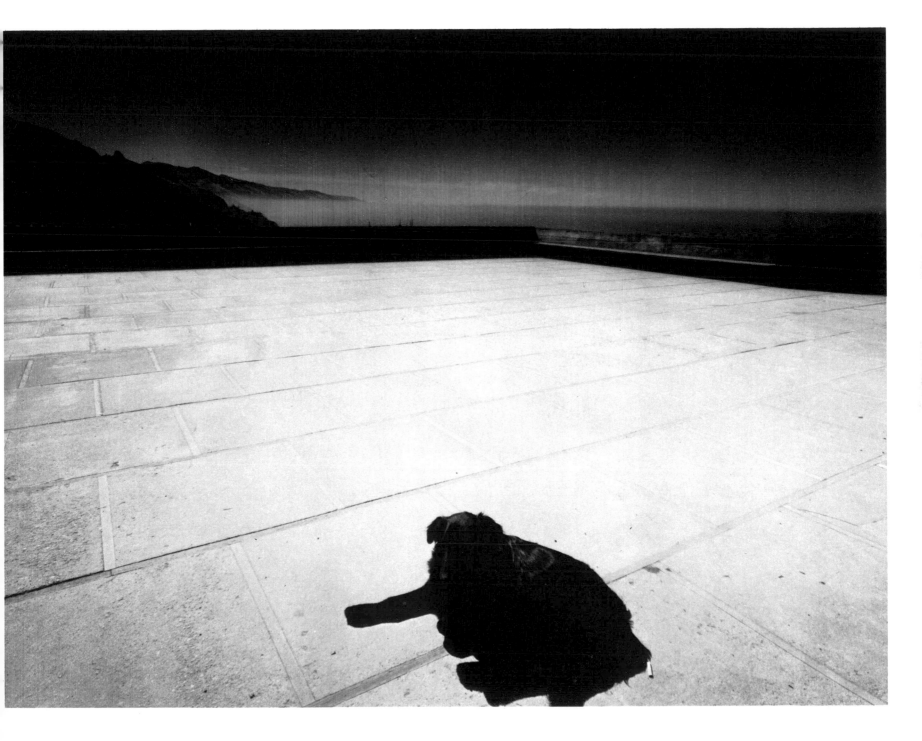

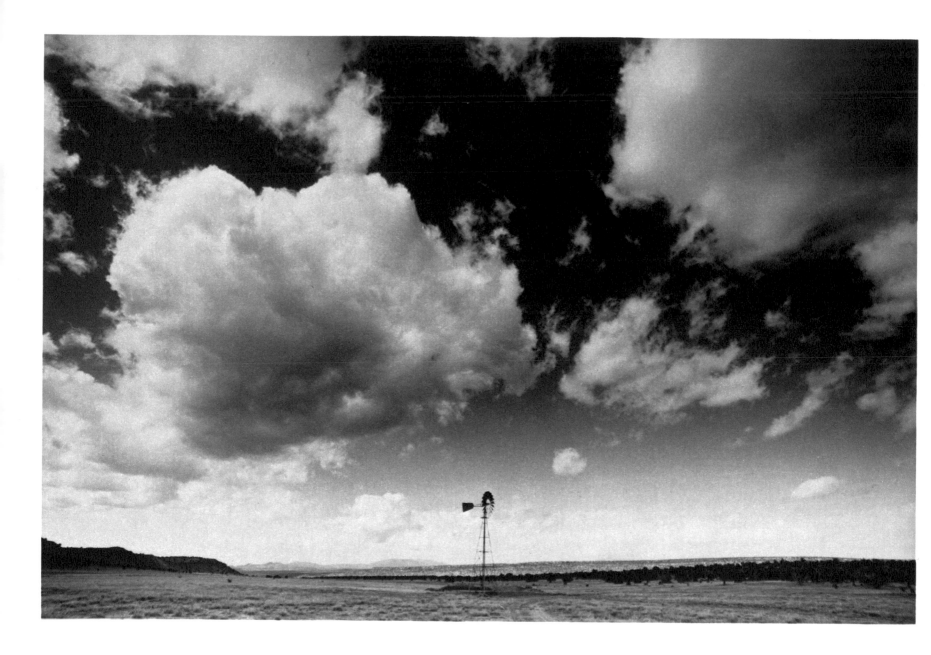

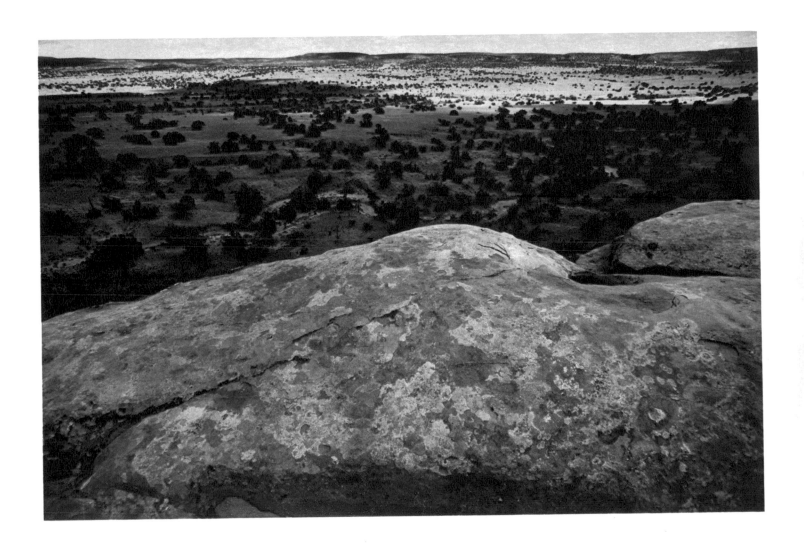

When a line is divided into two parts, the ratio between them is a proportion. Similarly, a ratio can be struck between any comparable elements in a picture, providing a relationship that may depend on qualities as objective as size, number and color, or as subjective as tone or interest. (The balance of the parts, and their dominance or subordination, are other questions, although proportion can influence either.)

The proportions of sky and land in the photographs on these pages are radically different—and neither picture follows the rules for supposedly harmonious proportions. Yet each photographer's intended meaning is well served. Where the vaulting sky occupies much more of the picture than the land *(opposite),* there is an overwhelming sense of the vastness of nature—and the toy-like windmill indicates how small a

human figure would be in this scene. But in the picture above, the sky is reduced to a sliver. This alteration of the proportions we normally expect changes our interpretation of other elements in the picture. The object in the foreground becomes a puzzle. It looks like a ledge, or even a mountain, from which to peer down on the land, but nothing gives a reliable clue to its true size. (It is really a rock 15 feet high.)

Rhythm

The word rhythm comes from the Greek *rhein,* meaning "to flow," but it implies a flow with a recognizable pattern. In musical compositions, a patterned flow is obvious, since such works of art are performed over a period of time. The visual arts display this rhythmic property too, even though most pictures exist as a whole, not changing with time. They gain their flow—and rhythm—because they are perceived over a period of time, as the viewer's attention moves from point to point.

Rhythm is created whenever similar pictorial components are repeated at regular or nearly regular invervals. The viewer's attention is lured through the image along the path of repetition, and the result is a sense of order and unity. In addition, visual rhythm may help to build a kind of viewing efficiency into a picture, in the same way that playing tennis or chopping wood is easiest when done rhythmically.

A rhythmic design was used to organize the photograph at right. The recurring component is shape. The viewer's attention repeatedly leaps the dividing line of the fence top to take in the shapes of a torn patch in the fence, a windowed house, another torn patch, a tree, yet another torn patch, and the roofs at the sides of the picture. Underlying this alternation is the less pronounced but more regular rhythm of the dark markings on the fence, stitching a bonus of order into the design.

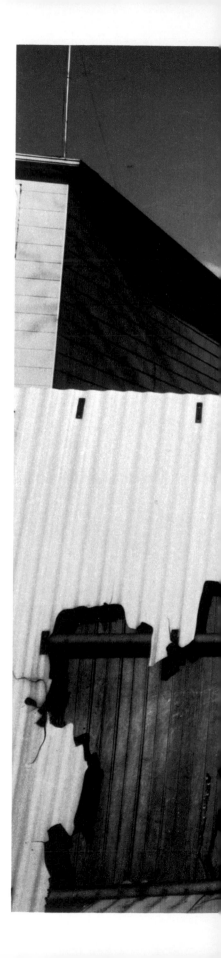

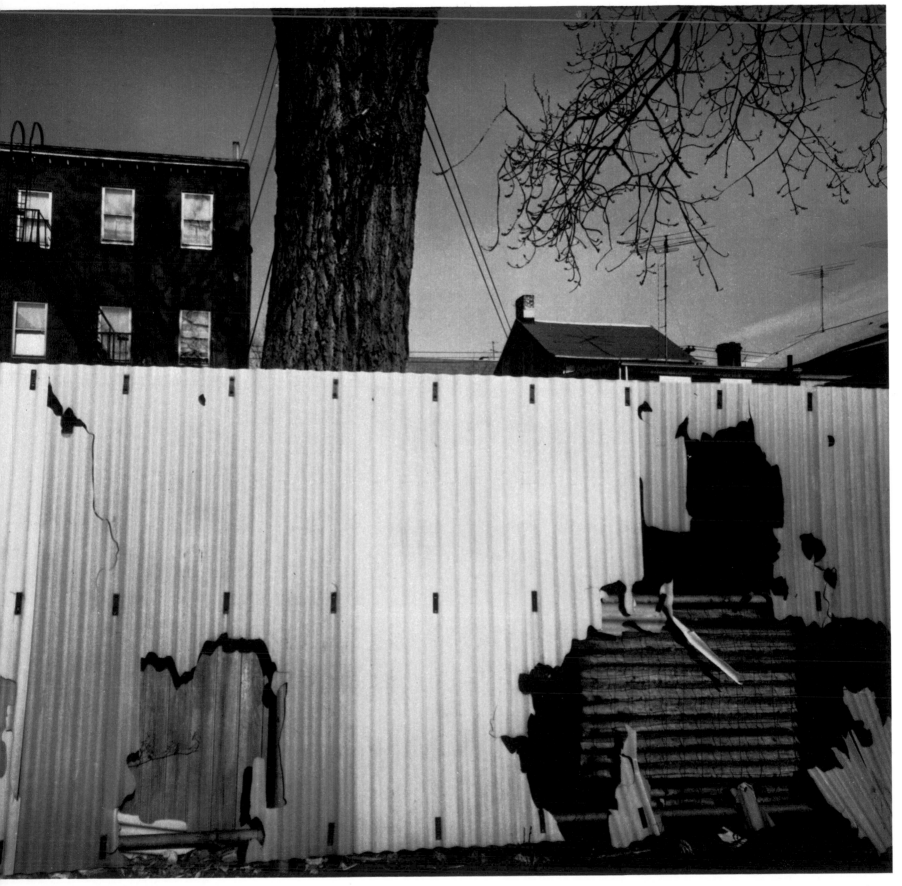

Perspective

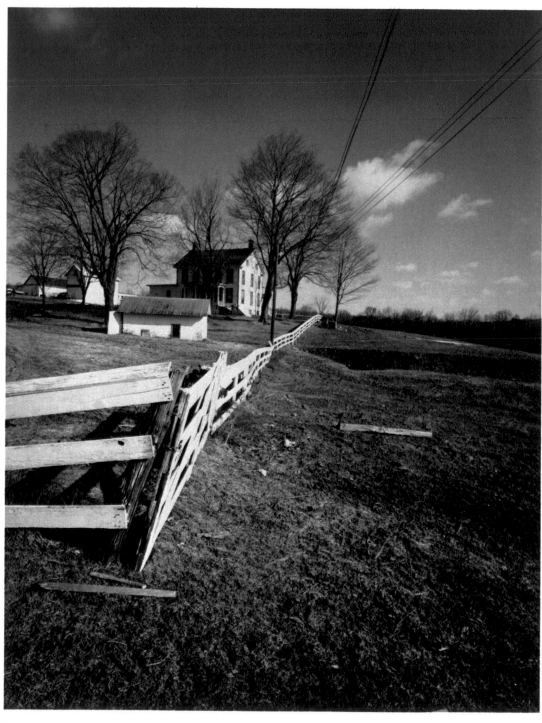

Perspective, by making objects appear to shrink with distance and by making parallel lines seem to converge toward a point on the horizon, creates the illusion of three-dimensional space in a photograph. It supplies clues—object size, line convergence—that the brain interprets as indications of depth.

The rules for suggesting space with perspective were formulated by 15th Century Renaissance artists, and their system became a convention in Western art. Yet there is nothing absolute about this mode of design. Anyone accustomed solely to Chinese painting, where near objects overlap far ones, might not get the idea of perspective —although he would soon learn to "read" perspective as effortlessly as Westerners do.

While a camera is constructed to produce perspective automatically, a photographer can either call on this sort of depiction or suppress it. For example, the straight-on shot on the preceding page gives an impression of flatness because it contains so few lines that converge toward the horizon. But the pictures on these pages rely heavily on convergence; depth in space is essential to their meanings.

The landscape at left gives the impression of open space by flaunting perspective clues—the relative sizes of house and fence, the converging lines of the fence and telephone wires. The cityscape at right also uses convergence—up to a point. By printing the shadowed background very dark, the photographer has cut off the converging lines of the street before they can reach a horizon. Both a desire for space and a denial of it are here, evoking a key quality of city life.

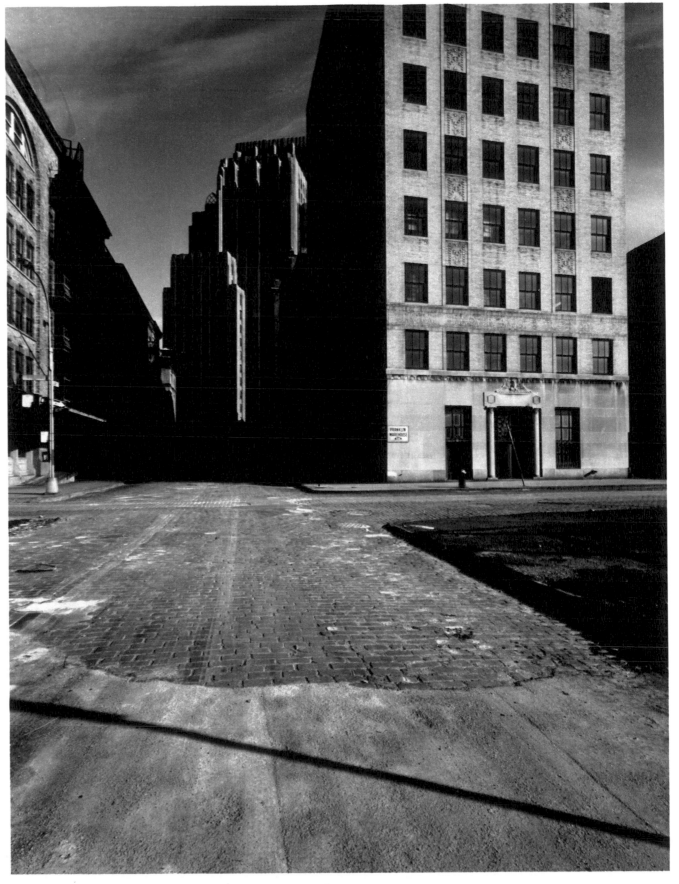

The Many-Element Design

Organizing a photograph around as many design schemes as possible does not ensure success any more than a large array of courses guarantees a gourmet meal. But most photographs do employ more than one sort of structure, even though the photographer may not have consciously analyzed the relationships between his visual ingredients. In taking the picture at right, Wolf von dem Bussche knew precisely what he wanted from each relationship, and the design was carefully tuned by controlling exposure and printing.

The photograph is balanced on both vertical and horizontal axes. The lamp globe at the bottom is counterweighted by the sign at the top, the mid-picture area serving as a fulcrum (the globe's greater size is offset by the sign's greater distance from the fulcrum).

At the same time, the leafy tree at the right-hand edge of the picture more or less balances the angular shapes at the left edge, with the roof line now suggesting a seesaw and the globe serving as a visual fulcrum. To give the black tree its necessary intensity, the sky around it was kept light. This horizontal balance is not quite stable, however, for the angular shapes seem heavier than the tree—and the roof line is indeed tipping their way. A wholly different sort of structure reinforces this feeling: the visual rhythm generated by the ridges on the rooftop displays shorter and shorter intervals from right to left, inexorably leading the viewer's attention in the direction that the roof seems to be tipping. □

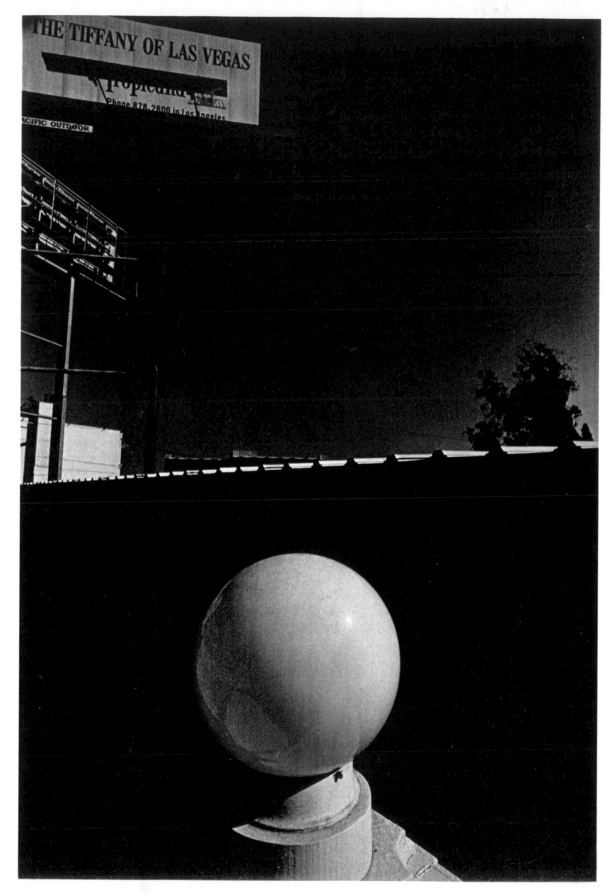

Responding to the Subject 3

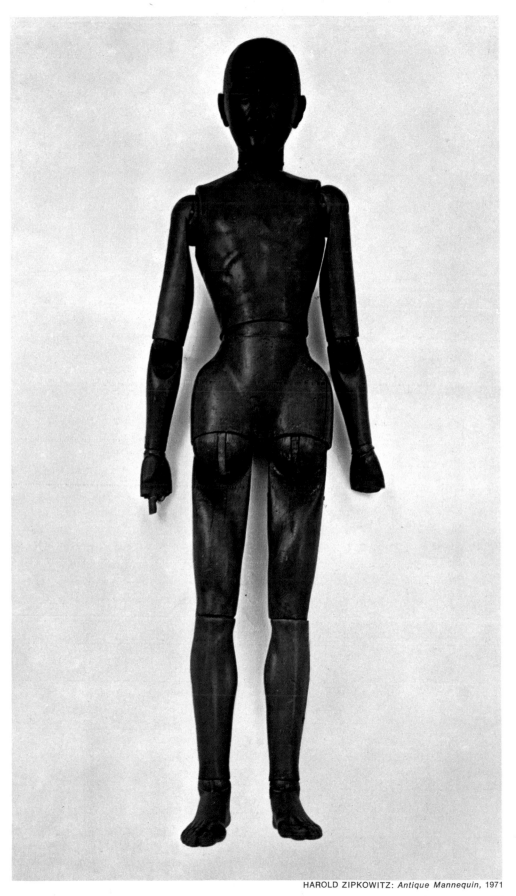

HAROLD ZIPKOWITZ: *Antique Mannequin*, 1971

In a sense, photography is built upon a foundation of prejudice, because vision—the basis of picture taking and picture viewing—always involves interpretation. Seeing with absolute objectivity is impossible for the human eye, since the experiences, emotions and attitudes of the viewer affect what he sees. A mountain that appears overwhelming to a Kansan may seem unimpressive to a native of Colorado; a car that looks rather rickety to an American might look like a technological marvel to a Patagonian. Whenever a camera is carried to a certain place, aimed in a certain direction and triggered at a certain instant, the photographer is being guided by his own, personal sense of what fragment of the world deserves recording. The visual components of the subject he chooses—and the way he synthesizes them —will be determined by what he thinks and feels, not by any universal, absolute law. Whoever views the photograph will, of course, add his own interpretation to the subject—and the impact of any picture is actually an unpredictable blend of the responses of both photographer and viewer. This factor of personal response is often unappreciated or underestimated by both those who take pictures and by those who view them. When photography was invented, early in the 19th Century, the mechanical feat of recording images with light so astonished the public that the human element was understandably overlooked. It was thought that a camera independently turned out a good picture every time an exposure was made, and one reporter went so far as to describe the new technique as a "self-operating process of Fine Art." Most people, however, gave the daguerreotypists a grudging measure of credit by calling them "conductors" or "operators," as if they took a picture the way a factory worker might throw a switch. Even today, many amateur photographers consider their function to be more or less passive button-pushing—and without a qualm, they will line up to take identical "best-view" shots of Yosemite Falls or the Grand Canyon.

There is, of course, no best view, because any subject can elicit countless different responses and interpretations, all perhaps equally valid. For example, a college football game may seem tense and thrilling to a sports buff, yet be completely boring to his wife. An alumnus, watching the game, may see his own team as heroic and the other as villainous. An ex-football player may perceive details in the execution of plays that are missed by everyone else. A painter might be oblivious to the flow of the game but acutely aware of the flow of colors. A child might be excited but bewildered. And each of these observers could well have a variety of other responses, depending on the weather, how well he slept the night before, and innumerable other factors.

Any of these responses could be conveyed photographically. If the sports buff happened to be a photographer, he might suggest the excitement of the game by shooting some moment of peak action with a telephoto lens, or

catching an expression of strain and determination on a player's face. His wife, on the other hand, might communicate her couldn't-care-less response by a picture of a spectator staring vacantly at a game that is made to seem very far away by the use of a wide-angle lens. The alumnus might express allegiance to his team by including the college flag or mascot in the background of his picture. The ex-football player could emphasize the precise execution of downfield blocking by making a time exposure that traced the routes followed by the linemen.

Such approaches assume that the hypothetical photographer-observers would recognize a need to take pictures that conveyed their own attitudes toward the game. But this is not always the way it works. Many photographers expect a subject to divulge a meaning to the camera as if by magic, and they make little or no effort to utilize their own attitudes toward what they are depicting. Thus they end up with snapshots—portraits with no discernible character or viewpoint, landscapes that include distracting elements, or pictures of events that seem random and insignificant. Yet such lack of direction is one of the most easily remedied photographic problems. The beginning photographer has to make a habit of *paying attention to his response,* always asking himself what he thinks and feels about a subject and how he can convey his assessment in an image. With experience, this process may become unconscious—that is, so efficient and automatic that it goes unnoticed.

On the following pages, the role played by human response is explored in a series of tests covering a broad spectrum of the problems that arise in photography. First, eight photographers were asked to take pictures of a single inanimate object—a wooden mannequin (depicted in an intentionally neutral manner on page 79). This assignment was a sort of laboratory experiment, for none of the photographers had ever seen the mannequin before, and they were given no suggestions about what to express. In a second test, other photographers were asked to capture the essence of "the city." Here was a subject that the members of this group had all seen before; it is, in fact, home for most of them, and they were expected to have a definite at-home feeling in responding to it. Yet few subjects could be more challenging in terms of the sheer range of visual possibilities. In the third test, still other photographers were asked to express "love." Instead of responding to a concrete object, as in the first two tests, these people were dealing with an intangible concept. In all three tests, as the results show, none of the photographers failed to have a response. Still, every single interpretation was unique. Their pictures show how they utilized the principles of perception and of design that were spelled out in Chapters 1 and 2—and also affirm that response is an essential component of the art of photography. □

Assignment: A Special Object

Your assignment is to take this mannequin and, using it in a situation, make a photograph that will satisfy you creatively and communicate your reactions to the viewer.

Eight professional photographers were given this assignment, which was designed as a kind of fundamental test of the importance of the response factor in picture taking. An old-fashioned wooden mannequin *(page 79)* was selected as the subject because of its basic ambiguity. Human in structure but devoid of life and gender, it represented a visual enigma whose identity and meaning were undetermined. And, in fact, it evoked remarkably divergent responses. Some photographers were charmed by its age and by the effort its maker had put into carving and staining its pine features. Some saw it as almost human, others were keenly aware of its deadness and several photographers viewed it with distaste.

Marcia Kay Keegan, one of the eight photographers, responded in a decidedly unconventional way to the mannequin. Despite its artificiality, she felt that it was somehow alive, and she was determined to suggest the inaudible pulse of life within its imitation human form. At first, she thought of taking the mannequin out into the countryside to show how easily it fitted into nature. Another possibility was to photograph it in Times Square—a location whose jangled, mechanized personality would point up a placid character that she read into the mannequin.

It was the serenity she saw in the wooden figure that impressed her most of all, and, as she mused on this quality, the answer came to her. She would pose the mannequin in a yoga position, contemplating a bouquet of chrysanthemums, as though seeking to become one with nature and the universe.

Having settled on this presentation, Miss Keegan faced the problem of getting the proper quality of light: she wanted the mannequin to show a kind of inner glow that she associated with spirituality. For a backdrop, she used yellow seamless paper. A small flashlight, covered with a sheet of yellow gelatin, was aimed at the mannequin's face. But the main sources of light were candles—eight of them placed behind the mannequin and two in front. In this warm, luminous ambiance, the mannequin is removed from the inanimate world and takes on the appearance of a living creature, filled with inner peace.

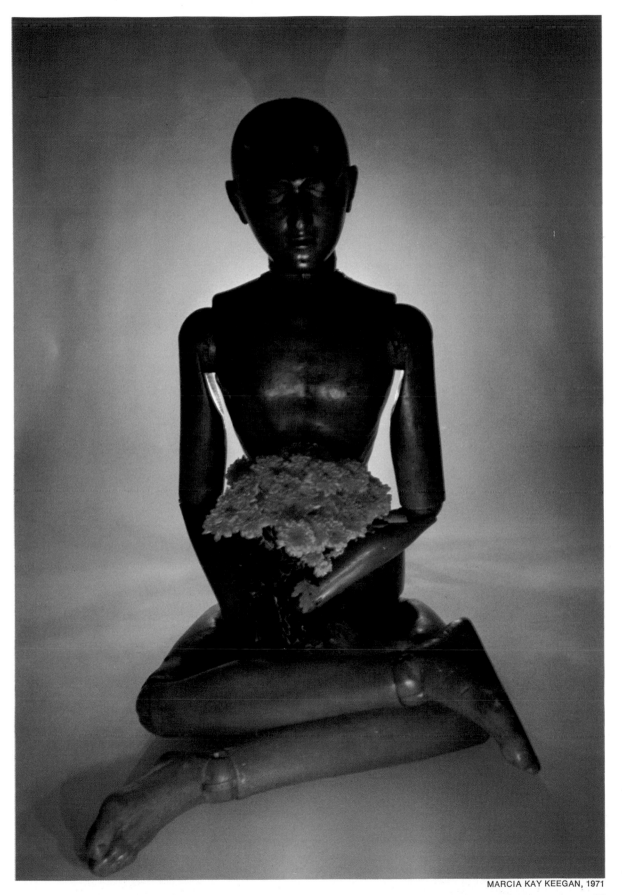

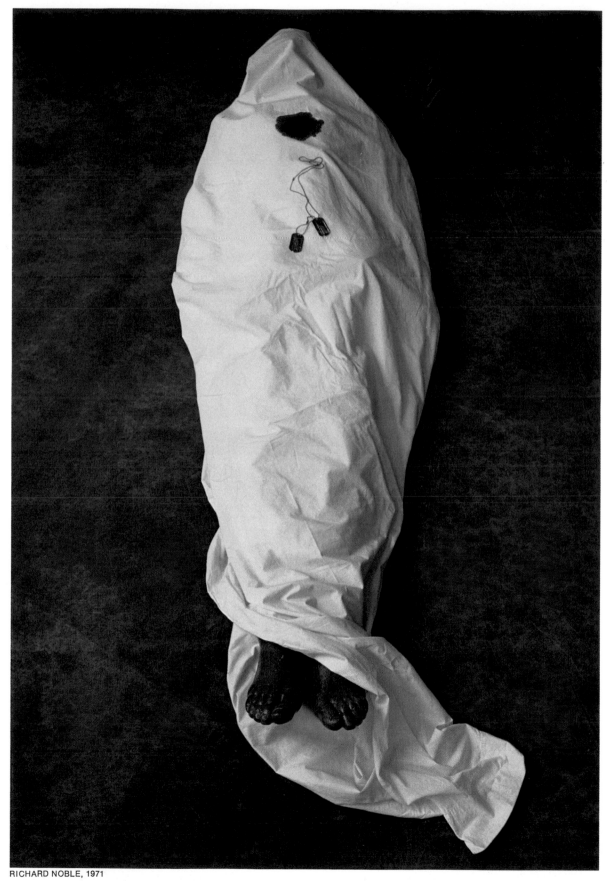

RICHARD NOBLE, 1971

84

Richard Noble was unsure what to make of the mannequin at first. Looking at the detailed carving of the feet, he was fascinated by their resemblance to real feet, but the rest of the mannequin seemed cruder. Overall, it impressed him as being a weird, freakish object. He tried placing it in various situations—in bed, in the bathroom, slumped in a chair as if it were drunk —but the mannequin did not seem to fit naturally into these situations. Then, seeing it sprawled on the floor, Noble was struck by its resemblance to a corpse, and he decided to use the mannequin to make a statement about death. Explaining how he narrowed this basic response down to workable dimensions, he says, "I asked myself, 'What's killing people nowadays besides natural causes?' I immediately thought of war. So it had to have blood. Then came the decision on where the mannequin was shot. Would it be in the leg, the face or the chest? I began to remember films I had seen in training camp when I was in the Army, and one particularly horrible film about chest wounds. That made up my mind."

Noble wrapped the mannequin in a sheet, arranging it so that the form would be apparent and leaving the realistic feet exposed. He placed his own Army dog tags on the figure's chest. Then he concocted a simulation of blood by mixing red and black India ink and glycerine and daubed the shroud with it. The only illumination came from a skylight in his studio. He shot the picture from an angle that, as he puts it, "would look as if you had just come upon this body and were looking down on it from eye level.

"This picture is not technically perfect by any means," he adds. "The blood is too dark, and the sheet looks washed out in places. Ordinarily, my work is strongly 'designed,' but I didn't want anything fancy or cosmetic here. This is a picture about war and death."

Dean Brown's response to the manne-
quin was strongly negative: "I admire
its workmanship, but it repels me. I
really hate it. It's a mockery of life
—deader than anything I can imagine."
He decided to express this repellent
lifelessness by photographing the fig-
ure on a beach, where it would seem
like a strange piece of flotsam cast up
by the sea. He spent an entire day driv-
ing along the shores of Long Island
searching for the kind of beach he
wanted. But in every setting he tried,
the desired surreal quality was absent.
He arose at dawn the next day and
again took the mannequin to a beach,
hoping that the morning light would im-
part a strange mood to his picture—but
he still sensed that he was failing to
convey his response satisfactorily.

Then it occurred to him that the
deadness of the mannequin might be-
come really apparent in a place where
living people dwell. He took it to the
house of a girl he knew, and placed it in
her living room. Again the situation
seemed "faked and wrong." Then he
dropped it in a long hallway; it came to
rest in what he describes as an "awful
position." Brown had the girl stand
near the mannequin, but something
was still missing. He asked her to walk
past the prostrate figure on the floor.
Pleased with this effect, he decided to
blur the motion slightly, with a slow
shutter speed, making the girl seem
more alive and the mannequin even
less so. At last, everything seemed to fit
—the grotesque position of the manne-
quin, the cramped barren hallway and
the mystery of the girl passing by. The
resulting photograph, so circuitously
arrived at, adds up to a deeply disturb-
ing visit to someone's nightmare.

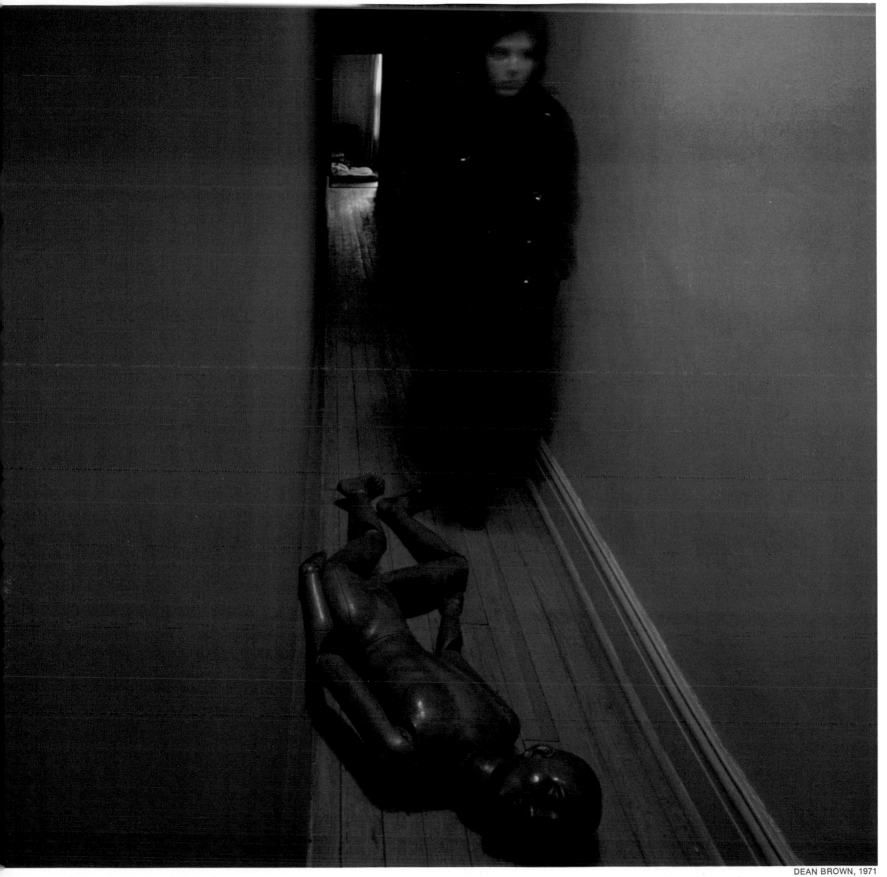

PETE TURNER, 1971

Pete Turner was not particularly moved by the mannequin. Although he liked its color and the care with which it had been carved, he did not see or feel any transcendent meaning. It remained an object in his eyes, and he had no urge to turn it into a human being or to make a comment with it. Seeking a way to incorporate the object in a strong design-scheme, he toyed with the idea of having the mannequin reflect itself repeatedly in a mirror. Then he began to notice the mannequin's age. "I knew it was old," he says, "and I had the feeling it was probably in the wrong place in time. It will probably last longer than the period of time I will live in." This idea provided the solution he had been looking for: he would use color and motion to create a feeling of time.

The picture is a tour de force of technical ingenuity. He posed the mannequin against white seamless paper. Then he hung a black curtain in front of it, and cut out a rectangular "door" through which it could be seen. To give the mannequin's head its own frame, he placed a black cardboard bar, four inches wide, across the opening in the curtain, thereby transforming the door into a Dutch door.

Turner fitted his camera with a 35mm perspective lens. Often used for controlling the display of perspective in architectural photography, such a lens can slide in any direction (much like the lens of a view camera) while the film remains in fixed position. It can shift the image on the film without altering image shape. Turner moved the lens diagonally, exposing at intervals—with a few deviations in the pattern to keep the arrangement from being boring.

In this manner he made two identical negatives, each with eight separate exposures on it. And each exposure was shot with a different color filter. Turner then combined the two negatives into a sandwich. Where the images were identical, he printed them slightly displaced from an exact overlap in order to add variety to the pattern.

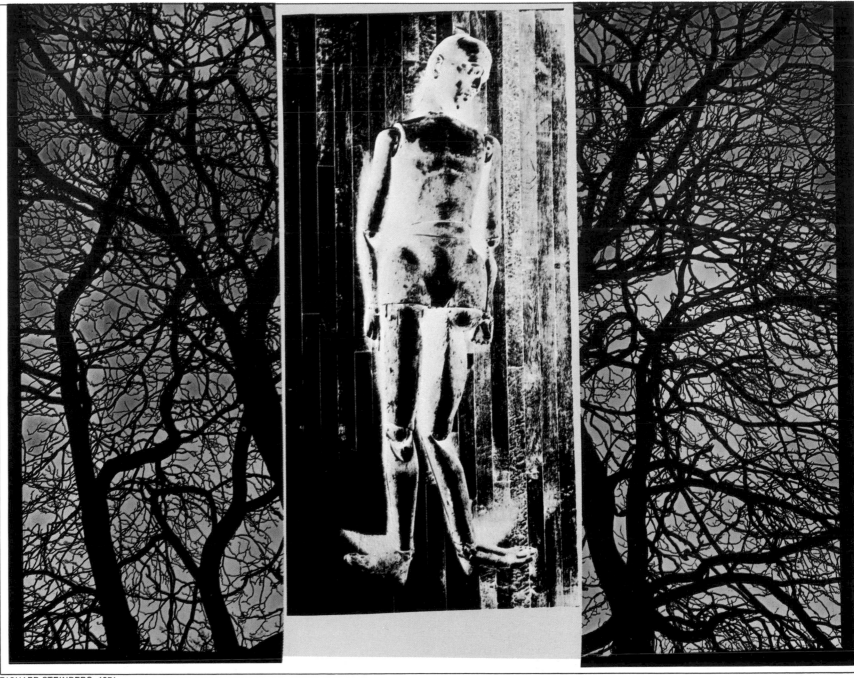

RICHARD STEINBERG, 1971

Richard Steinberg was wary of coming to quick conclusions about the mannequin, sensing that his first response might be wrong. The picture opposite was the product of a careful thought process, which he describes in the following way: "You look at this dummy and he can give you the creeps. You think he can come alive, or maybe he has some kind of supernatural powers that we can never see, because he exercises those powers when he is all alone in a room. Or you might fantasize that if you put a child on the dummy's lap, the child would be able to talk some secret mumbo-jumbo language to it. But I want the truth—not what something appears to be.

"I try to think about where things come from, their origins and evolution. I think about the dummy's mother—a tree that was alive with cells, generative powers, branches like ganglia, and bark with the pattern and grooves of variation and life rhythm. Somebody carved it, put it together and rubbed it. It was a transformation of a piece of wood into a replica of man's outer form, but the dummy is also untransformed. He is the real thing—not a replica. He is still part of a life force. Without looking at his outer form but looking at his inner form, we see his mother's branches, the flow from thick to thin, the organic layering that gives the grain a flow and pattern. And so I show you that our dummy has life—an organic life. I have rejected its outward human form by reducing it to pure black and white, a shadow of its former self."

Making the picture was a complicated business. First, Steinberg placed the mannequin on a wooden floor and directed two lights on it, from left and right. Using an 8 x 10 camera loaded with black-and-white film, he exposed at f/64 for 10 seconds. He made a contact print of the negative (giving him a positive image), and then copied the print on high-contrast copying film (giving him a negative). The tree was shot with a 4 x 5 camera, and the negative was contact-printed directly onto copying film, yielding a positive transparency. He then toned this transparency with brown dyes and cut it in half. Finally, he assembled the three film elements on a glass plate, with the mannequin's untoned, negative image in the middle and made the picture.

John Senzer first thought of the mannequin as a beautiful object, remarkably well crafted. But the more he looked at it, the more he reacted to it as though it were a person. His creative problem, as he conceived it, was to find a situation that would make the viewer consider the possibility of the mannequin's humanity. "I didn't want to *tell* anybody that the object is a person," he says; "I just wanted to pose the question."

He tried sitting it at a desk, positioning the limbs and head in a manner that would appear perfectly normal. Next, he took a picture of the mannequin watching television, along with two real people, whom he had instructed to accept its inanimate presence as part of the natural order of things. Neither of these poses seemed to show forcefully enough the possibility of the mannequin's humanness.

Then, Senzer explains, "I happened to walk past the bathroom—and that was it. The toilet was chosen as being obviously representative of a basic human function." The resulting picture virtually assaults the viewer's mind with its suggestion of humanity. In fact, its exaggerated approach has something of the quality of caricature.

Senzer's picture is the only one in which the initials C. B. R. are clearly visible on the forehead. They may be the initials of the craftsman who made the mannequin almost a century ago.

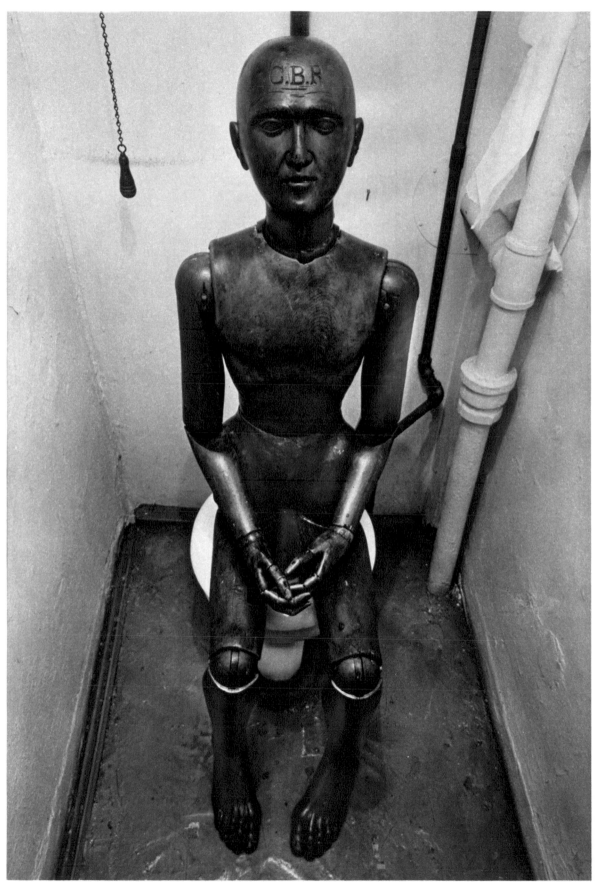

Neal Slavin's first response to the mannequin was almost defensive: he felt a temptation to use it to tell a human story, but resolved to resist that urge. The mannequin had to remain a mannequin —a symbol of man, but not the real thing. He saw it as a "faceless, sexless, timeless, personality-less object," and to get rid of any hint of life or sensuousness, decided to coat the object with white talcum powder.

However, he did want to show that the mannequin was capable of movement, since that was an important part of its construction. To demonstrate this flexibility, he shot the mannequin in about 40 different poses, with the head tilted, or the arms and legs bent in various ways. His intention was to create a composite print in which all of these poses would be arrayed in a circular pattern, but that scheme became too confusing, and he chose a side-by-side arrangement instead. About a dozen vertical sections of different prints were cemented on a sheet of paper; then the composite print was photographed and reprinted from a single negative. This final print displays a minimum of contrast, suggesting that the mannequin has a kind of generalized existence, subsuming all specifics. And the central, dominating slice of the picture is an out-of-focus view that seems, by its very lack of definition, to be the raw material for all the other slices.

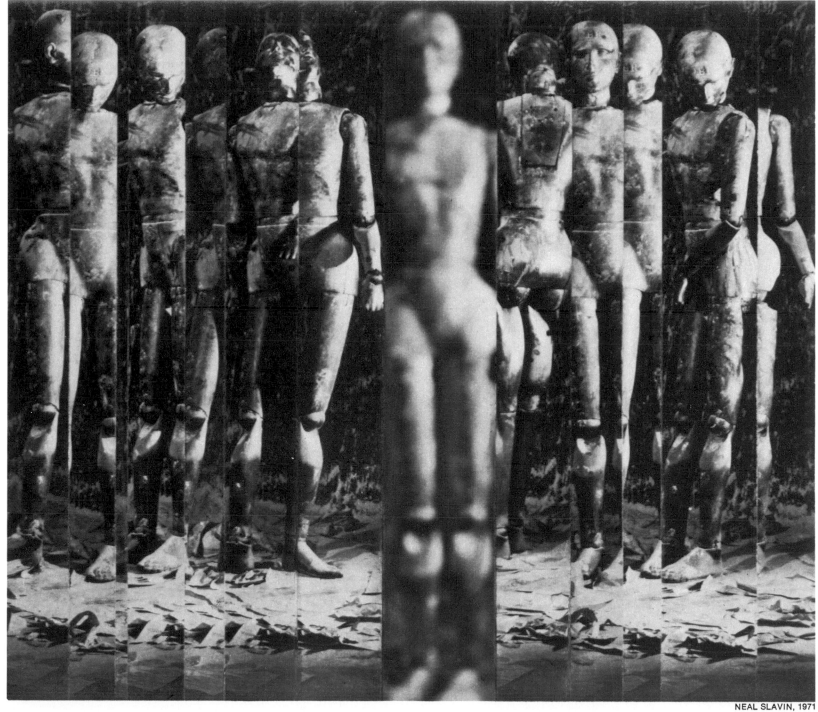

Duane Michals felt a twinge of shock when he first saw the mannequin: "It frightened me. Mannequins are very queer, bizarre things—they're imitation people made by people. When I began to work with the mannequin, I remembered a scene from a movie that I saw when I was a young kid: a boy was looking in a store window where a mechanized mannequin was putting on some kind of act; other people were watching this act along with the boy, but when it came to an end, they left and the boy remained alone; then the mannequin turned around and looked right at the boy. It was a very disturbing movie to see at that age.

"I knew I wanted to work with the idea of fear and strangeness. I was interested in what the object suggests, not what it is. My initial plan was to have a real person in the picture too. Sometimes I play a game with a girl I know, where I pretend I'm a mechanical person. It frightens her. I decided to dress up the mannequin in one of my suits and take a picture of this girl reacting to it. Then I realized that, instead of showing the girl being frightened, I actually wanted to frighten the viewer, so I began to work with the mannequin by itself. But my idea still wasn't working. I thought, 'How can I make this work?' I took the mannequin's head off, and suddenly it all came together." □

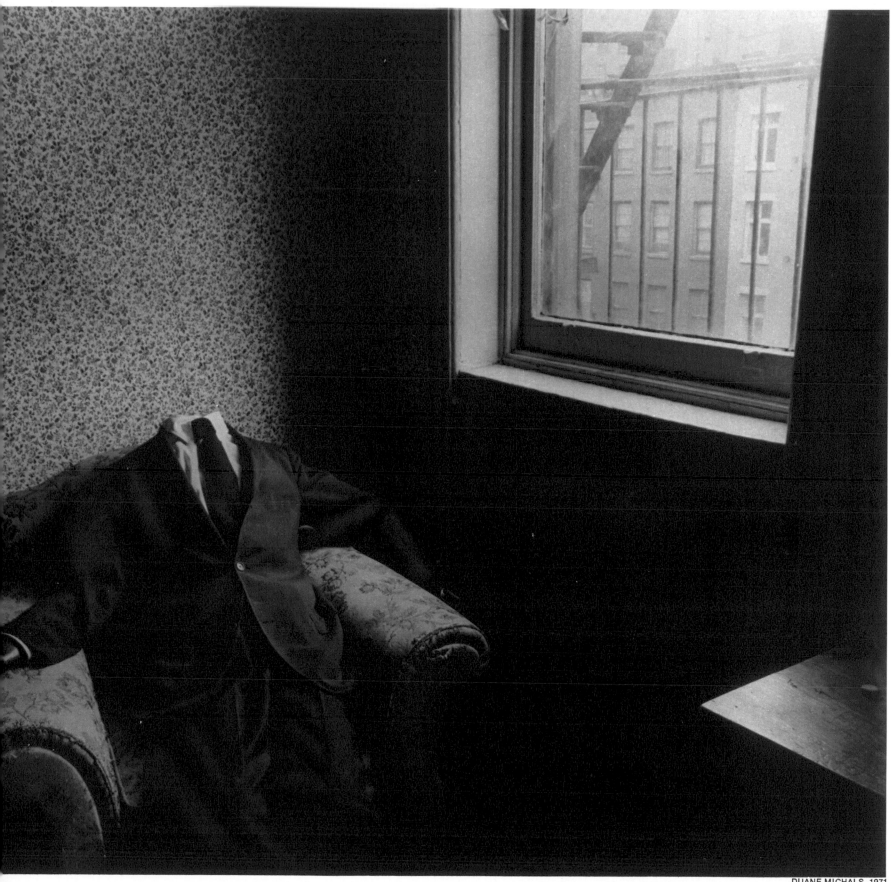

Assignment: The City

Your assignment is to make a photograph that holds for you the essence of the city.

This challenge, given to four professional photographers, was quite different from the mannequin assignment. Instead of dealing with a single, inanimate object, they would be confronted with a complicated, multifaceted subject—an ever-shifting tangle of streets, buildings, cars, jobs, lives and much more. Yet it proved no more difficult to respond to than the mannequin was.

Norman Snyder felt that the city has many essences and meanings, but one seized him more strongly than the others. "Wherever I go in the city," he says, "I find myself in the presence of things being built and other things being torn down. We never know what it is to live in a city that is complete. And it's not really planned. Construction and destruction both proceed without logic.

We demolish and reconstruct in the hope of ameliorating problems, but everything we build today will be torn down tomorrow. I wanted to make a picture that would question our assumptions about progress. Do higher buildings make us more civilized?"

Snyder had a location in mind. He often had driven past a group of old warehouses near the Manhattan waterfront and had been inclined to photograph them. He now decided to use them as one point in the tension between the old city and the new. The opposing point was readily available: the newest and largest of Manhattan's skyscrapers —the twin-towered World Trade Center —was rising nearby, its upper parts still naked grids of girders. And the old cobblestone street passing the warehouses was being torn up for no discernible reason. The scene spoke for itself, and Snyder used an 8 x 10 view camera to render every last detail.

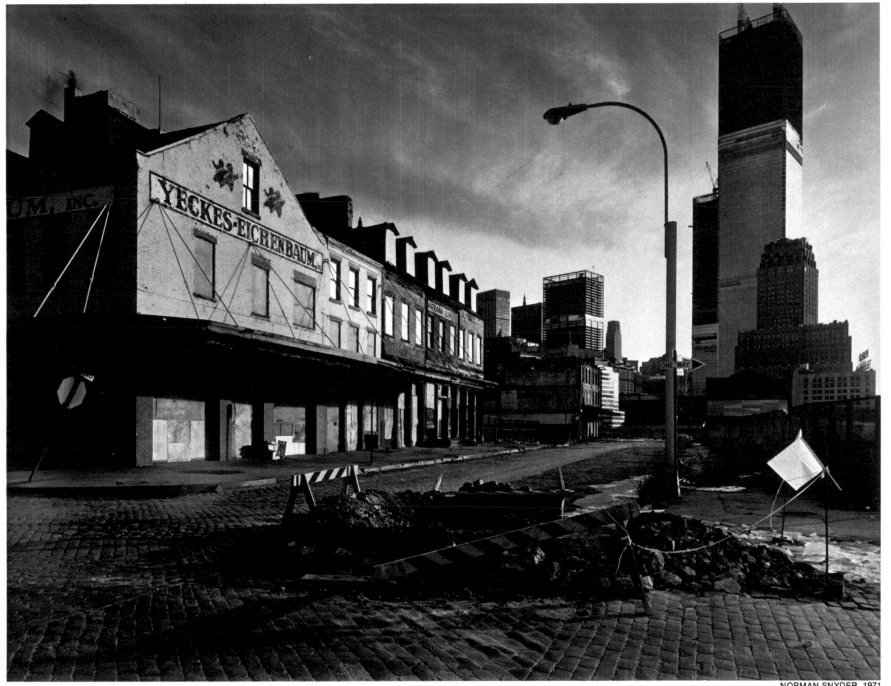

NORMAN SNYDER, 1971

99

GEORGE KRAUSE, 1971

"The city," says George Krause, "is a subject I'm always working on. In a sense, I'm really trying to make my own city out of·all my photographs." Since this assignment coincided with one of his major concerns, he knew that no single picture could possibly be a definitive expression of his response.

Yet one fragment of the city quickly came to his mind. While wandering through his native Philadelphia, he often had felt an urge to photograph City Hall. Located at the geographic center of the old part of Philadelphia, where all the streets seem to come to a focus, City Hall is, in his view, "a great old building, a beautiful place." Its marble columns had always struck him as futuristic, otherworldly additions that are not necessary to the building architecturally; they form "a strange sort of corridor that people walk through every day but don't notice at all." The people themselves impressed him as being anonymous and interchangeable within these surroundings. He decided to record the reflections of passersby in the shiny marble, thus acknowledging their presence but obscuring their identities.

Krause took the picture early in the morning, when people were coming to work and when "a beautiful light spills through an archway and bounces upward." The result is a monumental image that can claim a place in the city Krause is building photographically.

"There's no such thing as perception without compassion," says Larry Fink. "When I take a picture, I feel myself to be flowing into the body of my subject, identifying with the way he thinks."

Looking for a subject that would convey this kind of response to the city, Fink spotted a frustrated but resigned cab driver stuck in traffic on a cold day. In the back of the cab, staring out at a nightclub, was a fashionable young woman—"the embodiment of a would-be jet-setter," he says. The contrast between the two riveted him, and he began shooting. It was the cab driver who engaged his sympathies. This man was the essence of the city—commonsensical, toughened by his daily grind and unimpressed by whatever glittering scene so fascinated his passenger.

Inge Morath describes her photographic method as "a rapid recognition of form and content, often not premeditated—except, I suppose, for an inner readiness and a trained eye." On this assignment, the recognition came early in the morning when she was walking near The New York Public Library, and she quickly shot the picture opposite. "For me," she says, "this expressed New York: a mass of different, impersonal forms, somehow very beautiful in that cold light." Two pigeons in the foreground and a tiny human figure in the background weave a frail thread of life through the lonely spaces. ☐

LARRY FINK, 1971

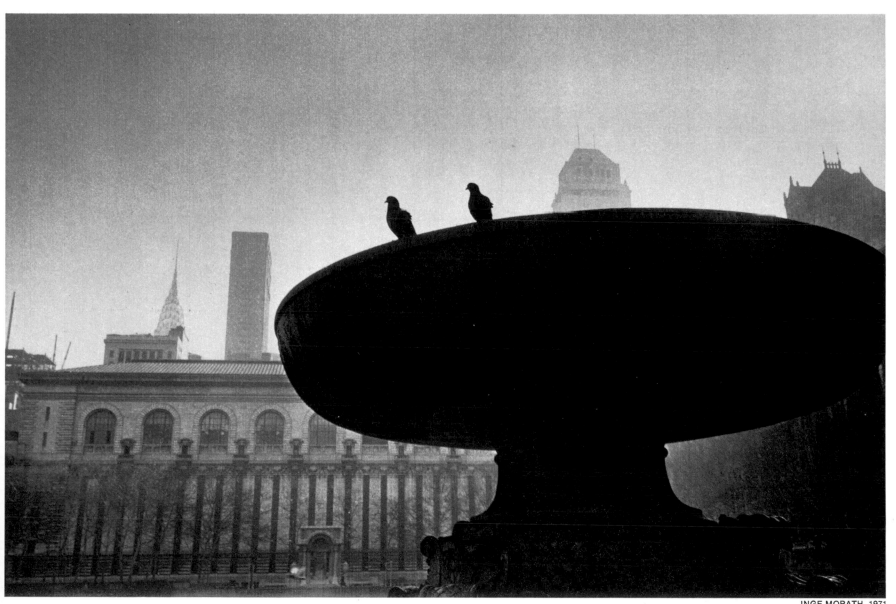

INGE MORATH, 1971

Responding to the Subject: continued

Assignment: Love

Your assignment is to make a photograph that communicates love.

It might seem that the photographers who were given this instruction could not respond as freely as those who dealt with the mannequin or the city —for the topic itself is a response. But as it turned out, "love" as an assignment yielded an extraordinary variety of subjects that ranged from newly-weds to animals.

Leonard Freed was overwhelmed at first by the feeling that the assignment summoned up in him. "What potency this word has!" he says. "It brings forth uncontrollable, tremendous, untapped emotions—both terrible and lovable." He decided to find a vantage point from which he could observe many kinds of love. From experience he knew that a perfect "trap" for all sorts of human situations was close at hand—right in the elevator of his apartment building. One day, riding it up and down dozens of times, he encountered mothers with young children, old married couples, passionate young lovers.

The young couples stirred him most strongly. However, their self-involved quality kept eluding him, even though he took many pictures. Then he saw a solution. By including a third person along with the embracing couple—a passenger who was embarrassed and all too eager to escape from the elevator—he communicated the heat and heedlessness of youthful love.

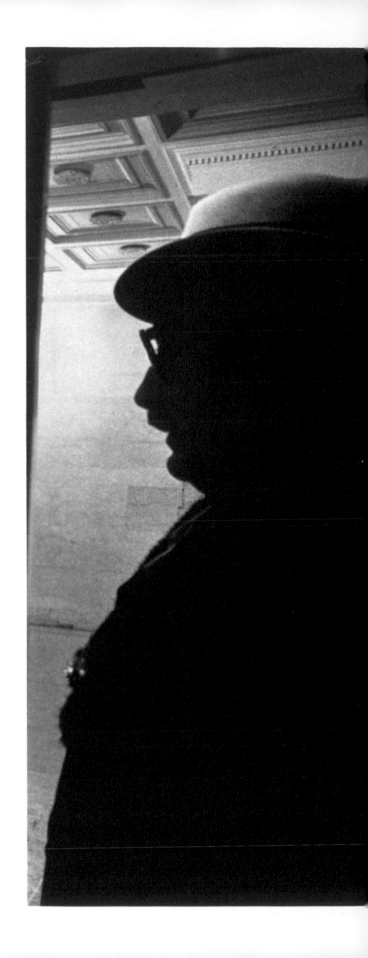

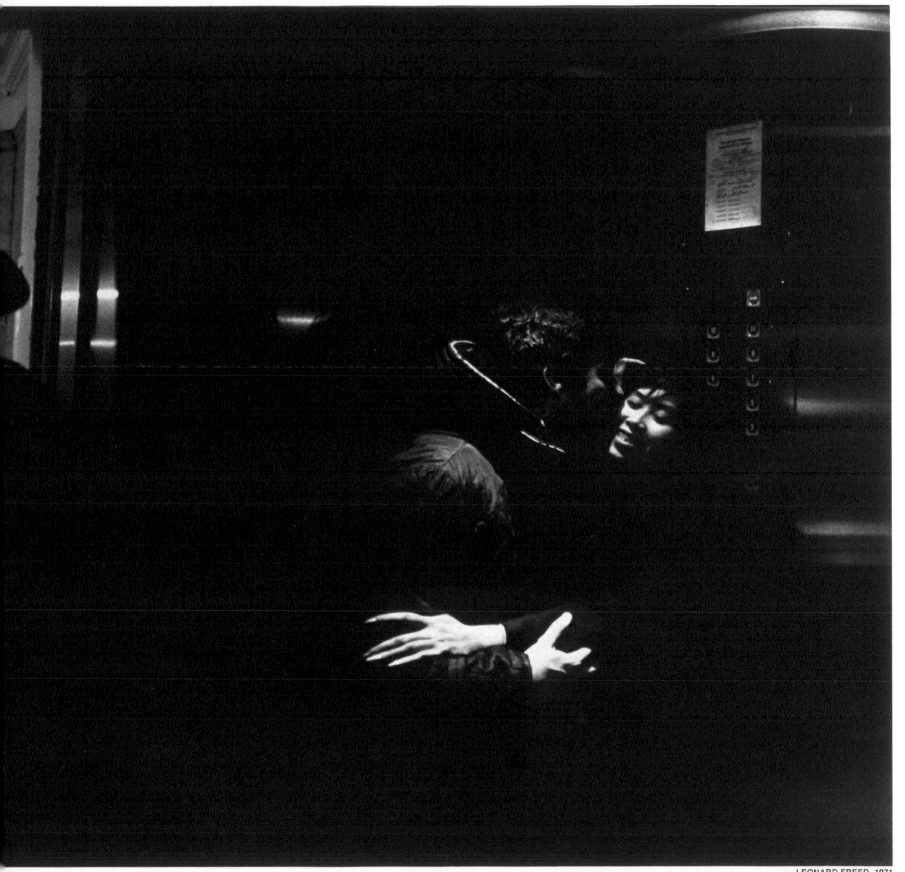

LEONARD FREED, 1971

105

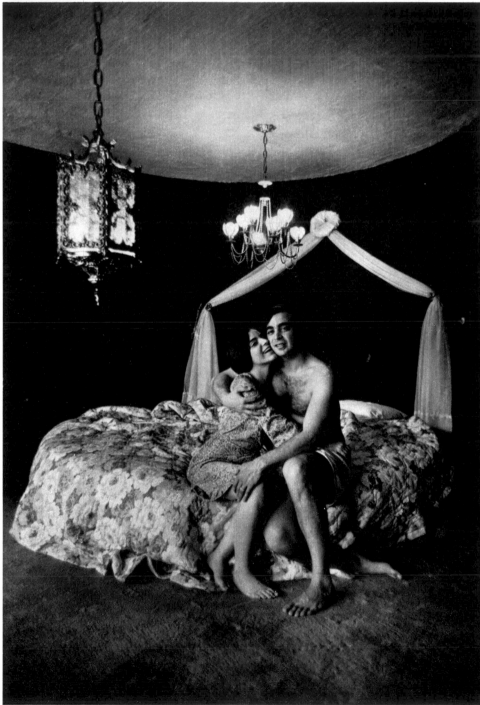

Tony Ray-Jones says, "I was interested in taking a photograph that lampooned the idea of romantic love existing in modern America." He remembered a magazine advertisement for a honeymoon resort in the Pocono Mountains in Pennsylvania, and he decided to investigate it as a possible subject for the assignment. It exceeded his expectations. To him, the place epitomized one American idea of love, which is "not love at all, but sex." Here, romance was grossly merchandised within a plastic package of sunken, heart-shaped bathtubs and oversized beds. "The entire place seemed synthetic, the emotions phony, and even the furniture and décor reflected the sham. Tables had drawers that were painted on them and didn't open. And the owner made no bones about the fact that he was selling sex. All the newlyweds were encouraged to join in a variety of social activities during the day, but night held its own unprogramed 'entertainment.'"

The young couple that was photographed did not fit perfectly into the atmosphere. The husband, a young lawyer, felt uncomfortable in the setting and ill-at-ease with the other honeymooners. Tony Ray-Jones, by depicting the pair in an attitude of feigned bliss, "hoped to produce a sense of contradiction and to question the concept of idealized love today."

TONY RAY-JONES, 1971

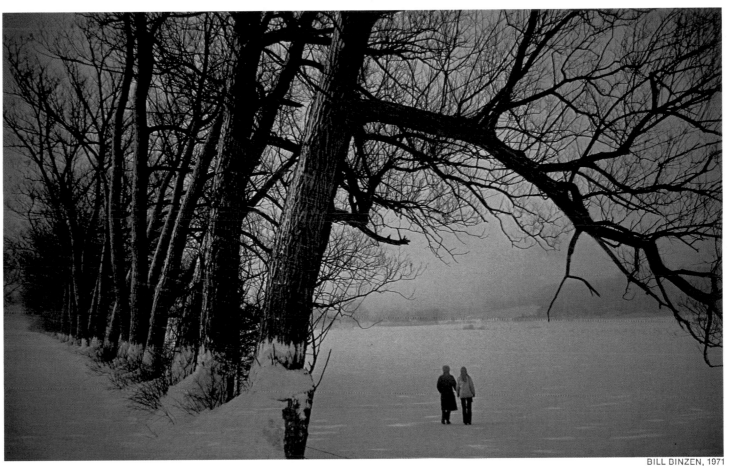

BILL BINZEN, 1971

To Bill Binzen love attains its purest, most intense state at first blossoming. In this early stage, he feels love generates such a highly charged emotional atmosphere that the ordinary world hardly seems to matter to the lovers, and they experience (however temporarily) "a curious and desirable sense of isolation." He decided to photograph a young couple in a snowy landscape where this feeling of isolation could be emphasized by the stillness and remoteness of the setting.

He first thought he would show two young people approaching a tree from different directions, thus suggesting that they were meeting for the very first time—but he rejected that idea as too obscure. The final version (above) is a simple but eloquent expression of the solitude of love. It is actually two sandwiched transparencies: on one, the trees; on the other, the young couple photographed from such a distance that their figures appear to be disproportionately small and alone.

Leslie Krims has an offbeat perception of the satire in ordinary life. Thus, he says, the very first response he had upon receiving the assignment was the one he used in shooting the picture. "It occurred to me to make an image of my mother displaying—proudly and with love—the collection of snapshots she's amassed chronicling my growing up (my mother being a fanatical snap-shooter). I called and asked if she'd search through the drawers and collect all the snaps with me in them. She agreed. When I arrived, I told her that I wanted to arrange some of the snaps on the wall and the rest I wanted to stick on her body. Her eyes widened and her mouth curled into an enormous grin and she said, 'I knew it. I had the exact same idea. I knew that's what you were going to do with the snapshots. You see how smart your mother is? Where do you think you get it all from?'

"I placed lengths of double-stick masking tape on the back of the snapshots I had finally chosen, then positioned my mother in a chair near the kitchen window (a comfortable and usual spot for her to be sitting) and began sticking the snaps to my mother's body and the wall. After a final positioning, I began making images and continued until I had finally exposed about 140 frames." Illumination was provided by light coming through the window. The print was made on a paper that renders images in a warm, brownish tone. And Leslie Krims wound up with a picture that says "mother love" as only he would think of saying it.

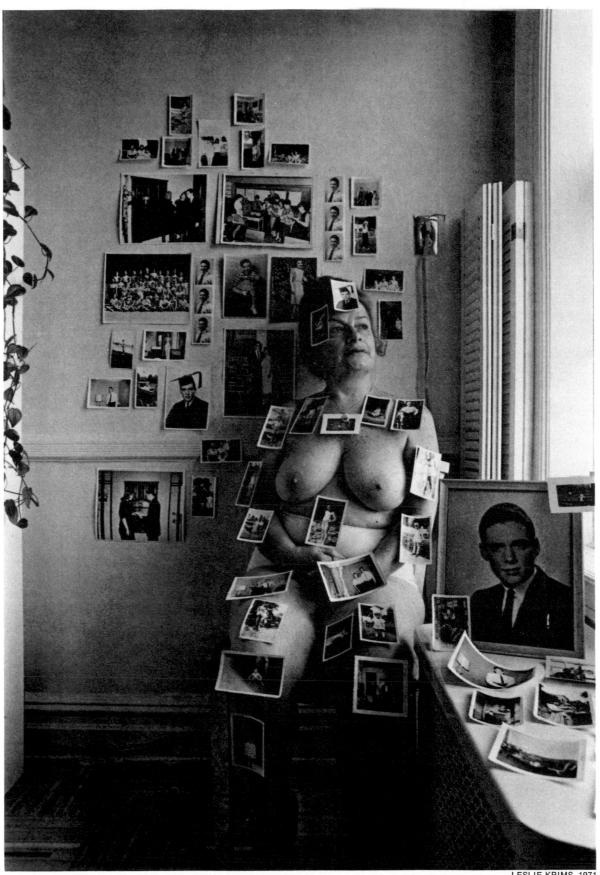

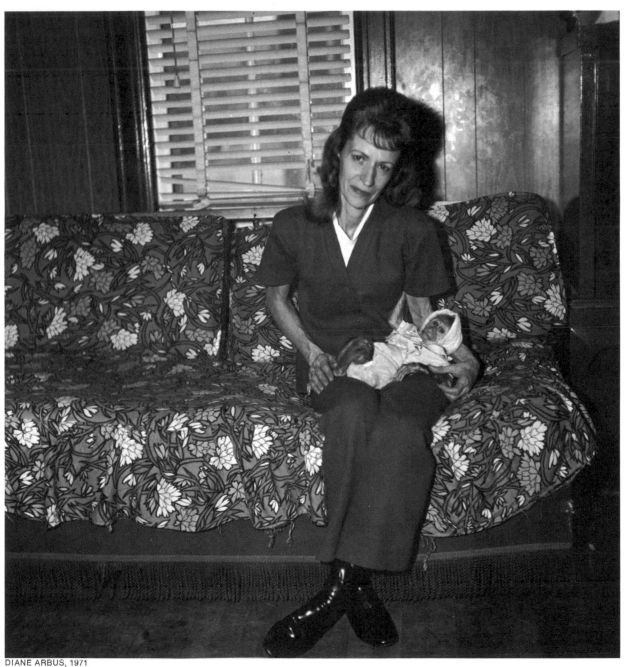

DIANE ARBUS, 1971

Diane Arbus feels that love involves a "peculiar, unfathomable combination of understanding and misunderstanding," and she took a great many pictures in an effort to capture this quality. She went to a bridal fashion show and photographed girls trying on wedding dresses for their fiancés and mothers. She took pictures of a blind couple, a homosexual couple, and a pair of 67-year-old identical twin brothers who said they had never been separated a day in their lives. Then she found out about a New Jersey housewife who loved animals and was particularly devoted to a baby macaque monkey named Sam. Miss Arbus asked permission to photograph her at home, and the woman agreed.

The photographs were made with electronic flash—intentionally placed close to the camera to create a veiling reflection and harsh shadows. By simulating amateur snapshots, she hoped to catch a flavor of "total ordinariness." Most of the pictures did not satisfy her because the woman was "cooing or smiling or excited or eager or nervous." The one at left, however, had a quality that she found deeply touching. It has the startling effect of looking like any father's snapshot of his wife and youngster. And the effect is emphasized by the woman, who "seems extremely serious and grave, in the same way you're grave about the safety of a child." ☐

Photography and Time **4**

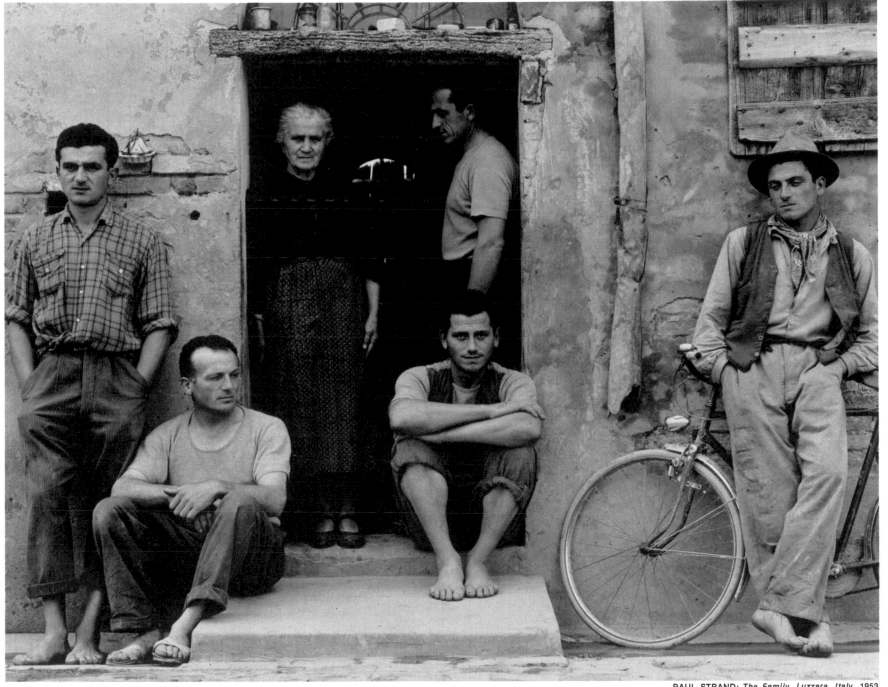

PAUL STRAND: *The Family, Luzzara, Italy,* 1953

The Importance of "When"

When people talk about time in connection with photography, they usually mean the time it takes to make a picture—its exposure time, determined by the shutter speed. Every picture involves time in that sense, of course, because the photographic image must be recorded on film over a certain period of time, however brief or extended. This chapter will consider time in another context: how a photograph can convey an idea of time to the beholder. The duration of exposure need not matter.

Photography explores the dimension of time from one extreme to the other —from the billionths of a second recorded by nuclear physicists studying evanescent atomic particles to the billions of years analyzed by astronomers tracing the birth of the universe in star pictures. It can answer many of the questions about time: When? How long? How frequently? (in some cases all in one picture). In the intermediate, more comprehensible ranges of time, which most pictures represent, photographers have found various ways of expressing time, partly for its own interest and partly because the sense of time influences the response of the beholder. Only three of these ways will be taken up here, and all relate mainly to the question "When?" First, the concept of suspended time: the picture in which the clock seems to have stopped. Its intent is not to specify an exact time, and its answer to "when" is ambiguous. Most landscapes, still lifes and formal portraits—pictures in which there is no indication of motion—are examples. Second, peak time: the so-called decisive-moment picture, which precisely specifies a particular instant and is as climactic and unrepeatable as the photo finish of a horse race. Third, random time: the picture of a before-or-after time, ambiguous again, like a sidelong glimpse of ordinary life—which indeed spends most of its time *between* high points.

Some other, less conventional ways of thinking about time are included in Chapter 5, and there are of course still other approaches—such as stroboscopic images and movement-blurred images, which can be made to answer the questions "How long?" and "How frequently?" The pictures that follow are widely disparate in subject and technique, as well as in the attitudes about time that they bespeak, and yet they have a common denominator. They are all reportorial in that they convey fact rather than fiction. What they show is not a creation of imagination but a view of the real world. Yet, in each, reality is employed to elicit a distinctive response from the viewer.

The effect produced by suspending time is eloquently demonstrated by Paul Strand's classic group portrait of an Italian family, reproduced on the preceding page. One hardly needs to be told that the group is gathered around the doorway to have its picture taken, or that it is a family and not an assortment of passersby. This is no brief encounter; the scene is carefully directed, the people painstakingly yet normally posed, at their impassive ease;

they obviously belong together. Strand later described the mother as "that pillar of serene strength," and the picture itself is full of self-sufficient serenity. It is a tableau, as artfully staged as the groups of marble-white living statuary that used to be unveiled with fanfare at the circus. And like those tableaux, it is symbolic, representing a concept that transcends the moment at which the picture was made. It is replete with emblematic details—facial resemblances, bare feet, work clothes, the utilitarian bicycle, the crumbling masonry—that reinforce the basic idea. Whatever this mother and her sons were doing before Strand gathered them for the portrait outside their home in Luzzara, Italy, and whatever they did when he let them go their ways, this family is captured forever to represent the unity of matriarchal families. While time stands still, these people share in a kind of immortality.

The fact that Strand took this picture with what might now be considered old-fashioned equipment is, oddly enough, relevant to the suspended-time picture. Strand recalls that "the photograph was made with a 5-x-7-inch Home Portrait Graflex purchased in 1931 and still of unimpaired usefulness to me. The lens is a Dagor 12-inch and it was stopped down to f/32, probably." His exposure was presumably about 1/30 second. "The Family" could have been photographed in almost the same manner a century ago, had it existed then. In the early days of photography, most pictures were carefully posed in ways that suspended time simply because technical limitations made difficult any other scheme. It was possible—with skill and luck—to freeze a peak instant or a random moment, but such pictures did not become easy to make, and therefore attractive to experiment with, until the advent of fast films and small cameras in this century.

Today photographers can easily seek, or avoid, the arranged moment of suspended time, seek or avoid the decisive moment, seek or avoid the random, ordinary moment. Few restrict themselves to a single attitude toward time. The carefully composed, static interval has its place, in everything from formal portraits to still lifes. The drama of the peak of action will probably always command attention. And offhand, fleeting glimpses increasingly feed the mainstream of present-day photography. Bruce Davidson is the only photographer represented in this chapter whose work provides examples for each of the three types of time expression discussed here *(pages 121, 132 and 137)*. Yet he does not always make an advance choice among the options for dealing with time; his conceptions and feelings about the subject determine how he will cope with it—where it is to be placed in time. □

Suspended Animation

The great value of pictures that seem to suspend time is their ability to generalize. They can suggest ideas that characterize the whole experience of the human race. They specify no unique instant—if made earlier or later, they could look about the same. Yet they do not by any means ignore time.

Take the picture at the right: like most photographs that suspend time it offers clear clues to time and the first thing it says is that it was made at night, not in daylight. Also, as with most pictures in this section, one can make other generalizations from its contents. It is a street scene in a city—San Francisco, as it happens—and it is a modern city, as the truck proves. Yet it could be a street scene in any American city in the mid-20th Century. So it is emblematic—standing for dormant, actionless nighttime in all such places. Just before or just after it was made, the street might have been alive with activity, the truck might have moved, the light in the double doorway at right might have been switched off—except none of that matters.

Like the picture that opens this chapter and the ones on the next six pages, this one is specific enough about time to stand as an evocative symbol. All movement is banished; indeed all life is suspended—it is as if the clocks had suddenly stopped ticking and we seem to hear the silence.

Just as if he were working with a view camera, more often used for such meticulously arranged pictures as this, William Gedney mounted his handier 35mm camera on a tripod to frame with great care this nocturnal San Francisco scene. In it, time—and everything else—stands still. The time is significant to the photographer, who thinks that "streets take on a character at night, and there is a sort of primeval thing about darkness."

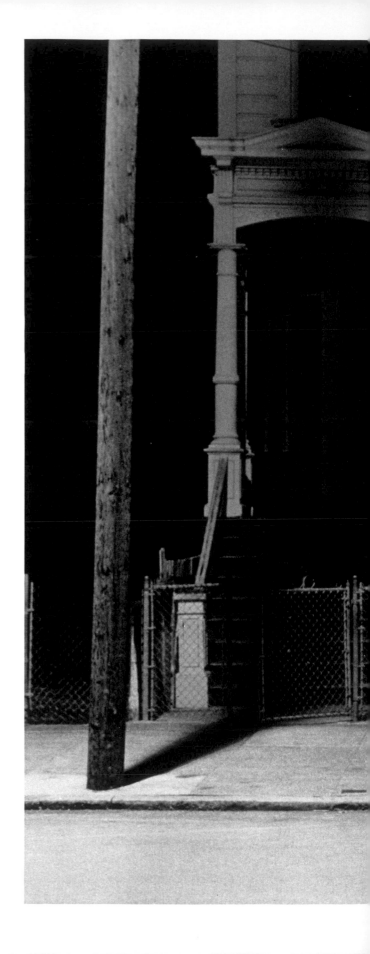

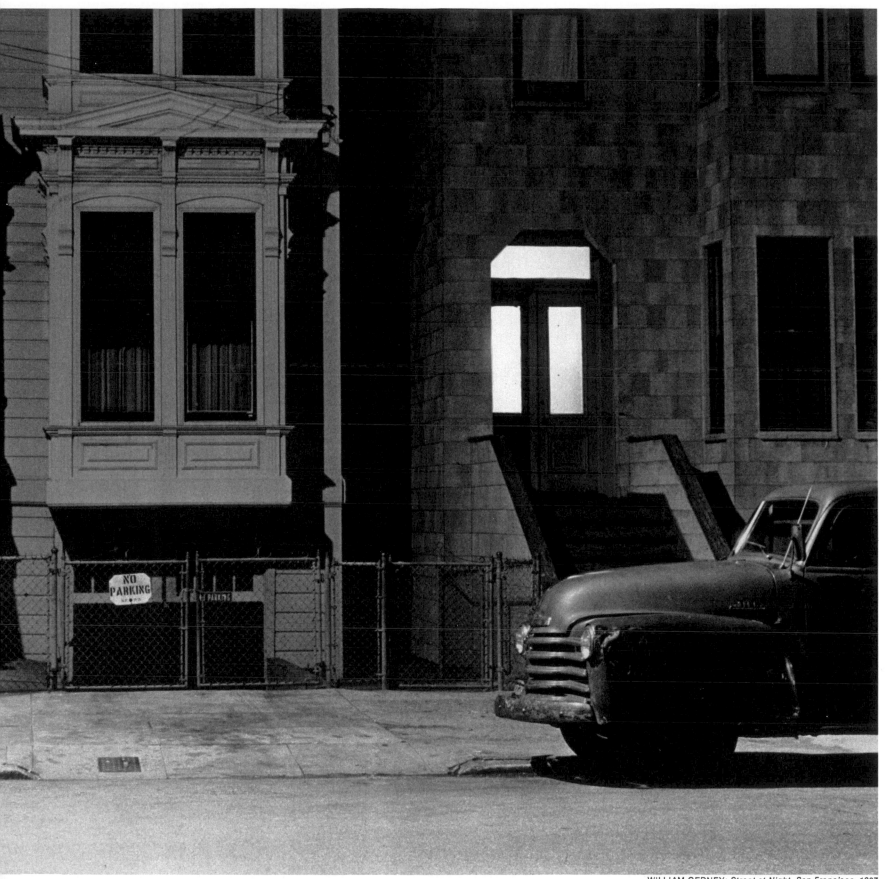

WILLIAM GEDNEY: *Street at Night, San Francisco,* 1967

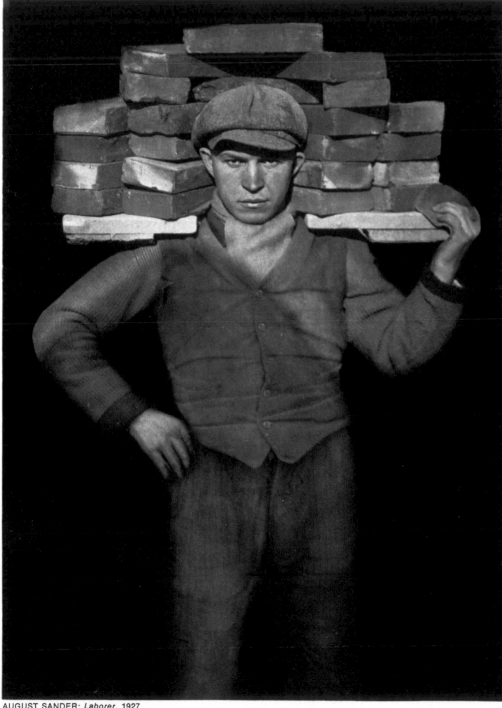

In the lifelong project that the German photographer August Sander called "Men of the 20th Century," this portrait of a Cologne laborer with a load of bricks was one among hundreds of precisely posed studies of Sander's countrymen. The time is both definite and ambiguous: the young man has paused between taking up his burden and laying it down, but there is no indication of hour, day or even year. Holding his pose as if standing still for a portrait painter, the subject reveals his trade with dignity without becoming a stereotype. Asked why he worked as a "Handlanger," or brick carrier, he replied: "There always has to be someone who carries stones."

There are few visual clues to time or place in this ▶ group portrait of a road gang beside a highway in Portugal. Yet the picture overflows with information: Bearing the picks and shovels that are the tools of their trade, the workmen have gathered in front of an eroded escarpment, not by accident but on purpose—to be photographed. Held fast in time, a collective symbol of their work, they stand as they might have stood more than a century ago for a picture that might have been recorded with a wet or dry plate.

AUGUST SANDER: *Laborer*, 1927

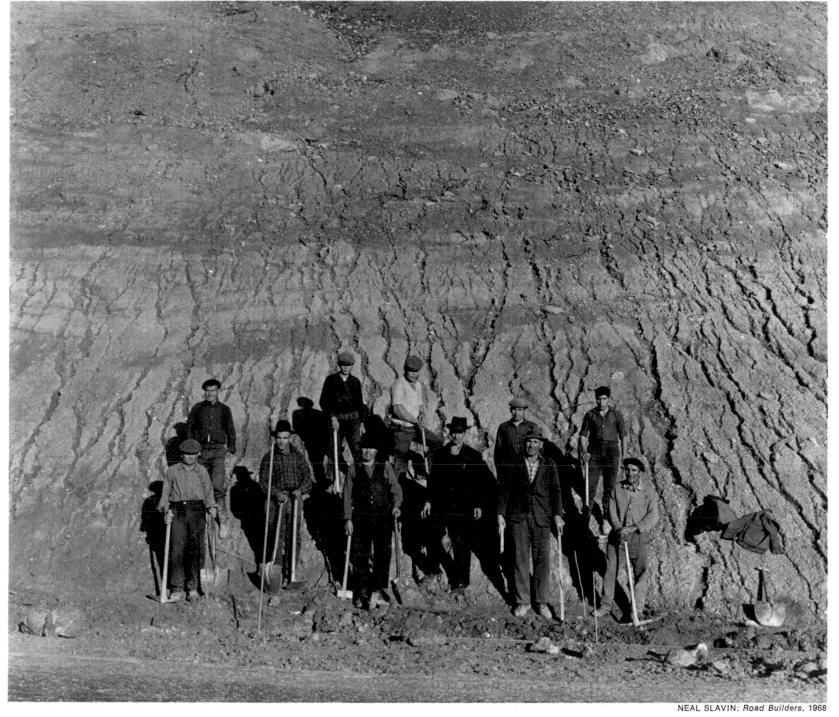

NEAL SLAVIN: *Road Builders*, 1968

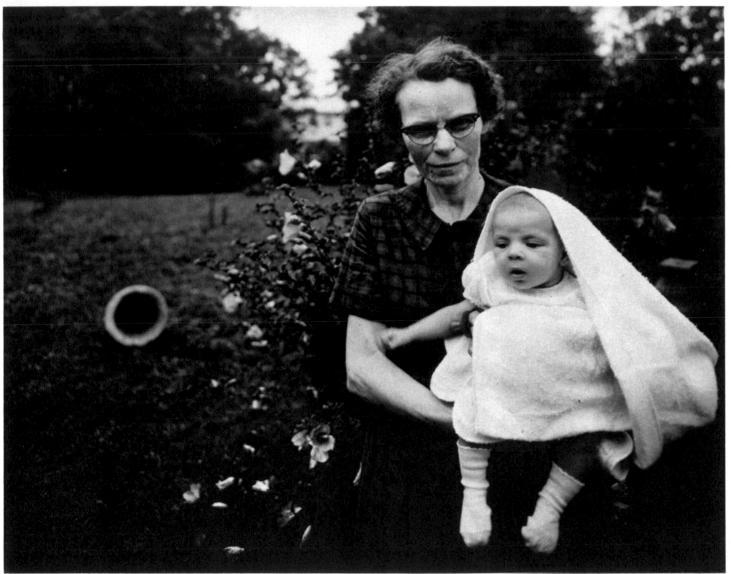

EMMET GOWIN: *Maggie and Donna Jo,* 1966

In making this one-second exposure of a woman and her granddaughter, the photographer tried several arrangements before deciding to balance the human figures with the cryptic shape (an overturned flowerpot) at the left. The mood is one of classic tranquillity that reinforces the expression of grandmotherly love on the woman's face. A little later, the baby doubtless squirmed; but here she is suspended in her grandmother's arms, and in time.

A relaxed and candid look at a mother and her ▶ child, this is one of a series of strong portraits made in New York City's East Harlem where photographer Bruce Davidson, according to one critic, captured "those private moments of suspended action" in the lives of his subjects. Much of the picture's impact comes from the unhurried confrontation between the camera and the subjects—and from the arresting contrast between the dark skin and light bedspread.

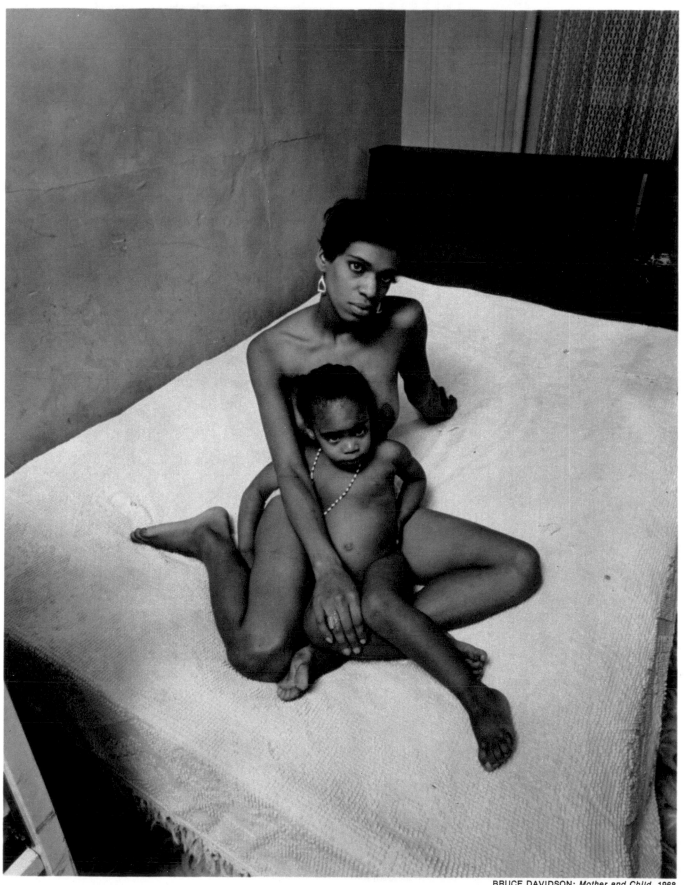

BRUCE DAVIDSON: *Mother and Child*, 1968

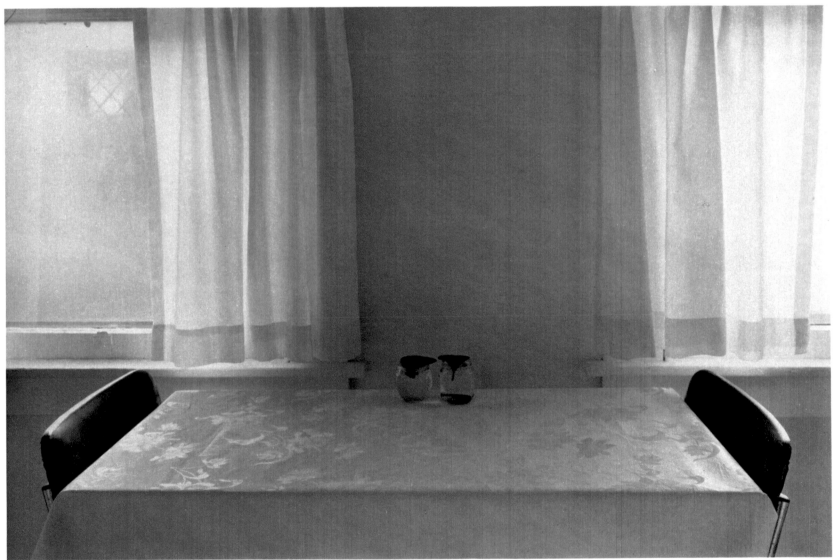

THOMAS BROWN: *Kitchen*, 1968

It was the muted quality of the light that first caught Thomas Brown's eye and led him to make this picture. In what he calls the "long moment" that the kitchen scene represents, everything is in static balance, at rest and with no hint of impending movement. It is between mealtimes —any meal, in almost any home of its kind.

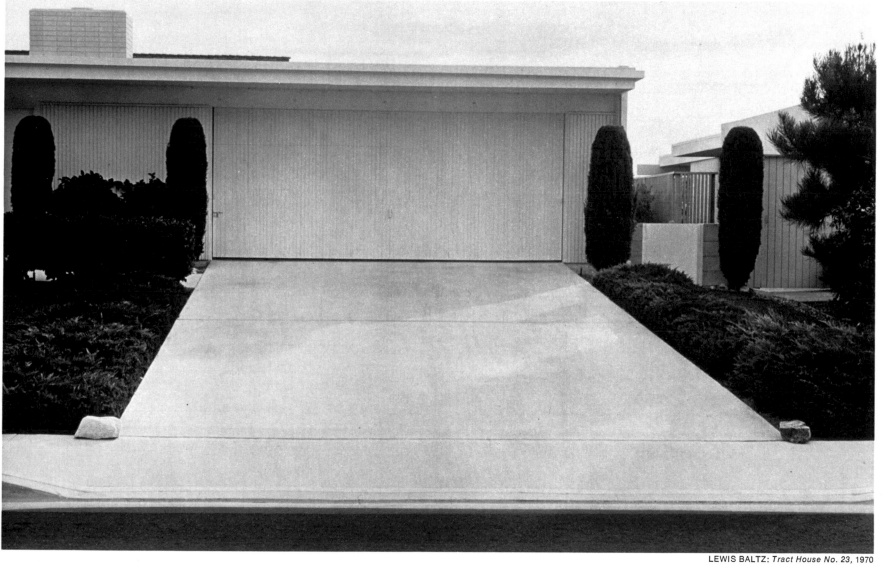

LEWIS BALTZ: *Tract House No. 23*, 1970

*The rigid symmetry of this Southern California
development-house garage was decreed by an
architect, not by the photographer. Every detail is
as meticulously placed as in a mausoleum; the
tumult of life seems entirely suspended; and the
only living things, the evergreen shrubs, are
black, as if they too were not really alive.*

The Decisive Moment

A quick and useful distinction can be made between the static pictures that precede this page and the dynamic ones that follow. In the picture suggesting suspended time, all action stops *for* the camera; in pictures that sample time at either a peak or a random moment, the action is stopped *by* the camera. The action-stopping photographer who coined the term "decisive moment" to describe the picture that picks out a certain, rather than uncertain, moment in time is Henri Cartier-Bresson, and among the finest examples of this expression of time are pictures of his, like the one on the opposite page.

The concept of the decisive moment depends on change. The photographer must think about what he hopes to record, then must shoot along and watch the unfolding scene before him. He makes his picture when visual and emotional elements come together to express the meaning of the scene. If he fails, he cannot try again because the telling moment will have passed.

Cartier-Bresson, as the author and art patron Lincoln Kirstein has written, "has been described as having a constant boxing match with time; time is both opponent and partner . . . to be punched and knocked down; one dances around an instant of time waiting for an opening, to fix, arrest, conquer."

Such arresting of time came with the development of photojournalism and the advent of the 35mm camera, which permitted pictures to be taken almost anywhere at almost any instant. While journalists used this approach mainly in reporting news events, some photographers—among them Brassaï, André Kertész, Cartier-Bresson and Bill Brandt—soon sought to extract meanings and emotions from situations involving not newsmakers but ordinary people. Their results showed how to capture for all time the fleeting instant that, more than any other, communicates an emotion or an idea.

Seizing an instant in flight, Henri Cartier-Bresson has caught the fugitive image of a man in mid-air. A moment later, when the man's foot hit the pavement, the picture would have been lost, for its beauty is locked into the transient symmetry of its composition. Many of the shapes are balanced against their reflections in the water. Even the leaping human figure is echoed by the image of a dancer silhouetted in the poster toward the rear.

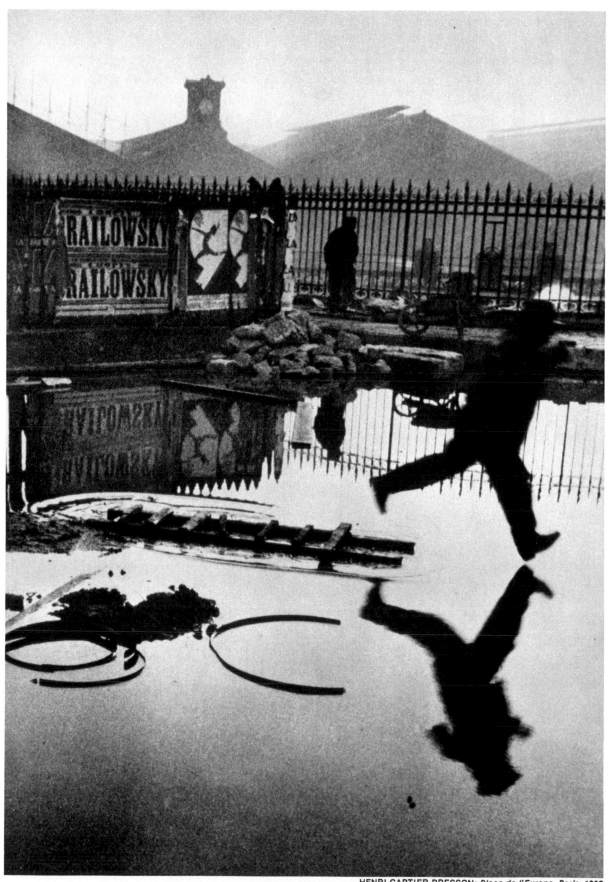

HENRI CARTIER-BRESSON: *Place de l'Europe, Paris,* 1932

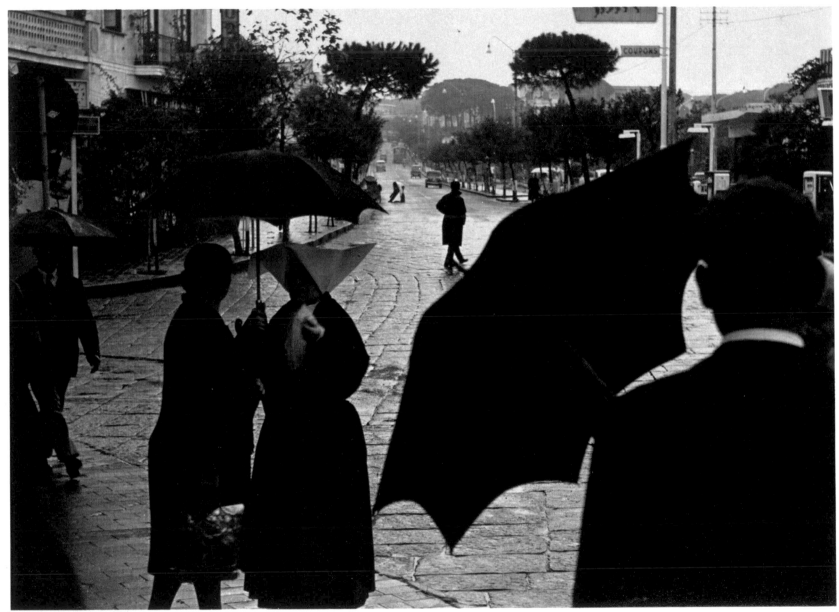

MICHAEL SEMAK: *Italy, 1961*

*Chance often provides the decisive moment, if the
photographer can grasp it. Michael Semak
stepped off a ferry at the resort island of Ischia,
near Naples, and saw a pattern of umbrellas.
With no time to focus or set exposure, "I raised
my camera and pressed the shutter," he says.
"The situation dissolved right after I got my shot."*

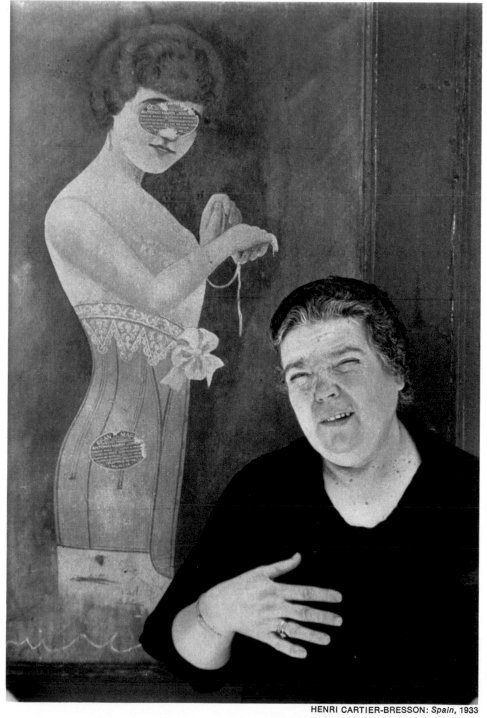

Henri Cartier-Bresson interferes as little as possible with the changing scene in front of his lens. In this charmingly casual portrait of a Spanish woman in Córdoba, he allowed the subject to pose herself and caught her at the very moment that her hand unwittingly approximated the position of the hands in the corset poster.

HENRI CARTIER-BRESSON: *Spain*, 1933

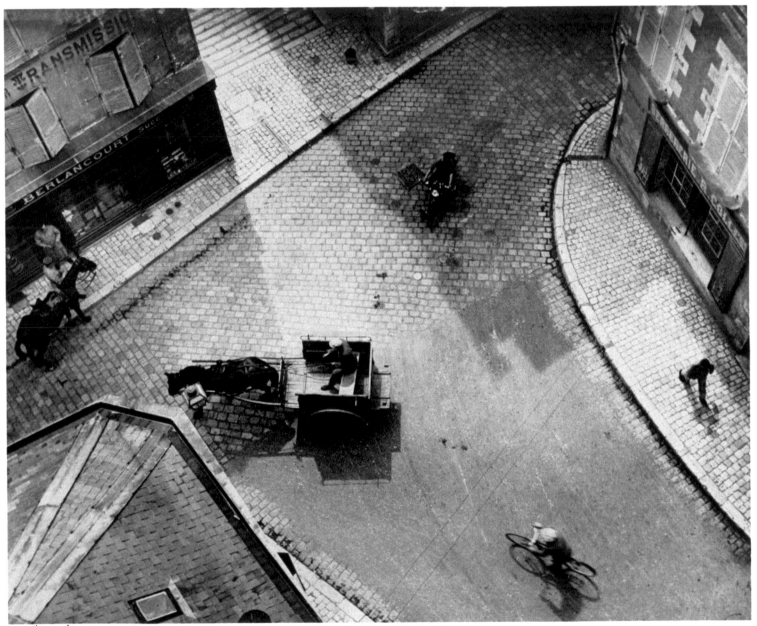

ANDRÉ KERTÉSZ: *Touraine, France, 1930*

*Among the first to exploit the time-freezing
capability of the small camera was André Kertész.
He made this view in a French provincial town at
the moment when the human figures formed
a triangle, as the corners of the intersection do.
"The moment dictated what I did," he said later.*

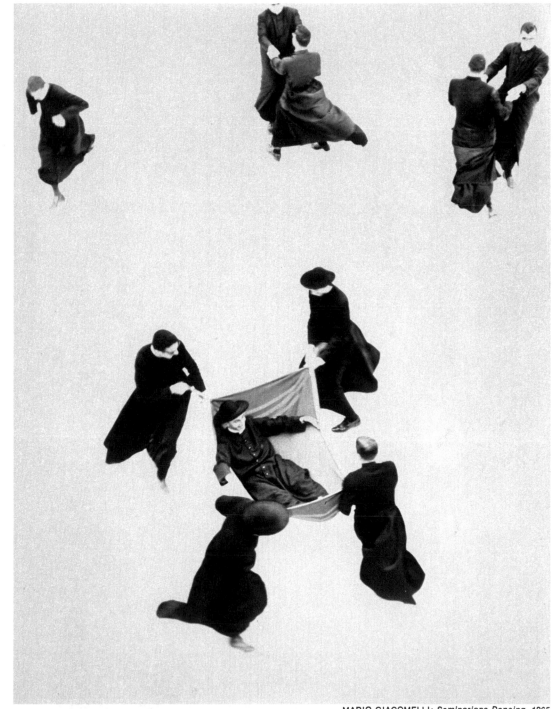

In this glimpse of Italian seminary students
kicking up their heels on the terrace of their
college, Mario Giacomelli has caught the
innocent joy of the young men expressed by the
momentary arrangement of their bodies.
"Photographing the dancing figures was the best
way to capture the ingenuous, childlike quality
of the priest's world," Giacomelli said. "Also, I
liked the graphic composition of whirling shapes."

MARIO GIACOMELLI: *Seminarians Dancing*, 1965

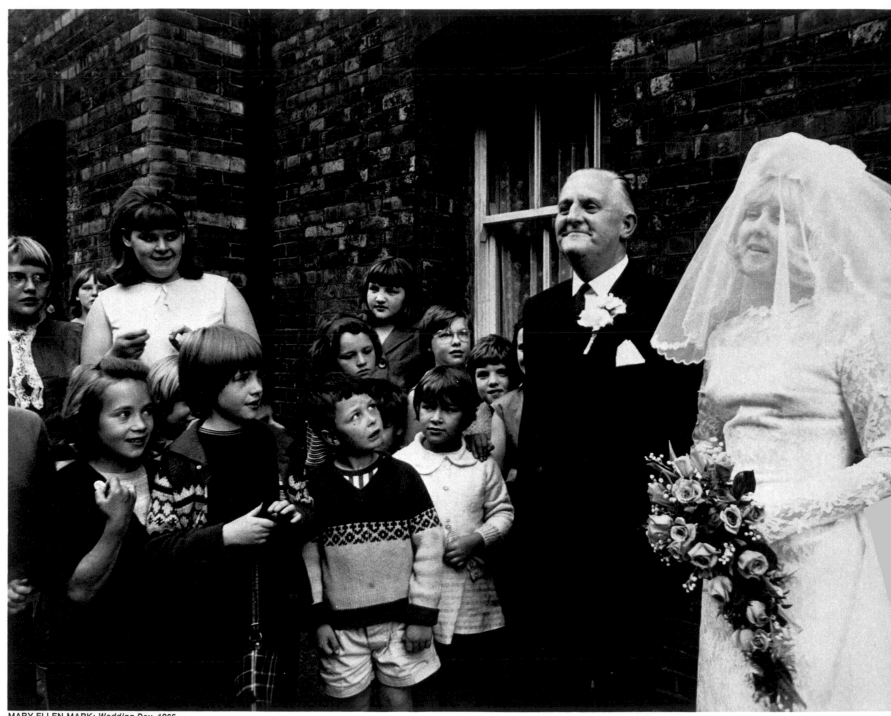

MARY ELLEN MARK: *Wedding Day,* 1965

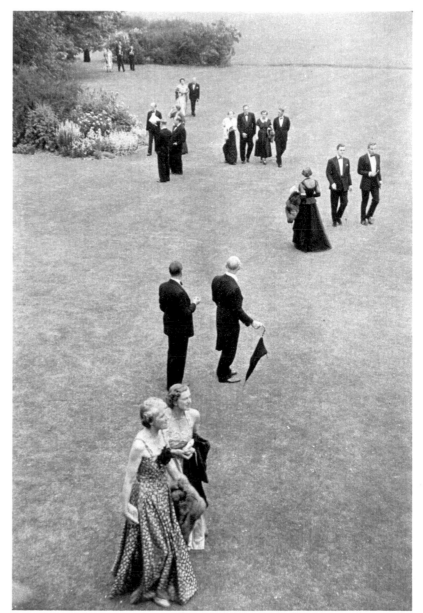

HENRI CARTIER-BRESSON: *Glyndebourne, England*, 1955

A London wedding gave Mary Ellen Mark a
moment in which the figures of father, bride and
onlookers arranged themselves into a design
that heightened the interplay of emotions. She
explains the scene as "three hopes coming
together"—the father's, the daughter's, and all the
dreams and fantasies of the children watching.

A momentary design pattern is preserved in this
curling arrangement of upper-class Britons
crossing a lawn at the Glyndebourne Opera. "If
the shutter was released at the decisive moment,"
wrote Cartier-Bresson, "you have . . . fixed a
geometric pattern without which the photograph
would have been both formless and lifeless."

131

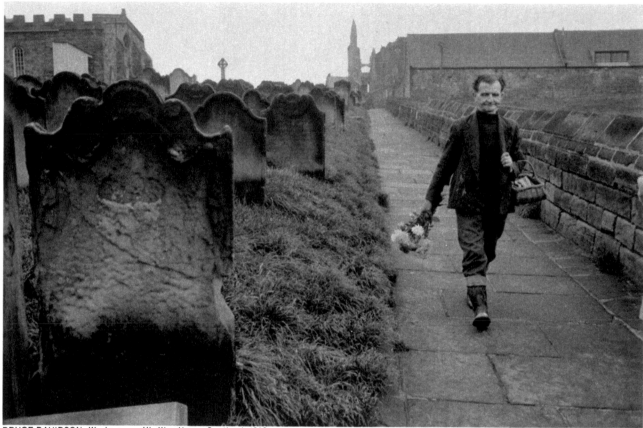

BRUCE DAVIDSON: *Workman on His Way Home, Scotland,* 1960

*Sometimes a photographer in ambush can select
his own decisive moment. In taking this quiet
picture of a workman walking past a graveyard,
photographer Bruce Davidson chose his camera
angle in advance, then waited until the man
reached the precise spot that gave visual balance
within the frame before he opened the shutter.
"A moment sooner or later," he explained, and
the man "wouldn't have been in the right place."*

*The light-and-dark balance of this scene
"appealed to me," Jack Schrier explains, "and
I had been waiting there for about ten minutes for
something to happen. I could suddenly see two
kids coming down the stairs. I knew it was going
to be good and I got very excited. I waited until it
was just right. Another fraction of a second and
the kid at the right would have already been
around the bend. A fraction of a second sooner
and the head of the boy at the left would not have
been separated from the black band at the top."*

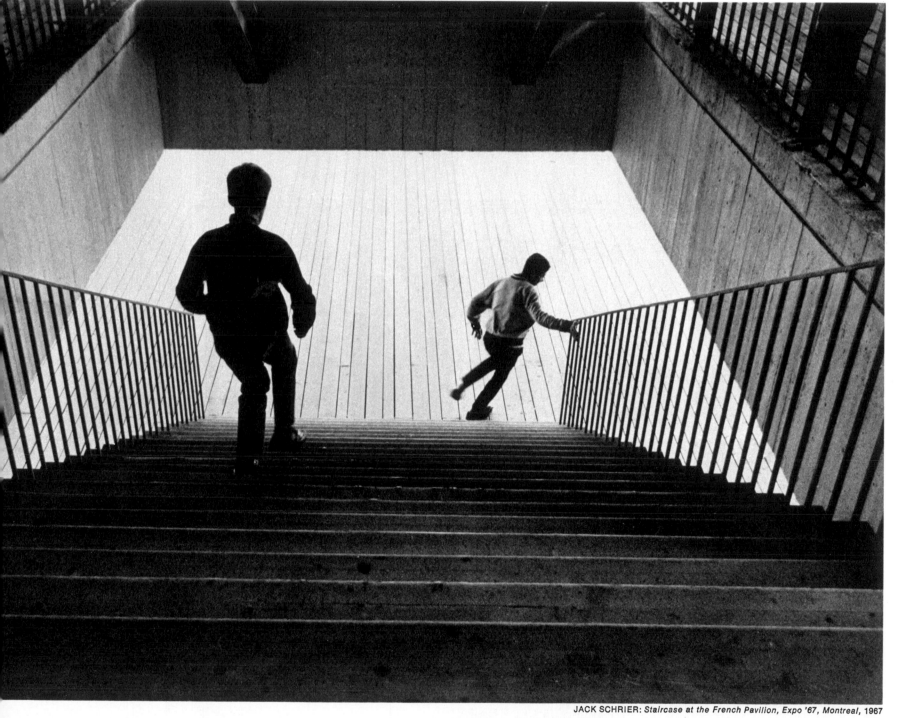

JACK SCHRIER: *Staircase at the French Pavilion, Expo '67, Montreal, 1967*

The Sidelong Glimpse

In the 1950s a group of reportorial photographers turned away from the precision of the decisive-moment picture. Rather than search out meanings from climactic, now-or-never moments, they switched their attention to another kind of awareness of time. They took to photographing those random moments when nothing much seems to be happening—life's non-events. Instead of the delicately poised compositions of Cartier-Bresson and his followers, their images often appear precariously off balance. Sometimes these photographers tilt the horizon line, cut off people's faces and feet with the picture frame, or they split their subjects in half with a stop sign or a tree trunk.

The results have a haphazard, seemingly unplanned look, as if glimpsed out of the corner of the photographer's eye. As often as not there is something jarring, even irritating, about such a photograph. Ambiguous and off balance, it disturbs the viewer—which is what the photographer intended.

This elusive, glimpsed quality in photography first caught the public eye in 1959, with the appearance of Robert Frank's book *The Americans*. A collection of seemingly chance glances at life in the United States—like the bar scene on the opposite page—Frank's book established a new concept of the right moment to take a picture. The "decisive moment," to him and the other new realists, does not fairly represent the real world. The perfect patterns that merge at such a peak moment, they believe, are not a normal part of seeing. And to try to contain those patterns in a photograph is to deprive a picture of its honesty. "I don't want that in photography," Frank contends. "The world moves very rapidly, and not necessarily in perfect images."

By tilting his camera and shooting from the hip, Robert Frank made this quick glimpse of cowboys at a bar. The picture seems to slide off the page like a falling shot-glass. It suggests not only the pungent odors of whiskey and cigarette smoke, but also some of the upset balance of contemporary American life. Indecisive, offhand, the picture reveals a moment of raw reality.

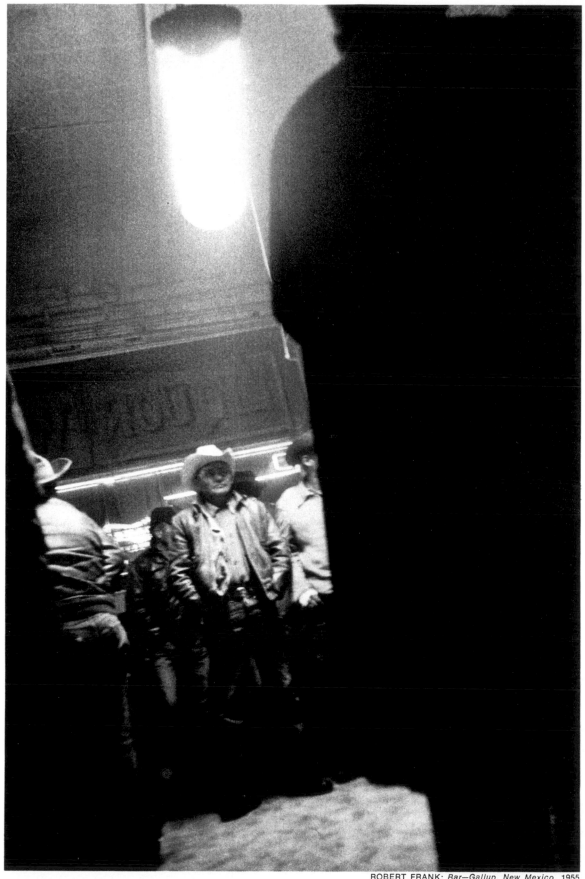

ROBERT FRANK: *Bar—Gallup, New Mexico*, 1955

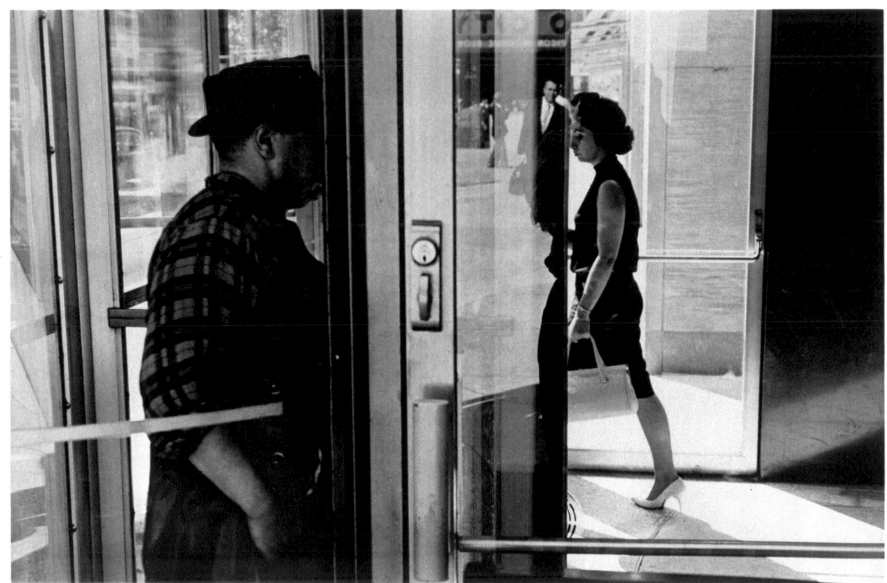

LEE FRIEDLANDER: *Revolving Doors,* 1963

*Like most pictures in which time is caught askew,
this photograph raises questions it refuses to
answer. Who are the people? What are they doing
there? Why is one man's face cut off, while
another man looks right at the camera? But that
was Lee Friedlander's purpose—to puzzle
the viewer, just as everyday scenes often do.*

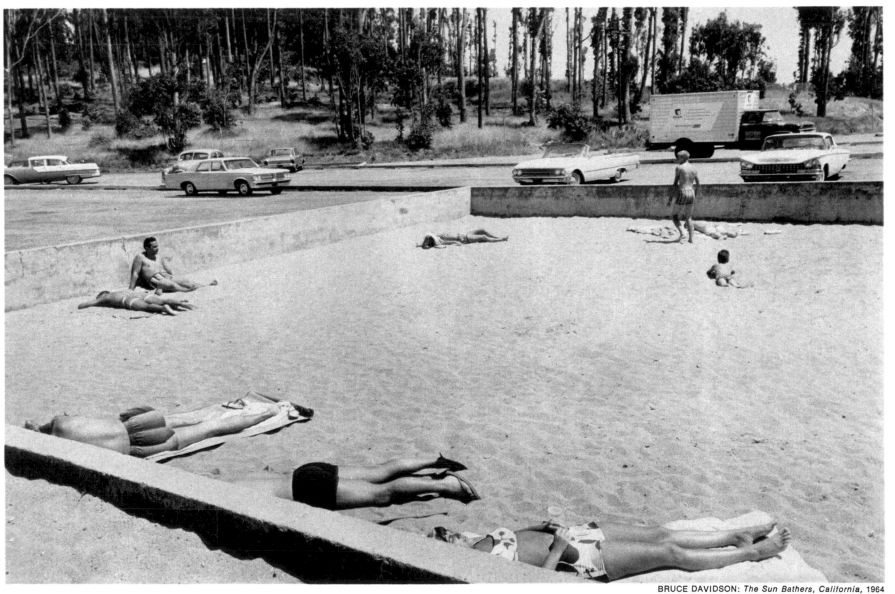

BRUCE DAVIDSON: *The Sun Bathers, California*, 1964

Coming upon this sun-bathing scene was an eerie experience, Bruce Davidson recalls. "The bodies were like larvae, like insects. The people were using the concrete to hide from the wind and sun, just as insects might hide under rocks." He made no attempt to "complete" the design—by moving a step forward he could have avoided cutting off the heads in the foreground—and his incomplete view creates an upsetting scene of headless bodies in a Kafkaesque enclosure.

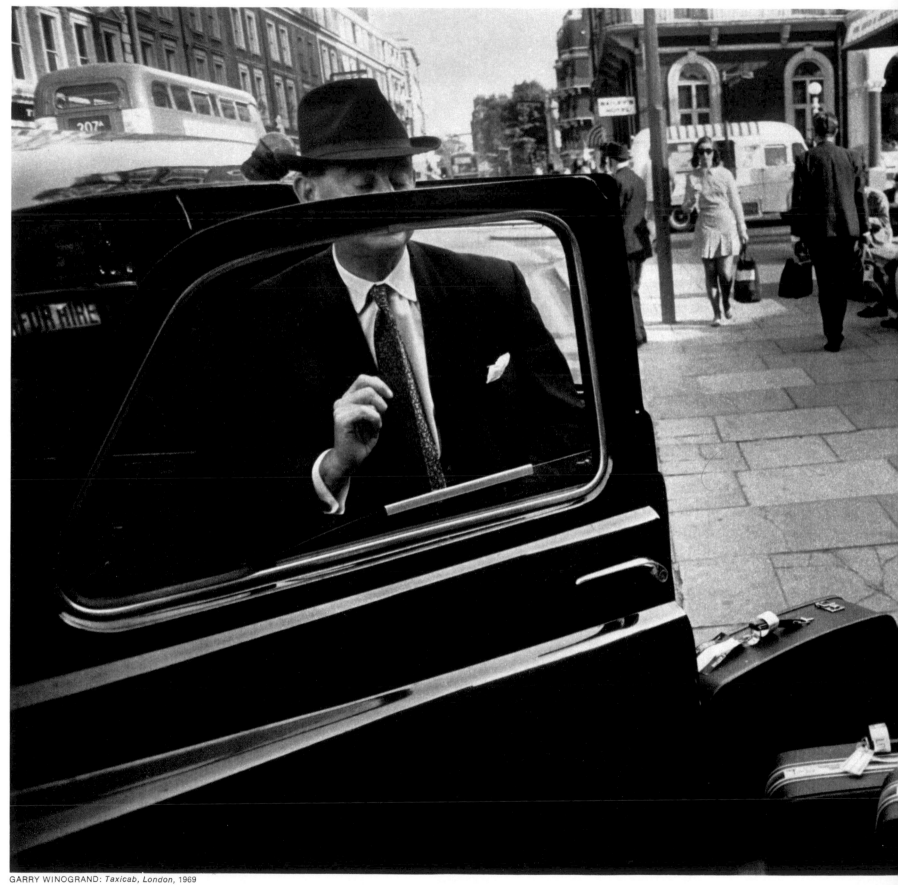

GARRY WINOGRAND: *Taxicab, London,* 1969

138

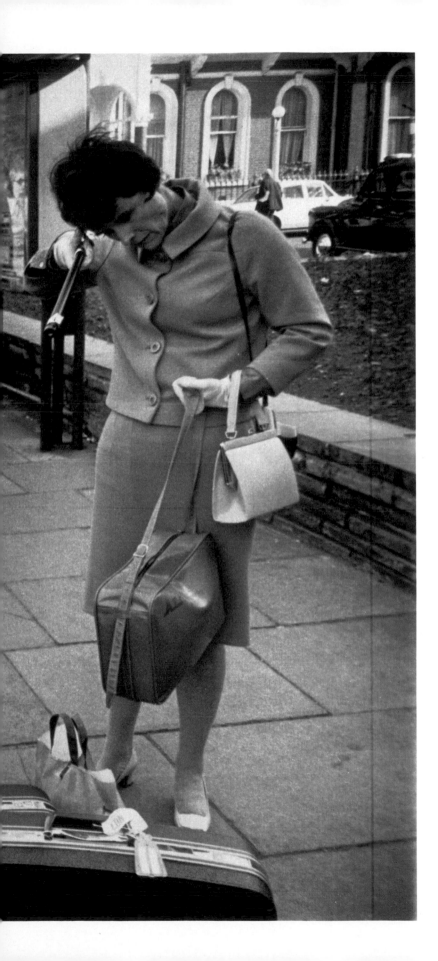

The sidelong glimpse often immobilizes a scene
at the instant before, or after, its various elements
fall into place. If the photographer had waited a
bit longer before taking this exposure of a couple
leaving a taxicab, the man's face might have
emerged from behind the car door, the woman
might have dropped her right hand. And the sense
of immediacy would have been lost. As it is, their
movements seem unsynchronized, their positions
awry, their next actions for the viewer to guess.

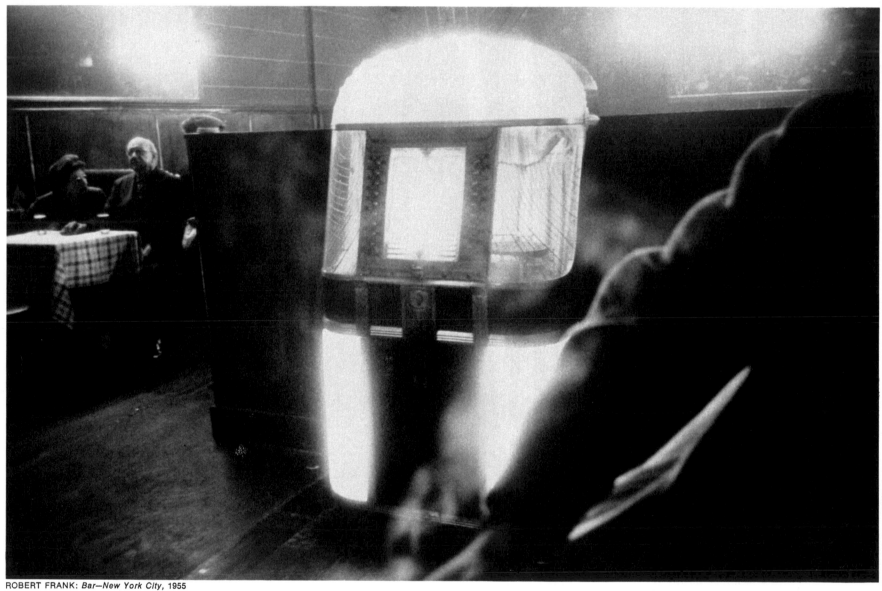

ROBERT FRANK: *Bar—New York City,* 1955

*A glance inside a New York bar, another
photograph from The Americans, has a feeling of
drabness and melancholy. The garish lighting and
the vanishing figure at right add to the sense that
this is a sad café; the people are not relating
to each other at all. Novelist Jack Kerouac wrote in
the book's introduction that after seeing pictures
like this "you end up finally not knowing any
more whether a jukebox is sadder than a coffin."*

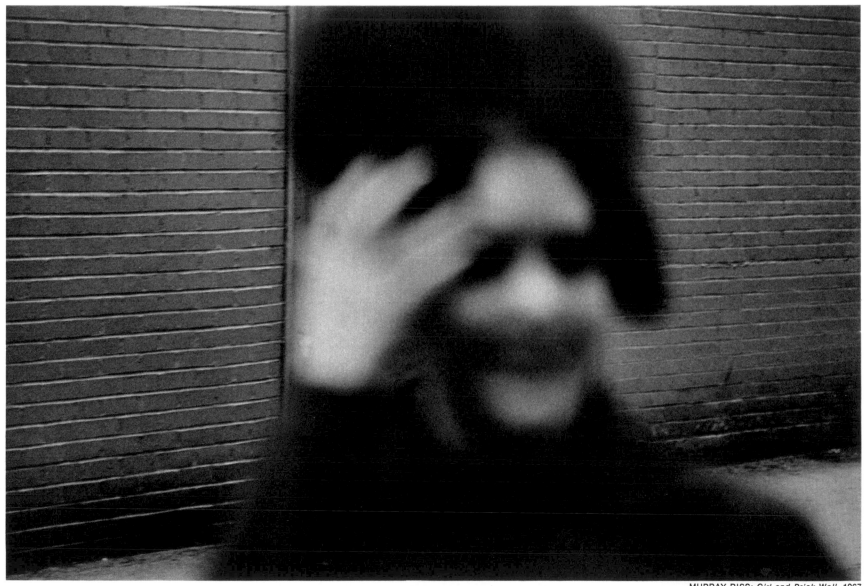

MURRAY RISS: *Girl and Brick Wall*, 1967

The effect is spur-of-the-moment, but there was nothing offhand about the making of this picture. The photographer had been trying, off and on, for almost a year to record the impersonal mood of a shopping mall in Providence, Rhode Island, where people hurried about without really looking at one another. Finally deciding to focus on the brick wall, he followed shoppers with his lens and he caught this fleeting foreground image.

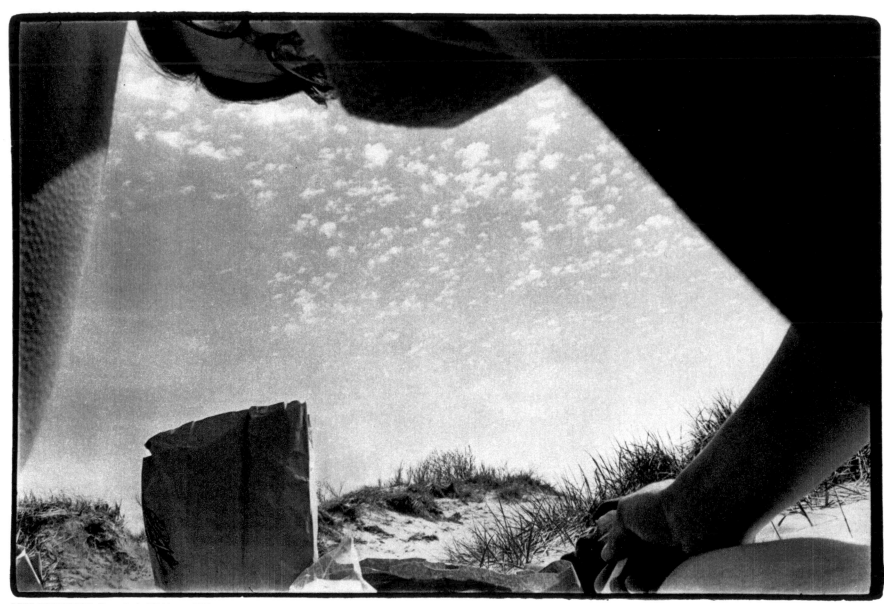

REED ESTABROOK: *Saugatuck, Michigan,* 1970

*Reed Estabrook was lying next to his wife at the
beach when she suddenly got up. At that random
moment her movement created a bizarre frame full
of odd shapes and uncompleted action, a view
that is disorienting because it is so unpredictable.*

REED ESTABROOK: *Fennville, Michigan,* 1970

*Riding in an automobile, one of the most ordinary
American activities, offers plenty of seemingly
ordinary moments for Estabrook to photograph.
He added an upsetting twist to this one by tripping
the shutter at the instant his wife's head was
about to block out the cow. The juxtaposition of
her head and the cow's makes the cow look
misplaced in the passing landscape—creating the
off-balance sensation of the random glimpse.*

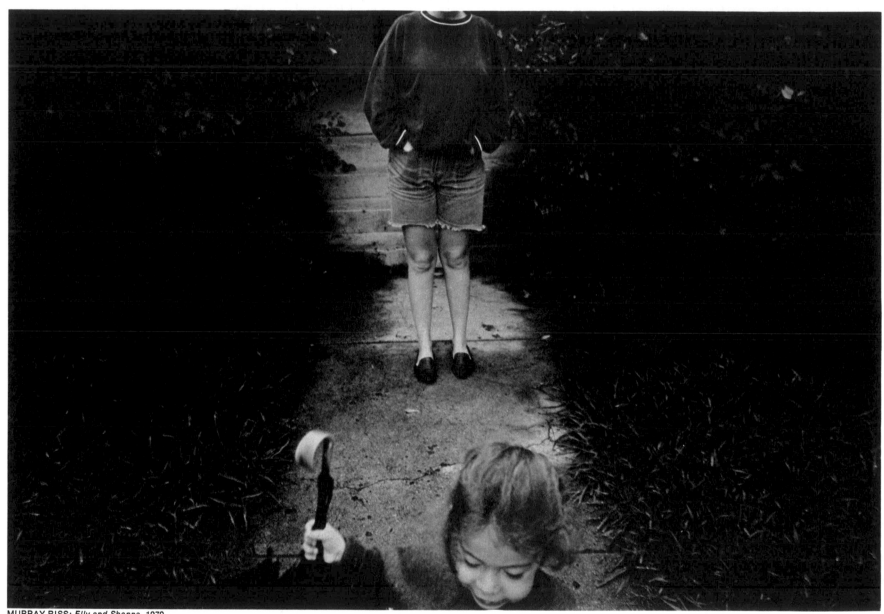

MURRAY RISS: *Elly and Shanna*, 1970

This chopped-off view of a woman's body and a little girl's head is not a photographic mistake. To Murray Riss it is a perfectly relevant peek into his relationship—loving, but complex—with the two people, his wife and daughter. The viewer cannot help trying to visualize a whole person— and putting the child's head on the woman's body seems to make the picture suggest that at some stray moments, at least, the leading women in his life have interchangeable qualities.

The Innovators 148

Photograph? Painting? This scene is both. ▶ Donald Blumberg photographed at St. Patrick's Cathedral in New York City and made a giant print on a four-by-five-foot piece of sensitized linen. Then Charles Gill altered the photographic image. He applied acrylic paint to broad areas, reclothed the woman in the foreground in light colors, put a silver mask on her, and capped his share of the work by mysteriously floating a hat in mid-air.

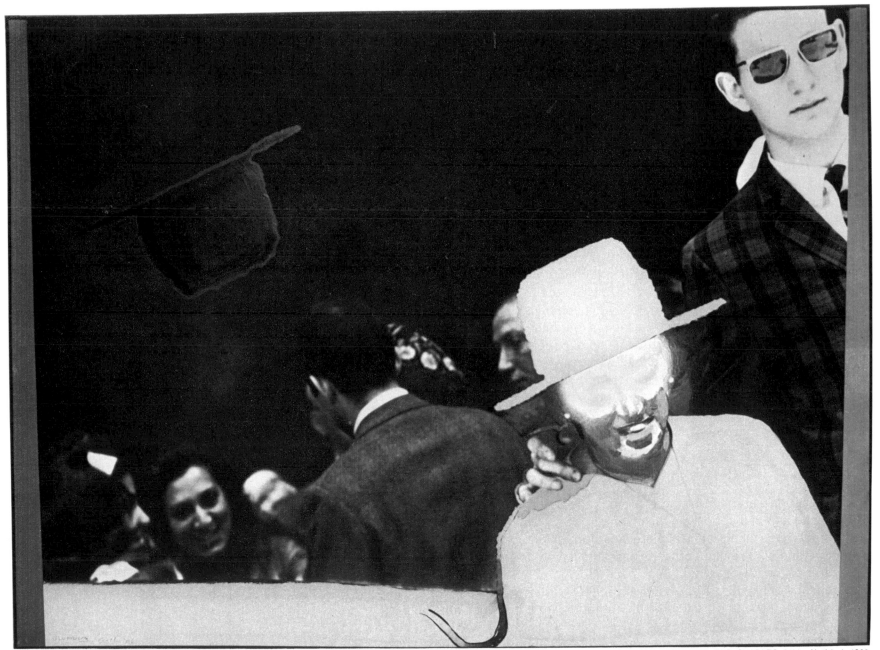

DONALD BLUMBERG AND CHARLES GILL: *Untitled*, 1966

The Innovators

Innovation is the rejuvenator of art. Without a steady flow of new methods and fresh ideas, any field, whether it be photography or the writing of movie scripts, begins to go stale. A good innovator, of course, should be thoroughly versed in the fundamentals of his craft. But in challenging old standards and exploring new approaches, he may help the art retain its vitality. This has been true in photography from the first and it is still true today, as resourceful and imaginative photographers continue to experiment with new ways to express themselves in pictures.

Many photographic innovations seem baffling at first because they take people by surprise. In breaking free of conventional molds, they ignore our preconceptions, and confound our sense of what to expect. In looking at most photographs, most people share a set of basic experiences and ideas about photography that enables them to recognize what they see. The need for this shared understanding is illustrated by anthropologists' experience with primitive tribesmen. When scientists visit a remote area, they sometimes try to befriend their hosts by taking their pictures with a Polaroid Land camera, and offering them the finished print. But the tribesmen, if they have never seen photographs before, are likely to hand back the print with blank, uncomprehending looks. Nothing in their experience has given them the ability to interpret tones or colors on a piece of paper—a photograph—and recognize in it their own likenesses. In the same way, though on a much more sophisticated level, some of today's photographic innovations go so far beyond our experience of what a photograph is about that we simply do not know, at first, how to react to them.

The pictures in this chapter are the work of innovators and many of them, on short acquaintance at least, are baffling. Their creators have used the materials of photography—but have utilized them in a variety of puzzling, unconventional ways to express their own special visions.

Such was the approach of the two men, one a photographer and one a painter, who together conceived the enigmatic scene on the preceding page. Only part of it was taken with a camera. For after the photographer had taken his picture and made a giant print, he gave it to a painter—who then covered over parts of the photographic image with acrylic paint and added brand-new elements of his own. What it shows cannot be found in the real world, as the subject matter of the traditional photograph can: it becomes not an abstraction but certainly a fiction.

The creation of such photographs is a recurring "new wave" in the art of photography Every decade or so, photographers such as Moholy-Nagy and Man Ray turn up with abstract work that challenges the conventions all over again. The latest such challenge to the traditional photograph began in the early 1940s, at the same time some painters were beginning to explore ab-

AARON SISKIND: *Rome Hieroglyph 8,* 1963

Fading graffiti left on an exterior wall in Rome —undecipherable, undated markings by anonymous men—provide the sources for shapes and textures that make up this picture. But the real subject is the way in which the markings reveal the photographer's own feelings and reactions. "As the language . . . of photography has been extended," Aaron Siskind wrote, "the emphasis of meaning has shifted—from what the world looks like to what we feel about the world and what we want the world to mean."

stract expressionism, a style that also maintained that art could be expressive without being representational. The photographer who opened the way was Aaron Siskind, a close friend of abstract expressionists Willem de Kooning and Franz Kline, with whom he once shared wall space in a New York gallery exhibit. Siskind's early work, done in the 1930s, was generally in the documentary style: he made photographic reports of Harlem tenements, Bowery life and New England architecture. His emphasis then was on subject matter. But somehow Siskind felt unsatisfied. "There was in me the desire to see the world clean and fresh and alive," he says, "as primitive things are clean and fresh and alive. The so-called documentary picture left me wanting something." And so in 1943 he turned his camera on some of the world's least fresh but most primal objects—rocks and boulders that he found along the New England seacoast. He photographed them and the spaces surrounding them as starkly elemental shapes that bore a certain family resemblance to some of the work of the abstract expressionist painters. The emphasis was no longer on subject matter. The pictures were not just reports of rocks, but expressions of something far more personal and subjective—Siskind's own thoughts and reactions to them: "I began to feel reality was something that existed only in our minds and feelings."

There is a decidedly nonrepresentational quality in most of Siskind's later work. His picture on the opposite page shows a peeling wall in Rome, but it is scarcely recognizable as such. For the viewer is meant to go beyond the original subject and involve himself in the photographer's treatment of it, in the textures and shapes that express the photographer's personal reaction.

Today many innovative photographers do not hesitate to make up their own scenes, using ingenious assortments of picture-taking and darkroom techniques. They daub their photographs with paint, reverse colors, combine negatives, print images one on top of the other and borrow images. In short they try to draw upon all areas of human experience to suit their own purposes. And in each case in which the photographer has succeeded, innovation once again has expanded the art. □

Objects of Fantasy

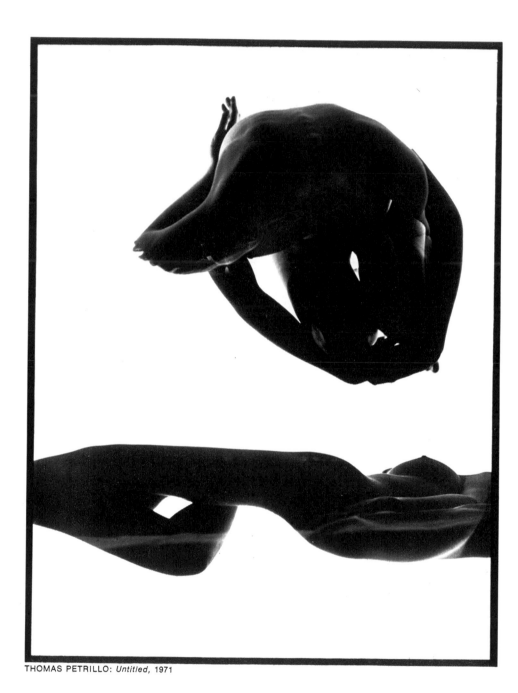

THOMAS PETRILLO: *Untitled*, 1971

Photography was probably the last art form to consider fiction and invention to be perfectly acceptable forms of expression. No painter within the past half century has felt obliged to turn out the kind of documentary canvas that showed George Washington crossing the Delaware. Poets and novelists have always, in effect, provided artistic fabrications, not reports. But photographs, because they look so convincingly real, have long been regarded as factual, straightforward and faithful to reality.

Not so the pictures shown here and through page 159. All are outright inventions in which conventional photography is only a starting point, not the entire creative process. Just as a novelist rearranges the world around him to fit the needs of his story, each of these photographers has transformed the real world into his own pictorial kind of fiction. Unlike novelists, however, and unlike the factual pictures in the previous chapter, they have shunned narrative for visual inventiveness.

The smoothly convoluted shapes in the picture at left obviously never existed "as is" in real life. They are the offspring of Thomas Petrillo's imagination—delivered with the help of technical virtuosity that included precisely superimposed double exposures of a nude model. To make each shape, the photographer aimed his view camera at

the model, traced her position on the ground glass, and shot. He then took a second exposure on the same plate with model and camera in a different position, but made sure that the second image merged with the outlines of the first one. The resulting composite, four exposures combined into two forms, is pure photographic fiction.

Snail shells and calla lilies are the sources for the picture at right. But Lawrence Bach has transformed them into symbols and shapes. Bach first sprayed the original objects with white paint. He then made hundreds of separate negatives of each object from a variety of camera angles and lighting situations, and chose the ones he liked best. These he combined in the darkroom into a single print, masking out parts of some negatives, and carefully positioning each image so that it conformed to a sketch he had made of his original conception. The three black lines were added to deliberately confound the viewer's sense of space, so that the final picture, in Bach's view, became "a sensuous, free-flowing continuum where objects lose and regain their identity." The shapes in the finished picture do appear to be floating through space, no longer images of specific objects but fictional symbols that convey the idea, but not the substance, of shells and flower petals.

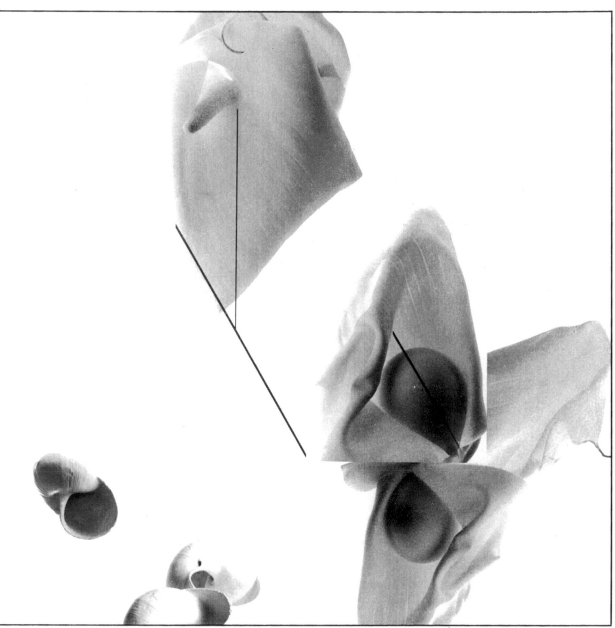

LAWRENCE BACH: *Untitled*, 1970

Challenging the Traditions: continued

Multiple Meanings from Compound Images

Some photographers not only create unreal objects, but even conjure whole new environments—mental landscapes that convey their own thoughts and impressions rather than reflections of the visible world. In some of these imaginary scenes the photographer makes comments on actual experiences. The harsh contrasts and jagged shapes in the picture at right convey some of the tension that characterizes city life. (It consists, in fact, of overlapping scenes photographed in Philadelphia.)

Sometimes the scenes seem to well up like dreams from deep within the photographer's mind. "I work out of my self at an almost precognitive level," says Jerry N. Uelsmann, who conceived the brooding, enigmatic picture of a bedroom and a face shown opposite.

In putting their private worlds on display, many photographers experiment with techniques that are not used in conventional picture taking. Tom Porett produced his vibrant cityscape not by previsualizing the final picture, as photographers are taught to do in school, but by making impromptu double exposures. He first shot a roll of film in one camera, with which he snapped the close-up of the face. Then he transferred the same film to another camera with a different lens and made a picture of a Philadelphia street. He had no idea, until the film was developed, which images would coincide with which, or how the frame lines of the negative would overlap. Uelsmann usually does not know how he eventually will use the scenes when he photographs them. He puts his developed negatives into a file that he culls, months or years later, to collect the images that he combines in the darkroom to make a picture.

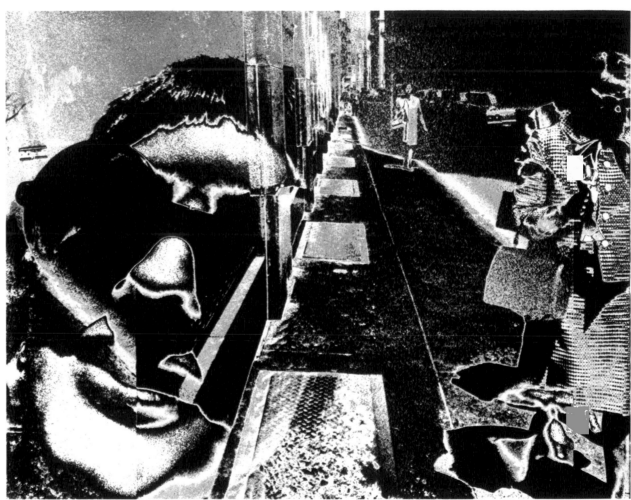

TOM PORETT: *Untitled*, 1969

The crowded images in this cityscape are mixed like traffic noise from a congested street. Some of its high tension comes from the unorthodox contrast in size between the close-up face at left and the street scene at right. Part of it comes from the darkroom, where the photographer masked part of the negative and made a high-contrast copy negative, which he then solarized—thus creating the electric outline around each dark area.

A lonely room, rumpled bed, opened door, tossed slippers, sleeping face: this mind's-eye picture, like most of Jerry N. Uelsmann's works, was conjured in the darkroom, where he combined his negatives into a single print. "Let us not delude ourselves by the seemingly scientific nature of the darkroom ritual," he once wrote. "It has been and always will be a form of alchemy."

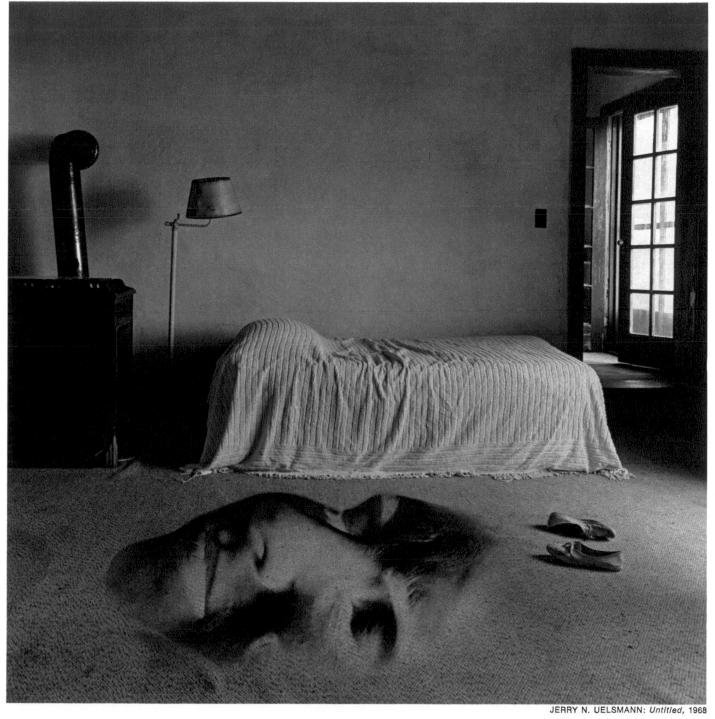

JERRY N. UELSMANN: *Untitled*, 1968

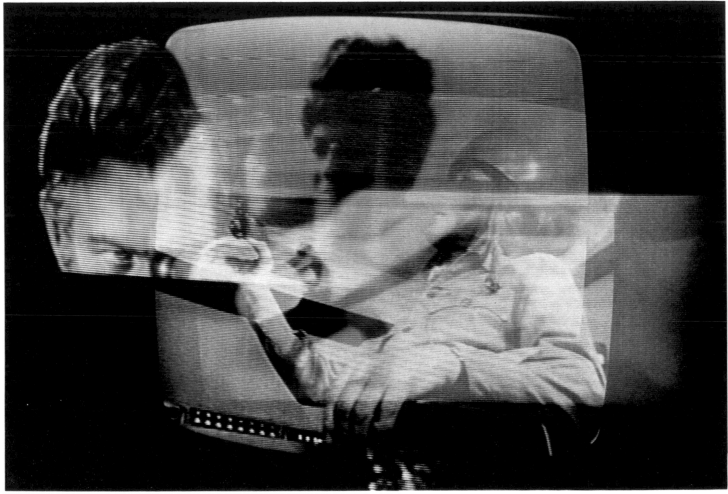

THOMAS F. BARROW: *Untitled*, 1969

Without actually committing plagiarism, artists in many fields have always felt free to borrow materials from each other—or from practically anywhere. Writers quote fellow writers, poets cull images from classical literature, and painters from Raphael to Andy Warhol have incorporated works by other painters into their own canvases.

Photographers as well borrow images made by others to suit their own expressive purposes. Both of the pictures shown here derive from borrowed sources. The one that appears above is a triple exposure of scenes generated by television cameras, and suggests the visual hubbub that assaults the viewer through the TV picture tube when channels are rapidly switched. The other uses a magazine illustration to populate the photographer's fantasy about a room in San Francisco.

"Any source of light should be admissible as a photographic subject—so why not TV?" Thomas Barrow believes. To make this picture he ran the same roll of film through his camera three times, creating the potpourri of random impressions a viewer experiences when flipping channels.

Memories of a friend's living room inspired Eileen ▶ Cowin's three-layered photograph. The base layer, a street scene, was taken from a magazine and hand tinted by the photographer. The middle layer is her own black-and-white picture, a copy of a painting by Hieronymus Bosch. On top of these she placed another black-and-white transparency of her own, showing the room itself.

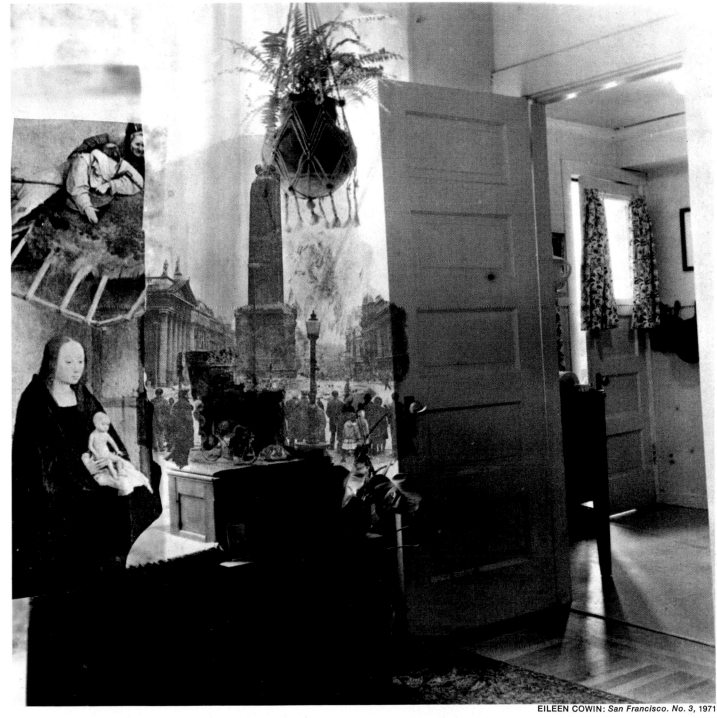

EILEEN COWIN: *San Francisco. No. 3*, 1971

In arithmetic, the whole is equal to the sum of its parts. In photography, that is not necessarily so. Strong, expressive pictures are sometimes made by taking two fairly ordinary scenes and superimposing one on the other. Even when the original pictures are not particularly eloquent, they can work together to evoke powerful feelings and ideas. The final picture becomes greater than the sum of its parts.

One photographer who specializes in such visual compounds is Henry Grossbard, who composed the conundrum shown at right. He simply mounted two color transparencies together in a single frame to form a photographic sandwich. But the combination of images, a metal double bed and an elegant mansion scaled down to doll-house size, summons up a world of associations. "Putting them together," he says, "is adding thoughts to them."

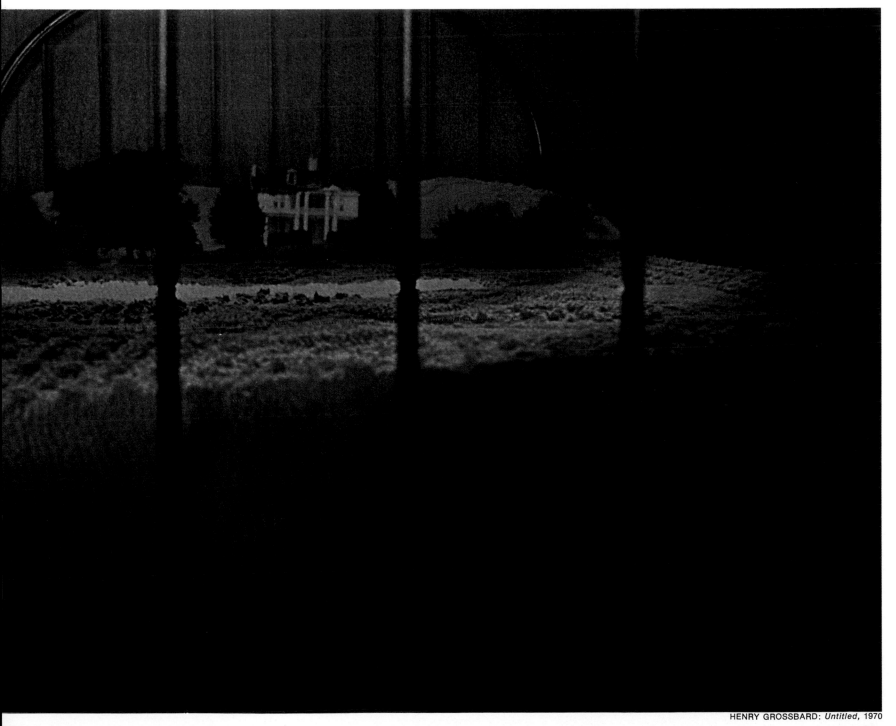

HENRY GROSSBARD: *Untitled*, 1970

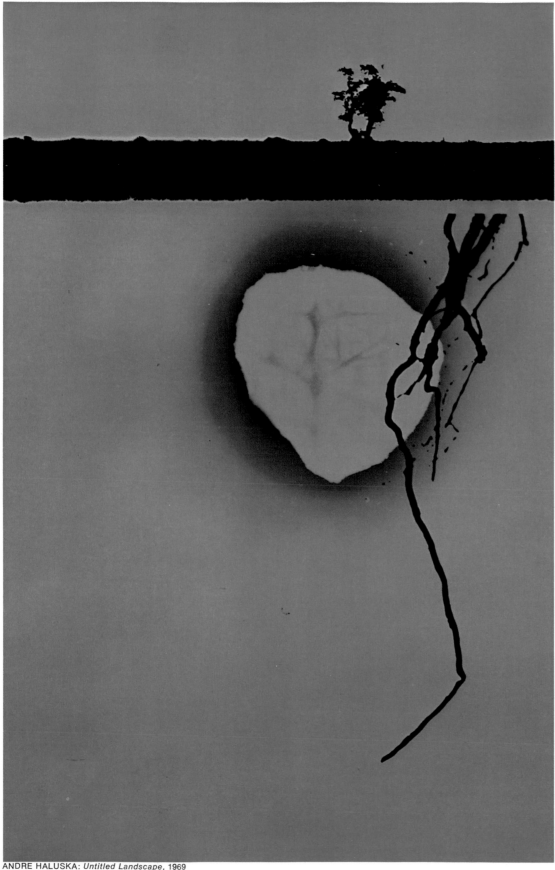

There is no law that says a photograph has to be taken with a camera. Thus a photogram, which is made by placing an object on a sensitized surface and turning on a light, is a simple and direct kind of photograph. It is certainly the earliest. Toward the end of the 18th Century Sir Josiah Wedgwood made photograms by placing leaves on paper sensitized with silver nitrate. (The images, which Wedgwood called "sun prints," quickly faded because he did not know how to fix them.) In the 1920s, both László Moholy-Nagy and Man Ray found that photograms were an ideal medium for their own experiments in abstract photography. The technique continues to be used by several of today's innovative photographers, who introduce their own individual variations. "The photogram is an immediate way to realize an image from a mental vision, because you don't have to go out and take a photograph," says Andre Haluska, who put together the fantasy landscape at left. □

A multiple-image photogram, this surrealistic landscape was composed from three different objects, recorded in turn on a sheet of color-print paper, each with a different colored light source. One is a roughly circular fragment torn from a magazine. One is an actual root, and the third is derived from a negative of a conventional landscape with a tree. The final print was then solarized with light of still another color.

ANDRE HALUSKA: *Untitled Landscape*, 1969

EDMUND TESKE: *Greetings from San Francisco*, 1971

A strong light projected through a postcard produced this photogram, which presents a ghostly X-ray vision of the card's message and its picture side as well. The images are all borrowed: an engraver drew the eagle on the stamp, a friend wrote the message and a photographer whose name appears at upper left on the card took the original picture of San Francisco's Chinatown. Bringing all this together in a photogram resulted in a multilayered scene that is Edmund Teske's own invention.

One Picture from Many

The boundaries of photography are increasingly being strained, stretched and expanded by innovative works that can be legitimately classified only as photographs. But what really does constitute a photograph? The definitions usually specify a two-dimensional picture of an actual object or event, a depiction of something that happened at a certain time and place. Within these bounds, photography has demonstrated both its power and its limits. The power is in its gripping illusion of reality, whether quiet or dramatic. The limits appear when the viewer realizes he is seeing, on a single flat surface, only selected portions of a scene whose actual textures and contours are implied by light and dark tones, with which the photographer must provide a view of the whole ongoing event.

Feeling hampered by such restrictions, some photographers have set out to test them—in the hope of breaking, or at least bending, them. While continuing to employ photographic methods, they have questioned many traditional assumptions: Does a photograph always have to be flat? Why does it have to be limited to one image in one frame? Must the event that is photographed be one event, or can there be several? Does this real event have to be one that anybody could witness—or is there not a place for photographs of "events" that have happened in the mind's eye or in a compelling dream?

To each question of tradition the answer of these innovators has been "No." They have shown that several images can be juxtaposed to form one picture—and that it may say more than any one image could. Their results are varied and all of them challenge the viewer's preconceptions: a photograph mounted on swiveling, interchangeable wooden blocks *(opposite);* a contact sheet that serves as the single portrait of a room *(pages 164-165);* a sequence of images embellished with sewing-machine stitches *(page 174).* They are photographs, yet they are also more than photographs—each a unique way to convey the artist's intent. The reward for the beholder, in recognizing the innovations these pictures introduce, is to enlarge his own concept of photography's outer limits.

A cross between photography and movable sculpture, this work, shown actual size, consists of picture segments mounted on all sides of walnut blocks, which may be stacked in any order on a wooden peg that serves as a vertical axis. Some of the segments are of landscape details—clouds, grass, wood—but the theme of the work is a female nude. When arranged in one way, the pictures on three faces of the blocks show her almost from head to toe. Even where she is not explicitly seen, shadows of her body profile against clouds or grass impart her presence, no matter how the blocks are stacked or twisted. As a unit they provide, through photography, a work that is neither two dimensional nor stationary.

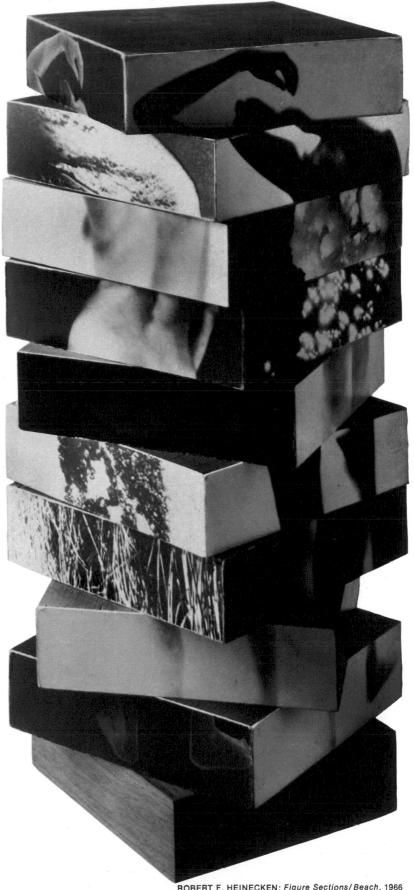

ROBERT F. HEINECKEN: *Figure Sections/Beach*, 1966

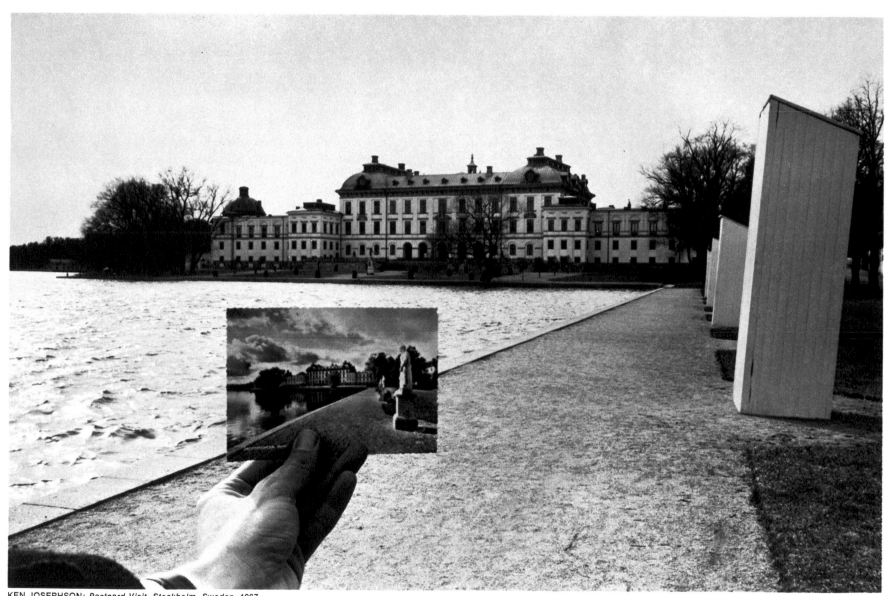

KEN JOSEPHSON: *Postcard Visit, Stockholm, Sweden,* 1967

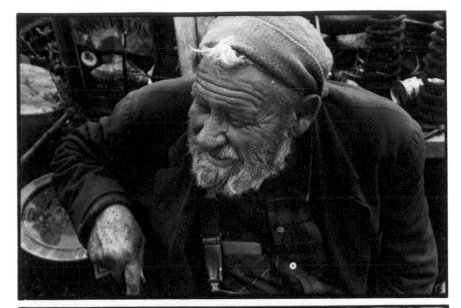

Ordinarily a photograph describes a real event within a single frame, but each of the photographs seen here violates that convention. Ken Josephson's photograph of a Swedish castle *(opposite)* would have been merely a tourist's shot without the hand cryptically holding up a picture postcard of the same castle. The Josephson photograph underlines the fact that conventional pictures are representations. It also states an inherent paradox of representation—that the same tones of black, white and gray can describe such different entities as a postcard and a castle. What the photograph concerns itself with is the concept of dual representation: the larger one in winter, the postcard scene in summer with the trees in leaf and the statuary unsheltered. Thus two events, in two seasons, are represented in one frame—and the viewer is reminded that either way, the castle is only a pictorial representation.

The sequence at right is a triple representation, three views of an old man, which when taken as a whole comprise his portrait. Each section is a detailed study. The stooped shoulders, weathered features and genial expression dominate the top picture. The middle portion shows the thick, expressive hands of a workingman, while the lower section with the unlaced boots and baggy trousers speaks of manual labor once done—a work uniform now casually treated in a time of leisurely retirement. Each picture frees the eye to study a portion of the figure uninterrupted by distractions. The three sections viewed together give a detailed summary of the man that might be hard to equal in a single-frame portrait—and they seem to take more looking at.

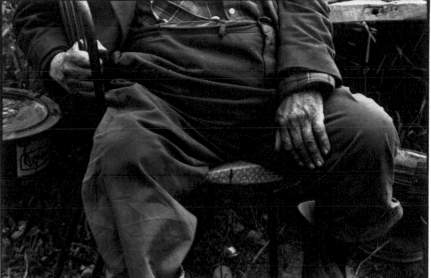

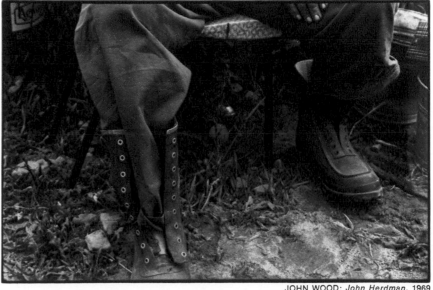

JOHN WOOD: *John Herdman*, 1969

This photograph is a mosaic: a contact sheet of numbered frames. In the usual contact sheet, the viewer examines each frame as an individual picture. But in this case the entire sheet is the photograph: a representation of a room that contains a bicycle, a wicker sofa and a chair. To make it, Reed Estabrook scanned the room with his camera, shooting each area in sequence. As a result, when the viewer scans the sheet, a "consecutive" impression of the room and its contents emerges.

Why bother to make a photograph of a room in this unorthodox manner? Estabrook is challenging the conventional notion that a photograph of a single subject can be accomplished only in one frame. The photograph, broken up into somewhat orderly bits as it is, has a definite appeal to the traditional sense of order. Yet its images, bound by the common sheet of film, impart a fragmented feeling that goes over the brink of straightforward representation.

REED ESTABROOK: *118 North Main Street, Providence, Rhode Island*, 1969

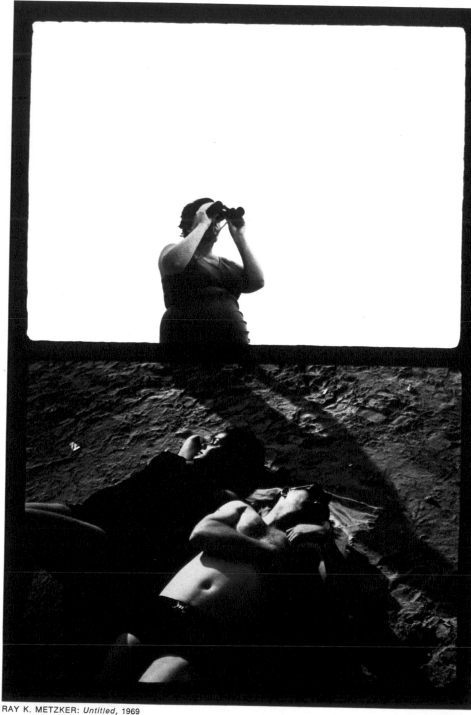

RAY K. METZKER: *Untitled,* 1969

Photographs need not be restricted to one event that happens in front of the camera or even to one click of the shutter. They can also be produced by a conjunction of events. Ray K. Metzker's beach scene at left comprises two events wedded into one photograph. The location of both events is Atlantic City, New Jersey. But whether they were taken at the same place or time is not evident—and not important. Metzker has related two discrete events—the woman with the binoculars, connected to the couple sleeping on the sand by a shadow that is not even hers. The photograph summons the atmosphere of the seashore by fusing images of people who go there.

A similar combination of events is shown in the paired pictures opposite. In each, the frames show that a continuously unfolding event can serve as a single photographic display. In the top pair a man prances before a clothesline hung with old American flags (ones with 48 stars). "It's not a combination of two moments," explains photographer Alice Wells; "it's a new moment, the multilayered reality that we really experience."

The bottom photograph of Wenzel Square in Prague was inspired by news pictures of the Russian invasion of Czechoslovakia in August 1968. When Gerd Sander, grandson of the German photographer August Sander *(page 118),* went to Prague the next spring, he was drawn to the place he had seen pictured so repeatedly during the upheaval. "You simply cannot capture the picture with one click," he said. Two frames, with streetcars and people in different positions, are required to convey the transient scene.

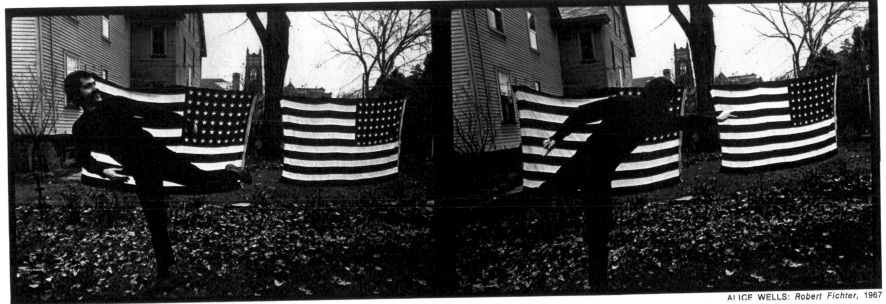

ALICE WELLS: *Robert Fichter*, 1967

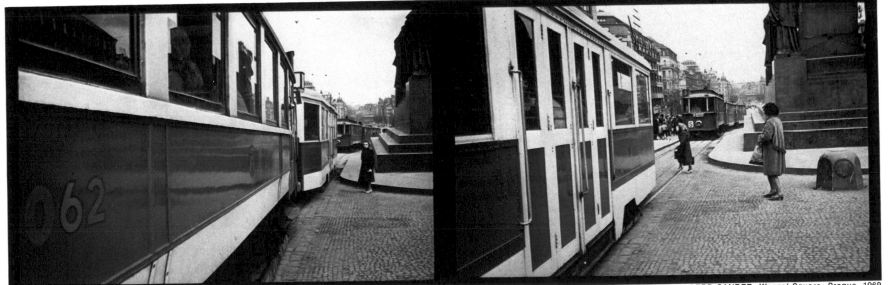

GERD SANDER: *Wenzel Square, Prague*, 1969

To record a scene in a way it can never really be seen, totally surrounding the viewer, Eric Renner devised a novel version of a rudimentary camera to take 360° pictures. He made six pinholes in a metal cylinder, covered each hole with a flap that would act as a shutter, then curved a strip of film inside the can. He placed this primitive camera in the center of a rustic schoolyard at Ticul, on the Yucatán Peninsula in Mexico. As the children gathered, some of them darting in and out to examine the device operated by the stranger, Renner opened the pinholes one at a time. He left each hole uncovered for about 45 seconds, then retaped it and opened the next. The light entering the pinholes left a ghostly series of overlapping images on the film *(right)* as the children ran about. The straight roof line is rendered as a curve because the image was projected on the inside of a cylinder rather than on the customary plane, and perspective is confused for the same reason. Splotches of light on the ground show where the film received the most direct exposures.

The 360° view might be easier to understand if it were greatly enlarged and curled into a cyclorama, with all the images facing inward and with the viewer standing at the center. As it is, the photograph is a straight strip, disorienting the viewer and giving the uneasy feeling that he is getting fleeting glimpses of things going on behind his back.

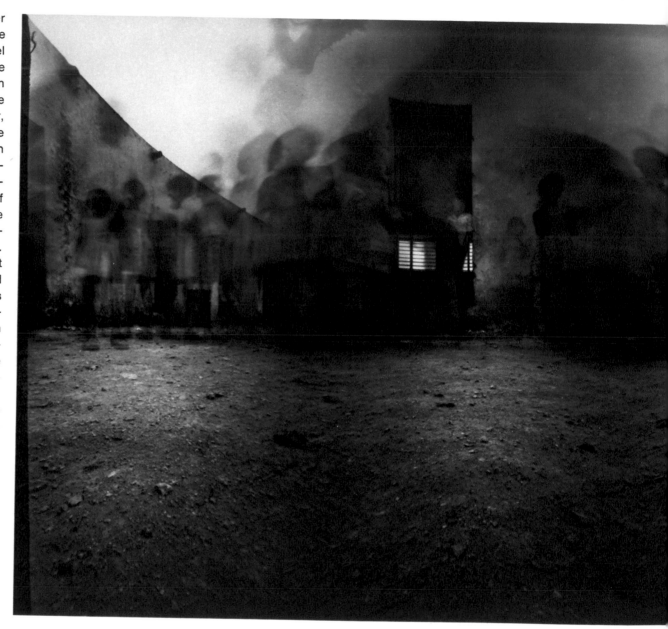

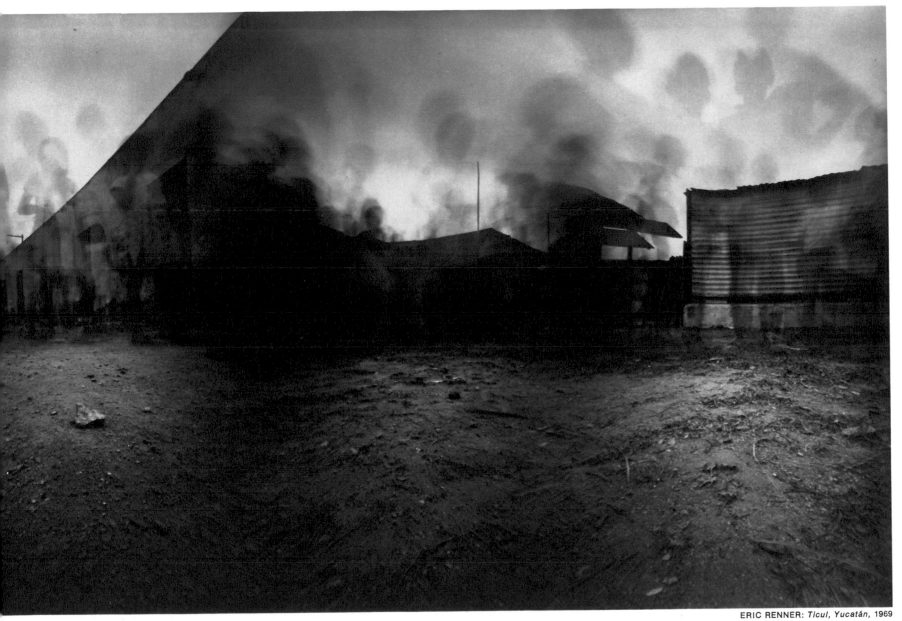

ERIC RENNER: *Ticul, Yucatán*, 1969

169

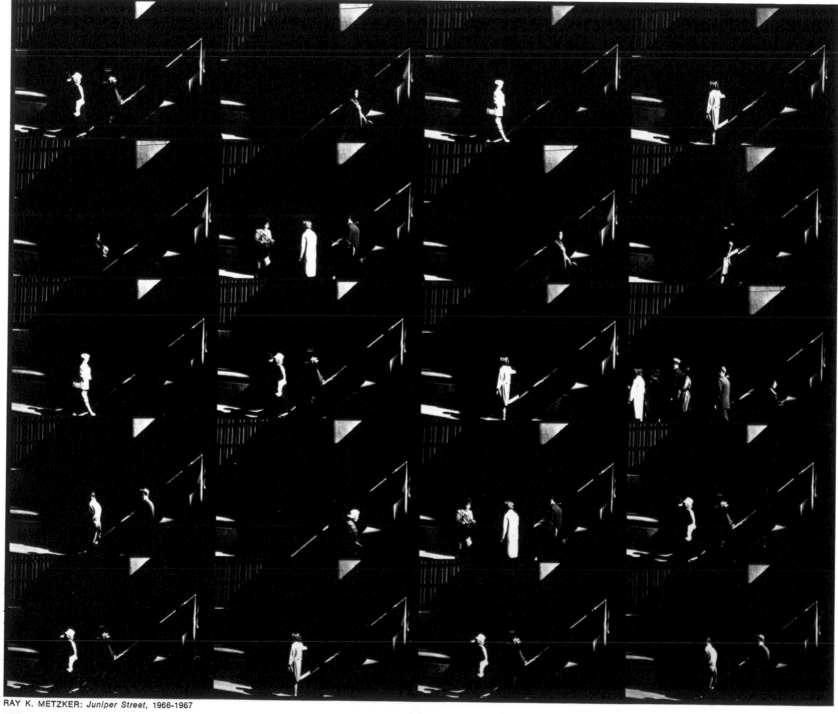

RAY K. METZKER: *Juniper Street*, 1966-1967

◄ *The people glimpsed here passed by this spot on Juniper Street in Philadelphia one day, unaware of each other and unaware that they were contributing images to a photograph made up of many photographs. In arranging the congregation of prints, Ray K. Metzker juxtaposed a variety of light-and-shadow impressions and played with a variety of human postures to link one print to the next, achieving with the whole a pattern of tone and action that no single print possesses.*

The picture on the opposite page—a composite of 20 prints—is the provocative work of Ray K. Metzker (another example of his innovations is shown on page 166). He stationed himself on a sidewalk in Philadelphia and took numerous photographs of the passing pedestrian parade. From one of his negatives he made five prints, from another three, from others two or only one, using 10 negatives in all.

Why does Metzker go to this trouble? Because he believes more meaning can be put into a picture, and derived from it, if it takes many looks at a changing scene instead of one look. This group gives a composite view that conveys the idea of people streaming along a city street better than any single image could. The human figures, though present in the street at different times, are given relationships one to another by being made to appear, disappear and sometimes reappear. But an increased significance is only one of the dividends provided by grouping. There are other advantages, as well, for the whole group exhibits properties all its own: patterns, shapes, rhythms that were simply not present in any one print.

Must a photograph record something that happens before the camera? Some photographers believe a photograph can show something that exists only in the mind of the creator. And both of the eight-frame elongated photographs seen above illustrate this concept. Both photographs (the two strips are unrelated) make no concession to traditional realism. The objects shown, the locations and the colors added by the photographer are arbitrary. The frames, however, have a logic; they should be read from left to right and their cumulative effect is based on sequence.

In separate frames of "Image Garden," at top, are a hand and an arm, which may or may not belong to the same individual. But the hand is flesh-colored, the arm the color of the wall. This interference with normal tonal reproduction, together with the strange subject matter, may be taken as a composition about tension and tranquilli-

WILLIAM G. LARSON: *Image Garden*, 1969

WILLIAM G. LARSON: *Small Talk*, 1971

ty. The TV screen with its very distorted pattern, the hand hanging beside the looped cords, the white hand grasping with delicate tenacity, the bleakness of the walls, all convey the anxiety. Tranquillity is restored with two blank frames that lead to the calming scene of a tree in muted bluish wash.

The lower photograph, "Small Talk," deals with recollections of childhood. The frames begin with objects seen from a low viewpoint: a claw clutching at wires, a telephone pole that looms over the viewer, the wire above the dog that continues to an insulated connection. In the last frame the viewpoint shifts, as if the photographer has now grown taller. Since the wire seems affixed to the final frame, a picture of a mother and daughter, it unites the beginning and end of the strip. In its own eerily connected way, the photograph seems composed of scraps of memories, faded days seen in faded hues.

173

KEITH A. SMITH: *Brian at Point Lobos,* 1970

The starting point for this picture was a dozen black-and-white negatives enlarged onto positive film. To reproduce them in white and blue, the photographer printed the transparencies on paper coated with a chemical used to make engineers' blueprints. Then he used the transparencies to make a pair of stencils for silk-screening, which produced colored images when pigments were forced through the unblocked portions of the silk mesh. With these stencils he silk-screened the black and purple tones over the blueprint.

Taken together, this series of views of a man at Point Lobos, California, makes one picture. By fragmenting the picture, breaking up the individual images and introducing colors of his own selection, the photographer conveys the idea that a picture need not be a literal report, but can be the starting point for an artistic impression. Here the starting point is the relation between a human being and nature, the image of one momentarily dominating, then being overpowered by the other. To unify the dozen views and indicate that he wants them to be regarded as a whole, Smith has machine-stitched colored threads around the frames, the blue margins and the entire assembled picture. ☐

André Kertész set out to convey a sense of fun ▶
and absurdity in his photograph of a dancer who
appeared in satirical productions in Parisian
cafés. Her pose is ridiculous—and yet visually
fascinating in the way the thrust-out arrangement
of arms and legs is circumscribed by the shape
of the sofa. A witty parallel is drawn between
this exaggerated pose and that of the sculpture
in the corner. The overall effect produced
by the picture is of unfettered, impulsive gaiety.

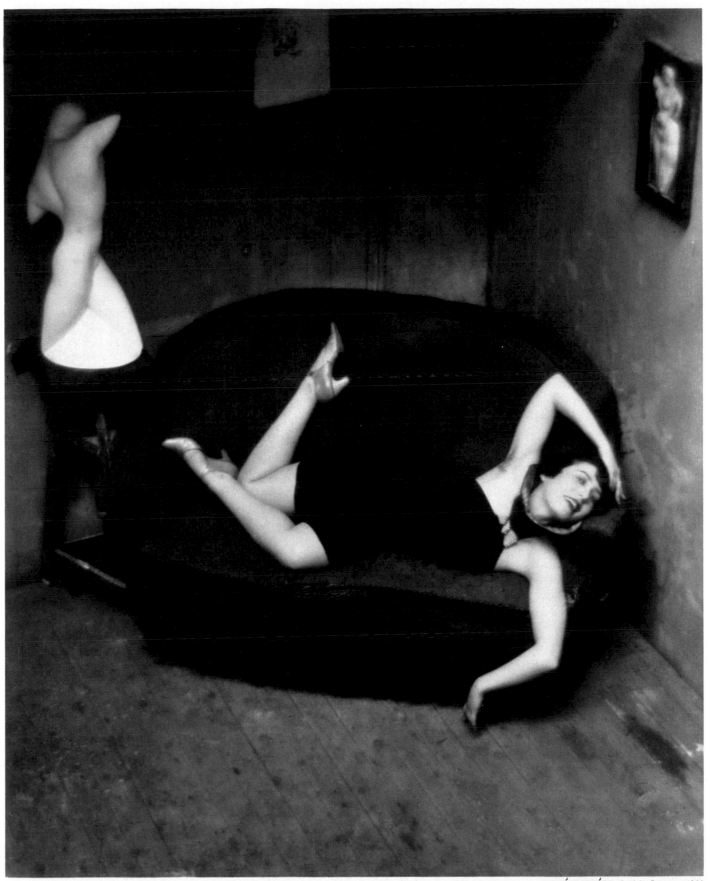

ANDRÉ KERTÉSZ: *Satiric Dancer*, 1926

177

The Pursuit of Excellence

Over the altar of a church in Venice hangs a Renaissance painting that is clearly a masterpiece. For 100 lire (16 cents), a tourist can put on earphones and listen as the recorded voice of an art critic explains the significance of the work—and announces, "This is the greatest painting in the world." Such a reckless statement might lead the knowledgeable tourist to ask for his 100 lire back. And yet, despite the fact that works of art cannot be ranked on any absolute and universally acceptable scale, like diamonds or eggs, judgments of artistic merit are continually being made. The photographer, whenever he looks through his viewfinder or examines his negatives in the darkroom, must choose one picture out of all the possibilities; he must be able to decide which exposures are better than others—and understand, intuitively or logically, why. If he cannot employ principles of photography to recognize excellence, he can never make a good photograph—except by luck.

This book has approached the difficult question of gauging success in photography by exploring the principal options involved in creating a picture. Every object to be photographed can be analyzed for a number of characteristics. It may exhibit one or more of the basic components of vision —such as shape, texture, form and color—and the components can be arranged within the picture frame to generate visual interactions that suggest such qualities as balance, rhythm, proportion, dominance and subordination. Arrangements of visual elements can be (and generally are) manipulated to show a certain response on the part of the photographer— that is, his interpretation of the meaning of the subject. The photographer also may indicate his intent through his representation of a sense of time—a cleverly seized instant of action, for example, or a randomly chosen moment —or he may achieve his purpose by his basic approach to photography, choosing either the orthodox idea of photographs as small, flat objects that depict reality by recording light on film, or some newer scheme such as scratching on raw film, a process that does not depend on light and disregards reality. All these considerations are analogous to a map of photographic possibilities. The photographer who is aware of the regions described by this map is much more likely to reach his goal of excellence than the one who proceeds blindly into the unknown. The map can indicate a useful way to a destination, even though it cannot set an exact course.

The history of photography is full of attempts to specify more precisely the best course for making pictures. Two of the most prominent schools of thought have been the so-called pictorialist and purist approaches. The pictorialists, who exerted a good deal of influence during the 19th Century, held fixed opinions about what a photograph should show and how it should be shown. They shared the artistic concepts of painters of their time, and they could be downright vehement in insisting on their tenets; for example, in

1859, Francis Frith, a leading English landscape photographer, advised a beginner that "if he be possessed of a grain of sense or perception, [he] will never rest until he has acquainted himself with the rules that are applied to art . . . and he will make it his constant and most anxious study how he can apply these rules to his own pursuit." The pictorialists believed photographs should have a dramatic center of interest and should be as tasteful as paintings and prints of the time, leading the viewer's eye through the image in a lively manner, but all the same giving a comfortable feeling of stability. They also had strong opinions about the ideas to be conveyed, preferring mythological themes, sentimental visions of family life, idyllic landscapes and other subject matter far removed from everyday reality. And their technical procedures—employing soft-focus lenses, hand-manipulated prints and many other techniques—made their images unlike those of normal vision but much like those in paintings.

The purists, reacting to the excesses of the pictorialists, adopted a completely different set of canons. They insisted that a photograph show what human vision would see under technically ideal conditions: everything perfectly sharp and clearly positioned in space (humans do not normally see that way, of course, any more than they normally see the fuzzy, sweet visions of the pictorialists). Techniques that brought such results influenced content and interpretations; the purists' portfolios are full of sweeping landscapes that delineate every texture and tone, and calm portraits that reveal each pore in the subjects' faces.

Both the pictorialist and purist approaches yielded great pictures. Their systems of photography worked, because gifted creators were able to meld visual ingredients, meaning and design into intelligible, concerted wholes —regardless of which set of rules the photographer chose to work with. The portfolio of pictures on the following pages presents an array of routes charted across the map of options. Here is the art of photography, as practiced in the 20th Century, working its spell of communication in a variety of ways. Perhaps the creative thrust behind each picture can only be described by the mysterious term *genius*—but the fundamental principles exhibited by the pictures are both explainable and universally available. ☐

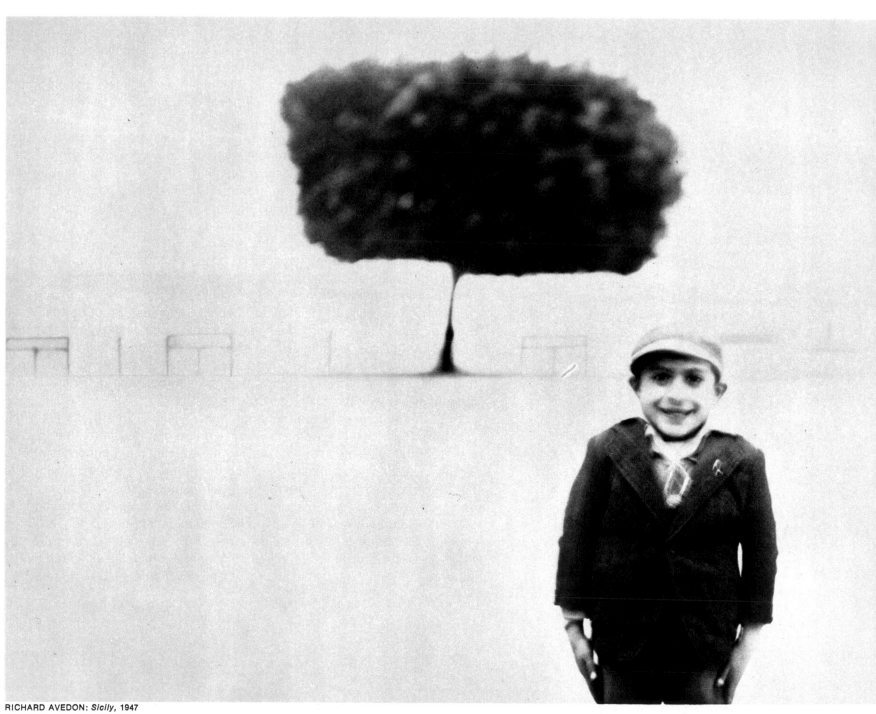

RICHARD AVEDON: *Sicily,* 1947

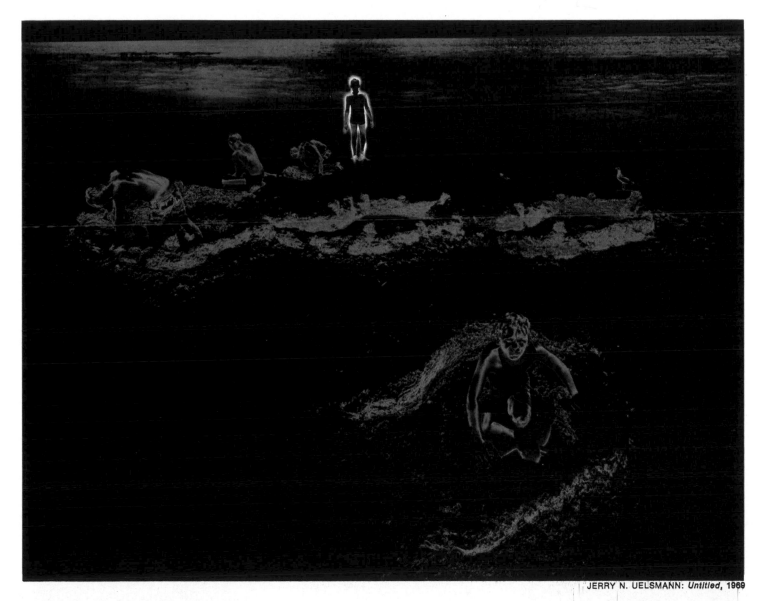

JERRY N. UELSMANN: *Untitled,* 1969

◄ *In the picture of a Sicilian boy, opposite, a feeling of strangeness and foreboding is purposely conveyed by what appears to be a breakdown in the photographic process. The makings of a happy, rather ordinary snapshot are here—an eagerly posing boy, a tree, a fence—but the result is a grainy, overexposed image so blasted by light that all material things seem on the verge of being dissolved. The viewer can only conclude that something is wrong—but does not know what.*

Everyday reality is again altered in the scene of children playing on the beach, above. The photographer solarized most of the print, briefly exposing it under a bulb in development to make light areas become gray, as on a negative. An aura of light surrounds the boy in the background—an effect achieved by masking this area during solarization. The end result of this darkroom doctoring is an image of mystery, setting the viewer off on a search for meaning.

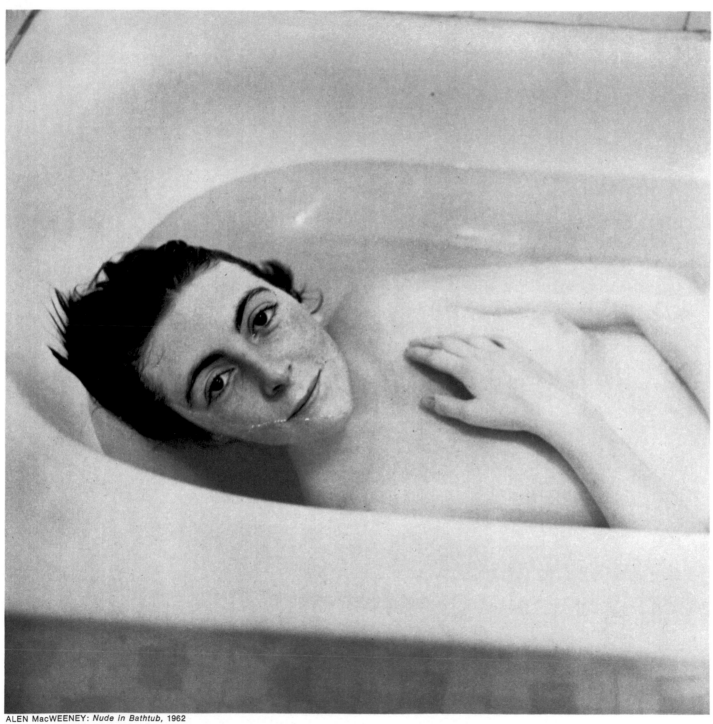

ALEN MacWEENEY: *Nude in Bathtub*, 1962

◄ In the bemused study of a woman in a bathtub, opposite, gently curved shapes proliferate: almond eyes, arched eyebrows, soft body contours, the surface of the water. This quiet interplay is complemented by subtle shifts of tone and by the languid expression of the subject. With the barest hint of a smile, she looks at the photographer, acknowledging his presence but continuing to savor the calm pleasures of her bath.

The figure at right has been beautifully photographed as if to simulate Classical Greek sculpture. The suppleness of the form is suggested by barely detectable gradations of tone. The skin texture is as smooth as marble. And the subject has even been framed for the headless and armless appearance of broken Classical statuary, although, in fact, the body is that of the photographer's son, aged 8.

EDWARD WESTON: *Neil, Nude,* 1924

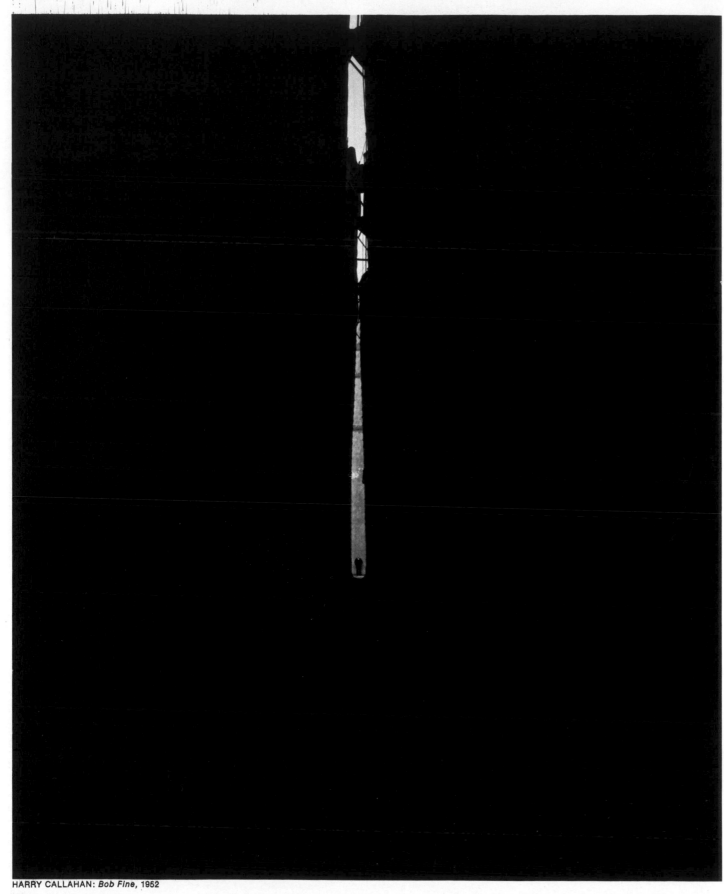

HARRY CALLAHAN: *Bob Fine*, 1952

184

GARY L. PRATHER: *Stable on Route 128*, 1966

◄ The picture opposite violates familiar proportions with a vengeance, reducing a man to a mere speck, dwarfed by two looming grain elevators. But by turning the elevators into areas of blackness, the photographer has ingeniously made the presence of the man apparent, even as he cuts him down to size. There is only one path for the viewer's attention to follow—right down the shaft of light to the tiny figure at the bottom.

The photographer saw only wonderfully clean-lined shapes when he came upon a roadside stable one rainy day while driving north of San Francisco. The glistening roofs appeared to float. He stopped and waited for the rain to let up. Then, shooting in sunlight and exposing to darken everything but the roof, he changed the stable into a structure of angles and planes that seems perfectly self-sufficient as it hovers in a void.

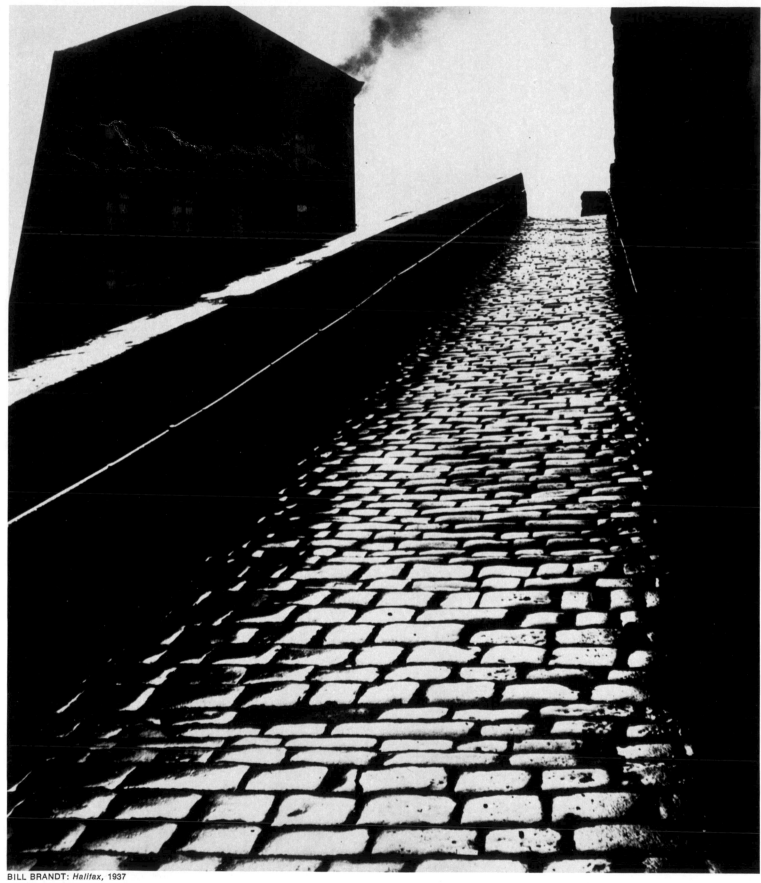

BILL BRANDT: *Halifax*, 1937
186

The Principles at Work: continued

◄ Halifax, in the coal-producing Yorkshire region of
northern England, looks as glossy and black
as anthracite in the picture opposite. High-contrast
printing turned the factory into an irregular shape
without depth, and emphasized the pattern of
the brick roadway. The road leads the eye back
and up into the picture, then appears to pitch off in
space, as if chopped by some sudden ax stroke.

Artistry admits no limits of age. Jacques Henri
Lartigue took the happy photograph at right
in 1904, when he was eight years old. Although the
balloon has just been tossed up by his nanny,
it could be rising, falling or hovering. The picture
Is so neatly balanced that the latter seems
most likely to be true, imparting a sense of airy
lightness entirely appropriate to the mood.
Lartigue did indeed shoot at the moment the
balloon reached the peak of its flight, for only then
would it be motionless—so still it would not
blur in the long exposure his slow film required.

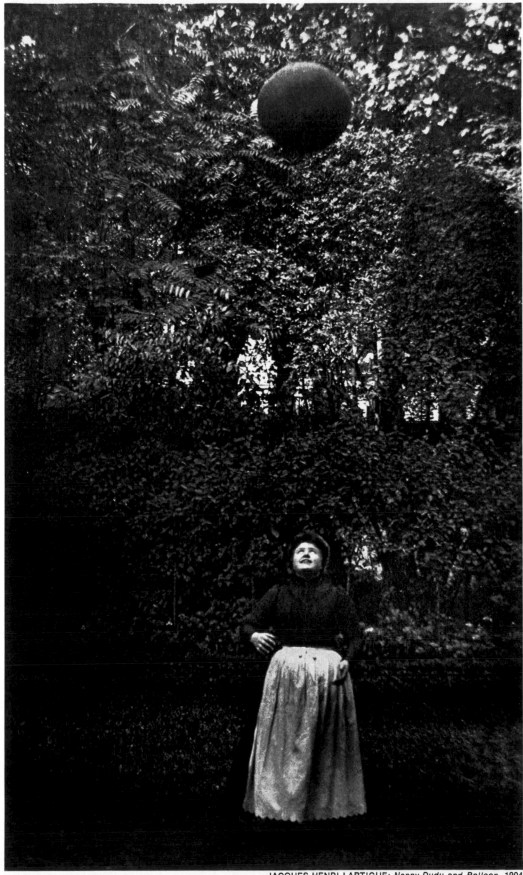

JACQUES HENRI LARTIGUE: *Nanny Dudu and Balloon*, 1904

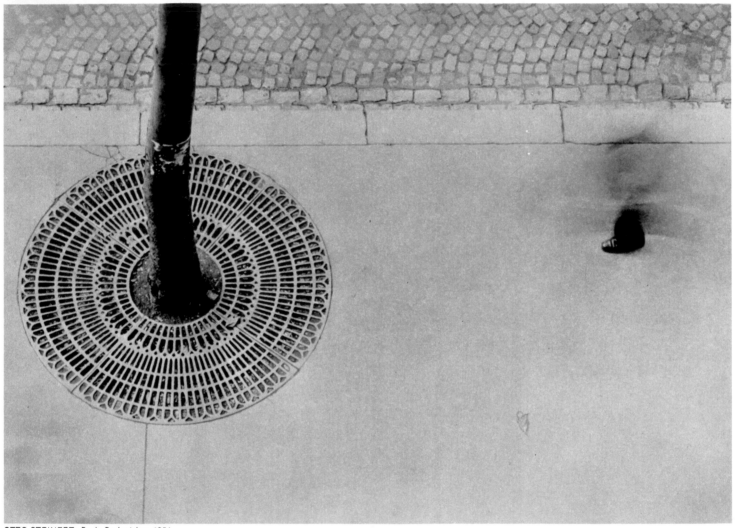

OTTO STEINERT: *Paris Pedestrian*, 1951

A pattern of radiating lines and concentric rings is given highest priority in the picture above. It is first stated strongly by the protective grid at the base of the tree, then echoed weakly by the bricks of the street. The passing pedestrian might have figured more prominently in the picture if he were completely visible, but he is blurred, except for one foot, by a ¼-second exposure—a footnote that makes it clear he will soon be gone from the scene but the arresting pattern will remain.

A dazzling study of form is presented in the ▶ picture opposite, which establishes a complementary relationship between a tree and the surrounding valley. The cylindrical form of the trunk (just enough of the leafy top is shown to indicate the tree's identity and scale) and the ring form of the valley are concentric, conforming to each other. Seen together, they suggest the energy latent in a carousel, for the valley appears ready to spin around the axis of the trunk.

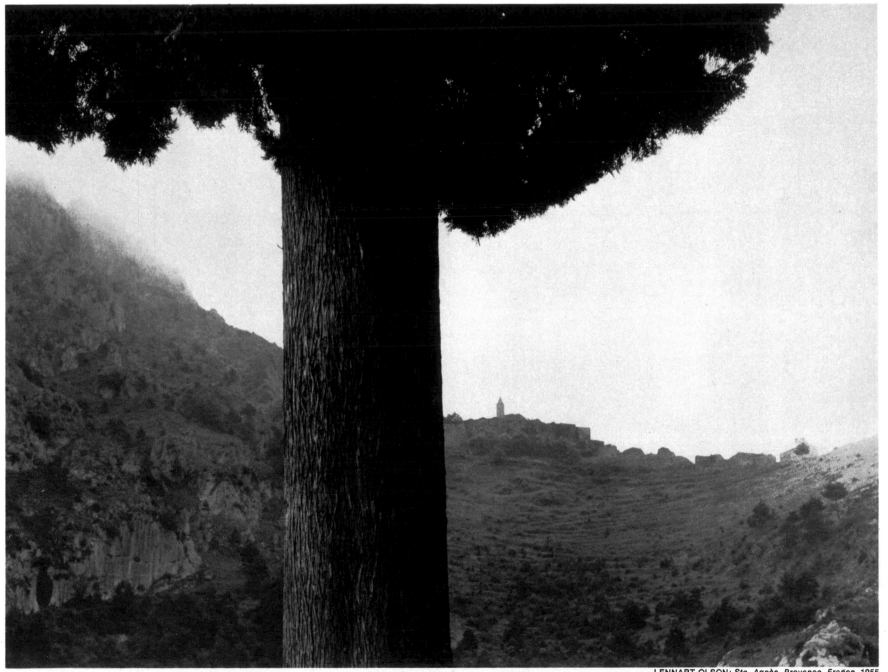

LENNART OLSON: *Ste. Agnès, Provence, France, 1955*

HARRY CALLAHAN: *Ivy Tentacles under Glass, 1952*

Pattern is the primary visual ingredient in this composition of ivy tentacles, photographed on a pane of glass placed over lighted white paper. The picture's communication is very restrained, denying the viewer everything except endlessly repeated gray-black squiggles upon the white background. The reward of such economy of content is great because the subject is seen and savored with a clarity that would be lost if there were any distractions present.

As in the scene above, shapes repeat themselves ▶ to form a pattern in the picture opposite—not for reasons of economy but to charge the subject with the emotion felt by the photographer. The men are recruits training in Biafra during the 1968 revolt against Nigeria. By using a long lens to crowd and flatten their forms, the photographer has deliberately robbed them of individuality and shows them as a mass of anonymous, interchangeable men huddled together for warfare.

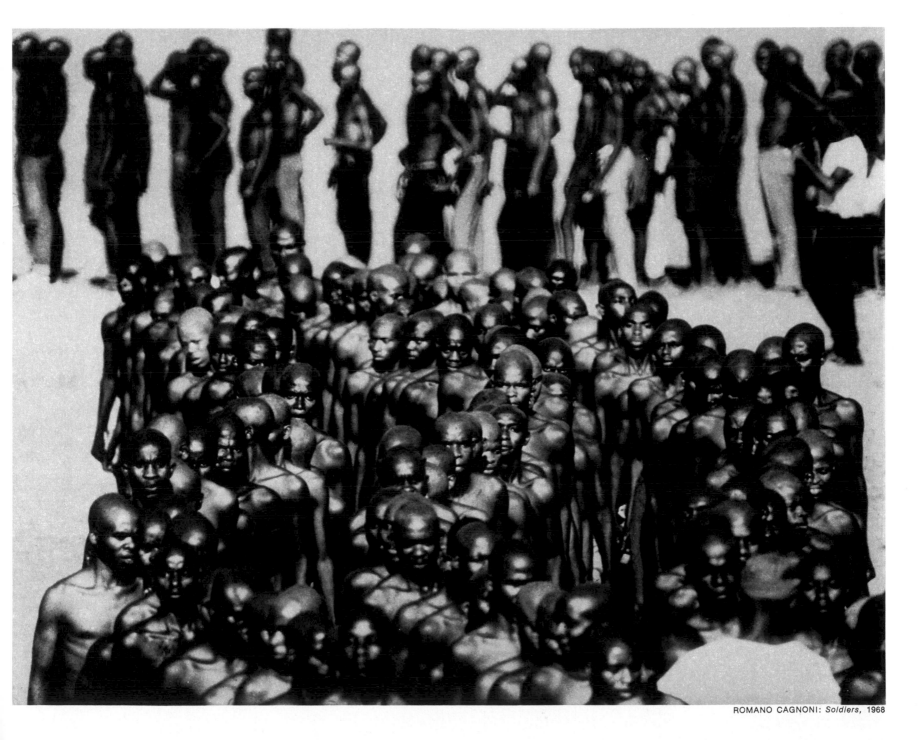

ROMANO CAGNONI: *Soldiers*, 1968

At left, André Kertész confronts the viewer with a paradox: a still life with a highly expressive gesture implied. The tulip droops like a ballet dancer bidding a farewell to an applauding audience. Although the metaphoric gesture does suggest fatigue, it is extremely graceful—an impression reinforced by a rhythmic organization. Four stages of decline are evident: the upright leaf at the top of the vase; a second, horizontal leaf; a third, drooping one; and finally the down-pointing stem, which completes the rhythmic flow.

An indomitable personality is captured in this ▶ portrait of Isak Dinesen (opposite)—the Danish baroness whose long career ranged from farming and nursing in Africa to writing world-famous Gothic tales. Proportion conveys the photographer's response: by aiming upward, making the head seem imperiously perched atop the great bundle of a wolfskin coat, Richard Avedon suggests Miss Dinesen's outsized spirit.

ANDRÉ KERTÉSZ: *Melancholy Tulip*, 1939

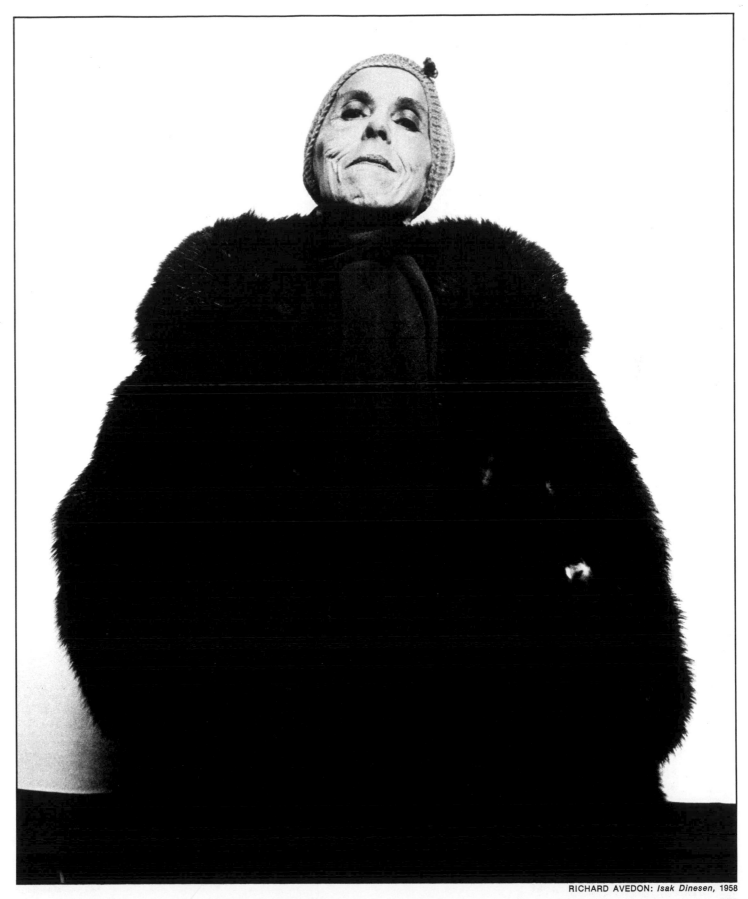

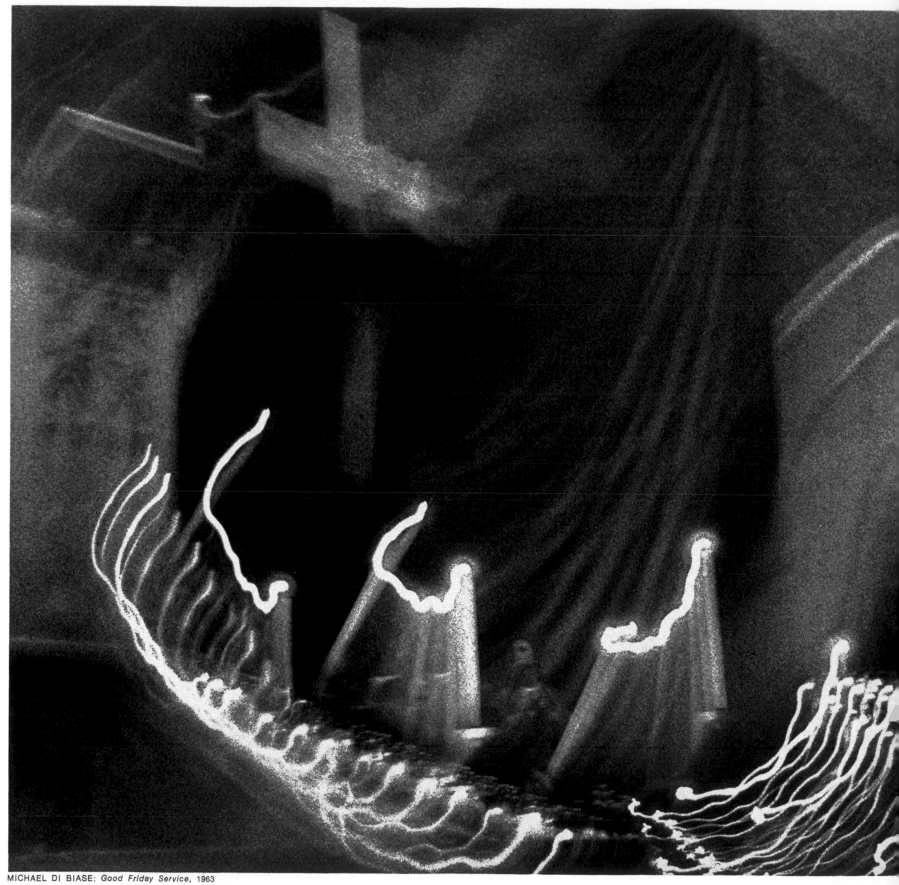

MICHAEL DI BIASE: *Good Friday Service*, 1963

WYNN BULLOCK: *Unmarked Graves*, 1969

In a photographic transubstantiation of matter into spirit, the interior of a church becomes a world of whispered shapes and strange traceries of light. The photographer exposed for about two seconds to record the Cross and the dim archway; then, before closing the shutter, he quickly moved the camera to one side so that the flames of the candles would draw trembling patterns on the film.

In the picture of graves above, substance has been infused with spiritual meaning by the photographer's response. He presents opposing symbols of life and death: the bright, fresh magnolia blossom against dim gravestones. To him, death is as much a part of nature as the living flower, and even the gravestones have been made to look like uncut rocks.

Powerful emotions of childhood freedom and loneliness are evoked by a picture that looks like a slice of reality at first glance, although almost too orderly to be true. In fact, it deliberately seeks to generate the deep, disturbing feelings of a dream by a representational approach that seems somehow wrong. True: this is a composite, made by pasting several prints together. The swinging boy and the grass in the foreground were printed from one negative made at a park. The houses were printed from another negative made in a provincial town. Looking closely, the viewer realizes that the houses on both sides of the picture are the same image; the negative was printed once, then flopped and printed again. The right side has been made dark in printing to simulate shadows and conceal the visual trick.

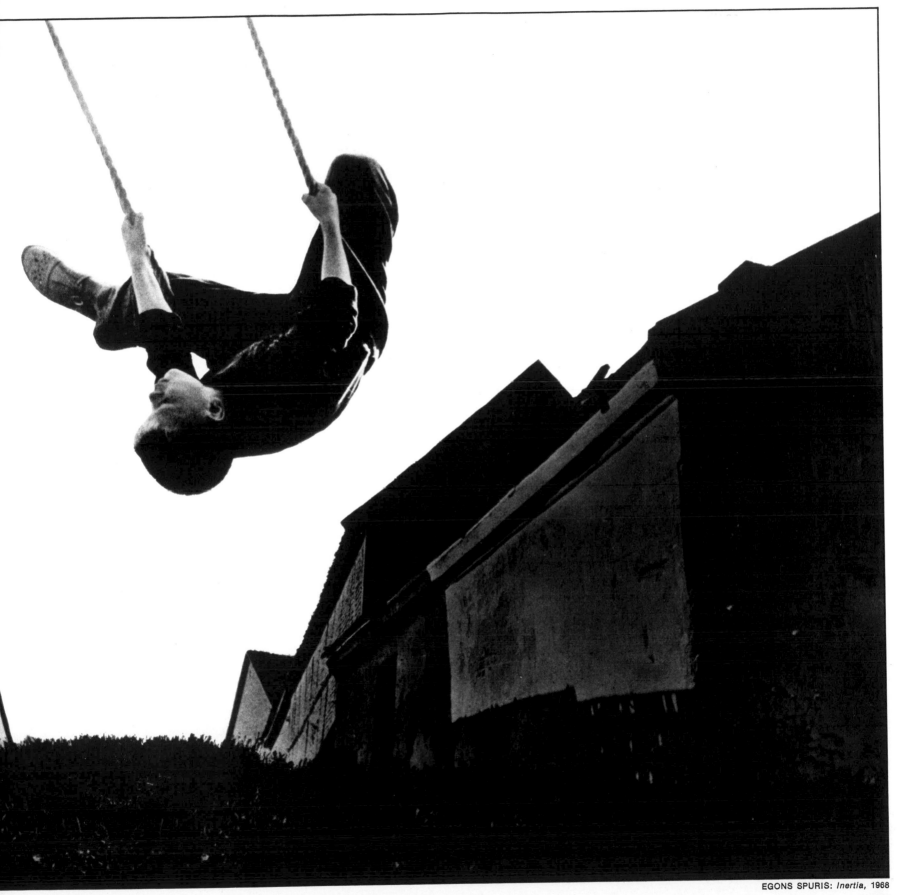

EGONS SPURIS: *Inertia,* 1968

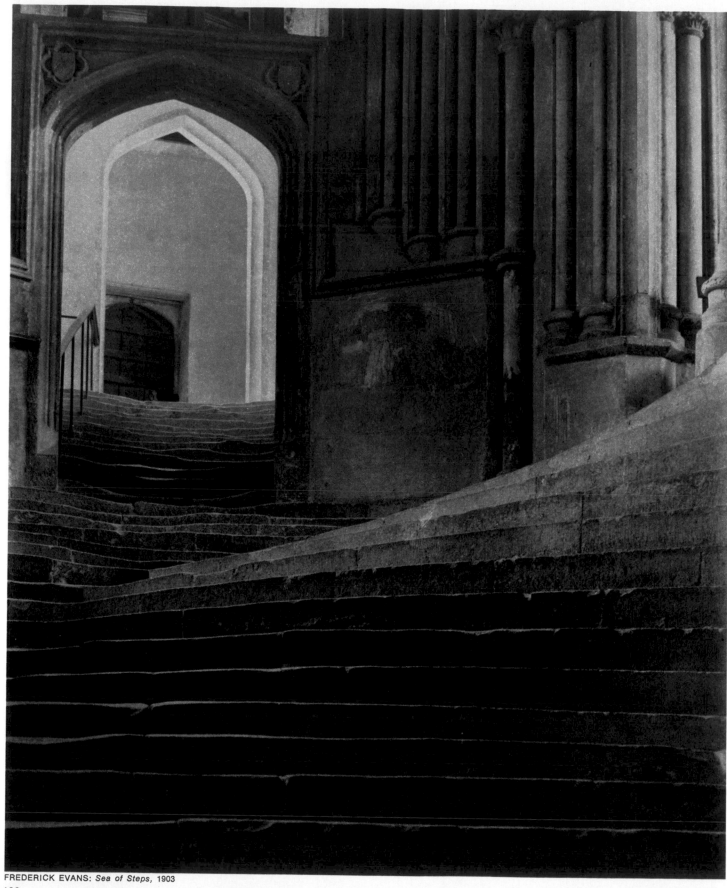

FREDERICK EVANS: *Sea of Steps,* 1903

198

◄ *Carefully orchestrated rhythms give the picture of a stairway in Wells Cathedral, England (opposite), the surging flow of an ocean swell. Almost everything in the scene displays gradual modulation: the receding steps grow smaller (due to perspective) and narrower (due to the constraints of the archway); the angle of the steps on the right rises steadily toward the perpendicular; the vertical pattern of the columns at top narrows as it nears the archway; and the archway itself turns out to be many arches, growing smaller as they lead into the distance.*

The visual attribute of form is ingeniously explored (right) in a picture of a massive boulder squatting beside the adobe wall of a church in Taos, New Mexico. The three-dimensional curvature of the boulder is not revealed by any graduated tones of sidelighting—as in a conventional treatment—but by the curved outline of a shadow falling across it. The density of the forms is also treated in a provocative manner. The photographer, by shooting the picture in the soft light just after sunrise, gave the adobe walls an appearance of pliability. The most solid-looking element—the black shadow near the center—is one that, in fact, has no substance, thus inducing the viewer to look again at the picture to understand the real nature of the forms.

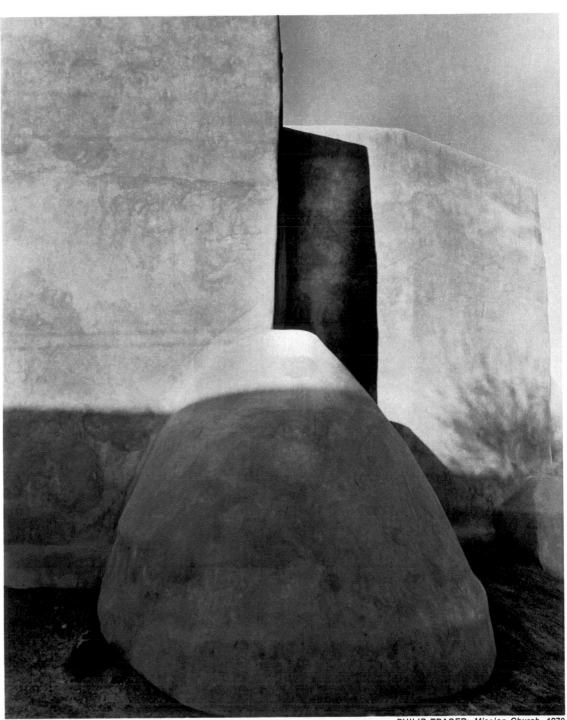

PHILIP TRAGER: *Mission Church,* 1970

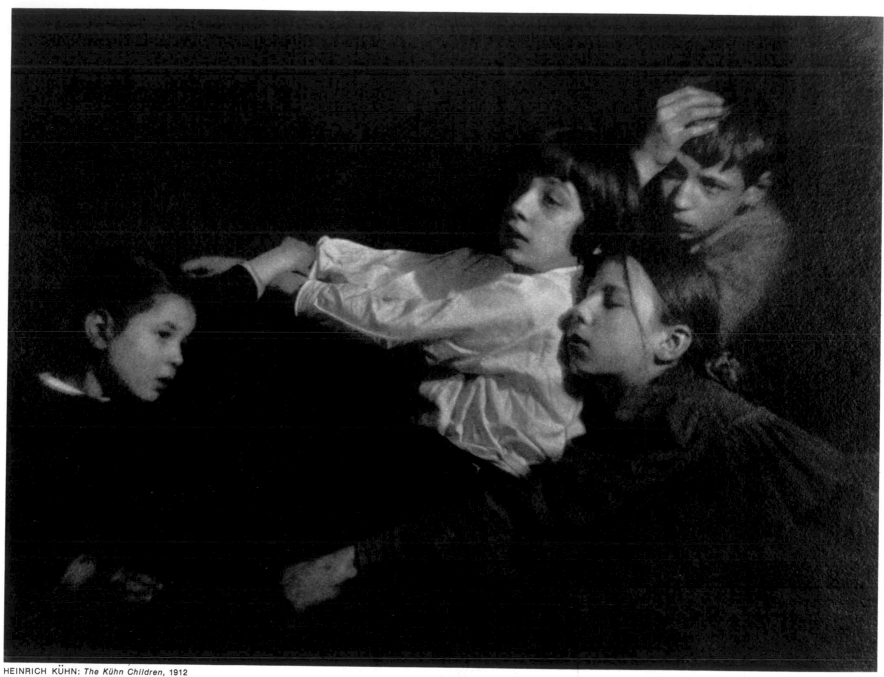

HEINRICH KÜHN: *The Kühn Children,* 1912

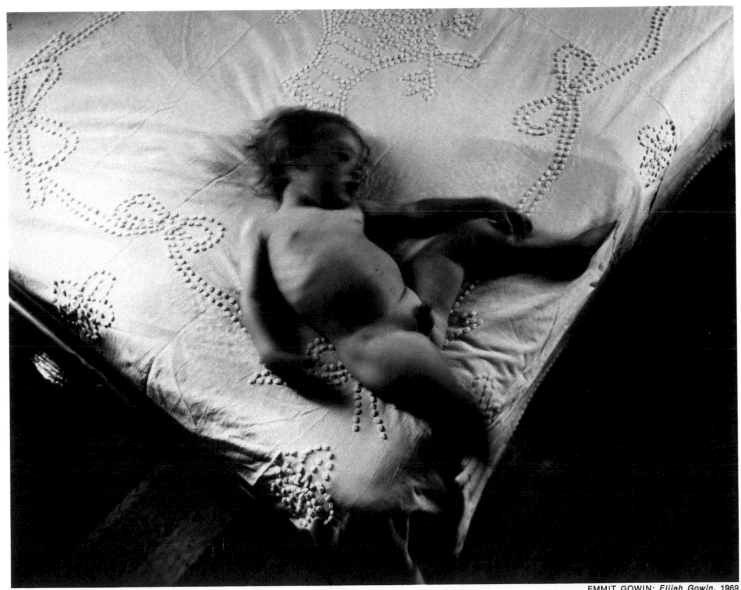

EMMIT GOWIN: *Elijah Gowin,* 1969

◄ Heinrich Kühn's portrait of his children was clearly inspired by the dreamy moods and stable but lively designs often seen in 19th Century painting. The thoughtful expressions of the children set the theme of deep family feelings. And by having the children tug each other toward the center of the picture, the photographer has constructed a well-knit, yet elastic, design—and at the same time suggested the family's closeness.

In photographing his infant son, Emmit Gowin created an image remarkably like a cherub painted on a Baroque ceiling. Here, balance and an illusion of movement are simultaneously achieved. The corner of the bed is framed to make the halves of the picture almost symmetrical. But the swirling arrangement of the baby's limbs—and the slight blur caused by a long exposure—lend great liveliness to the formal design of the scene.

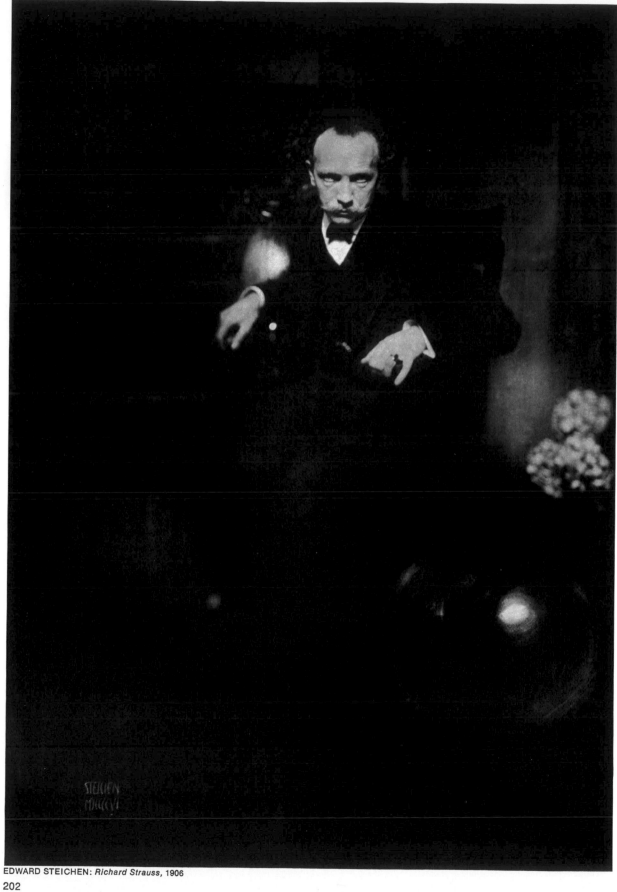

The photographer's assessment of the character of his subject is instantly apparent in this portrait, which catches the German composer Richard Strauss leaning forward with a fixed and belligerent stare, like a lion ready to spring. The almost unbroken expanse of blackness surrounding Strauss adds to the impression of tremendous force, barely held in check.

EDWARD STEICHEN: *Richard Strauss*, 1906

Bent with fatigue and despair, an unemployed British miner plods homeward with a scavenged bag of coal. The photographer's vantage point and instant of exposure were chosen to frame the man against the light-toned path so that his hunched posture would be clearly outlined. The theme of misery is reiterated by the landscape —dark, treeless and overhung by a sooty sky.

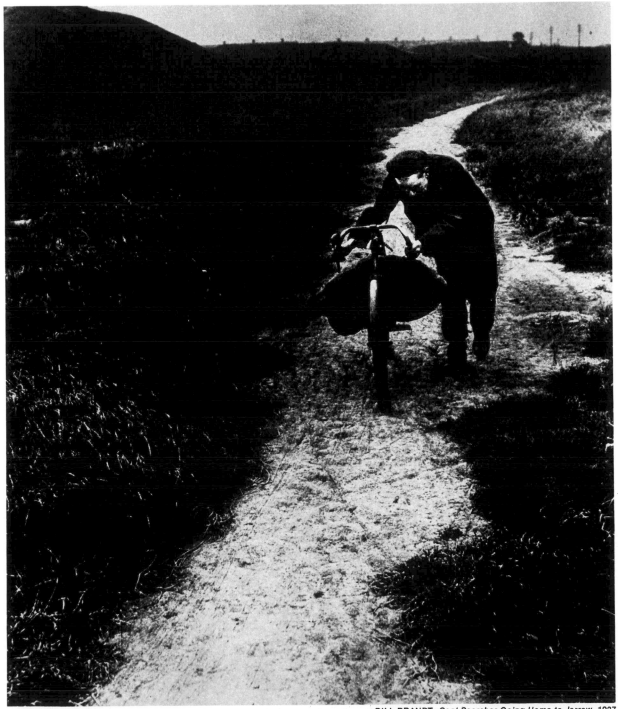

BILL BRANDT: *Coal Searcher Going Home to Jarrow, 1937*

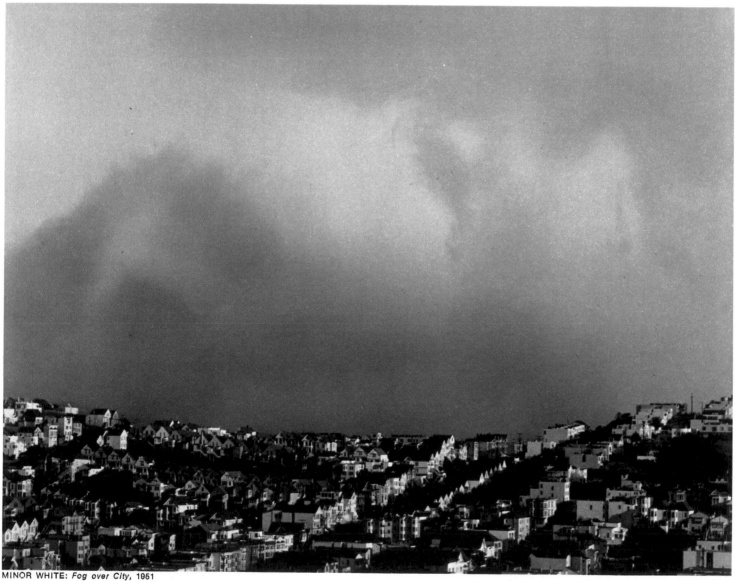

MINOR WHITE: *Fog over City,* 1951

Either city or sky could be the protagonist in
the picture above, but the real hero is light—bright
and directional on the houses, gloriously soft on
the approaching fog bank. To give full due to the
gentler play of the light on the fog, the sky is
proportionally larger. The photographer also
subdued the city (San Francisco) by shooting
from a great distance with a long lens, avoiding
any distracting details of people or traffic.

An aspen grove in Colorado is enshrined in a ▶
photograph that exploits the repeated forms of the
tree trunks. The photographer shot at twilight to
avoid shadows that might have vied with the
vertical pattern, and stopped his aperture down to
f/4.5 at one second to obtain maximum depth
of field. As a result, the trees appear to recede
endlessly; the viewer is invited to step into
the picture frame and to walk deep into the grove.

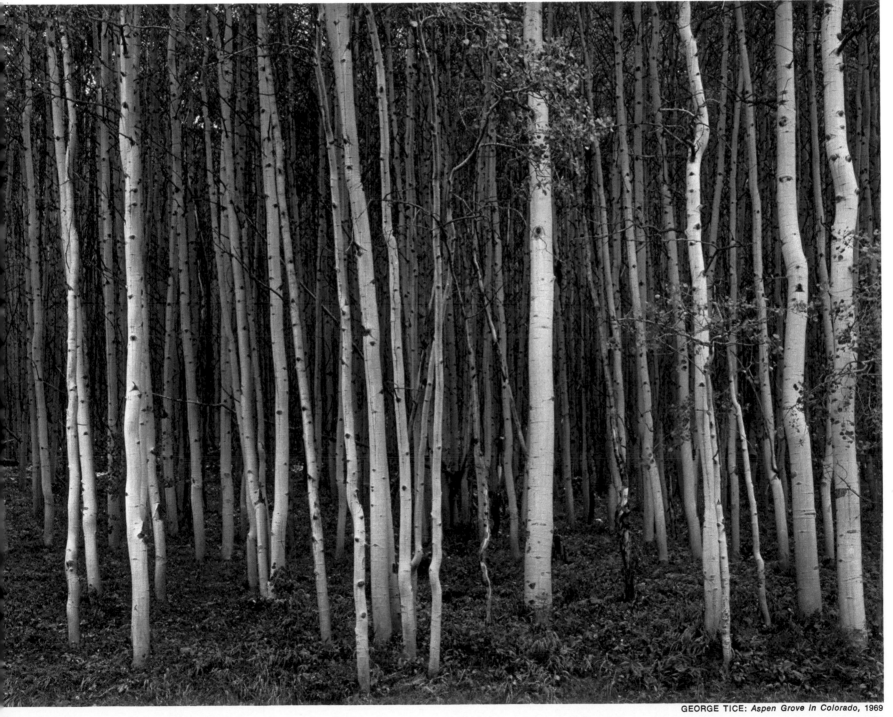

GEORGE TICE: *Aspen Grove in Colorado,* 1969

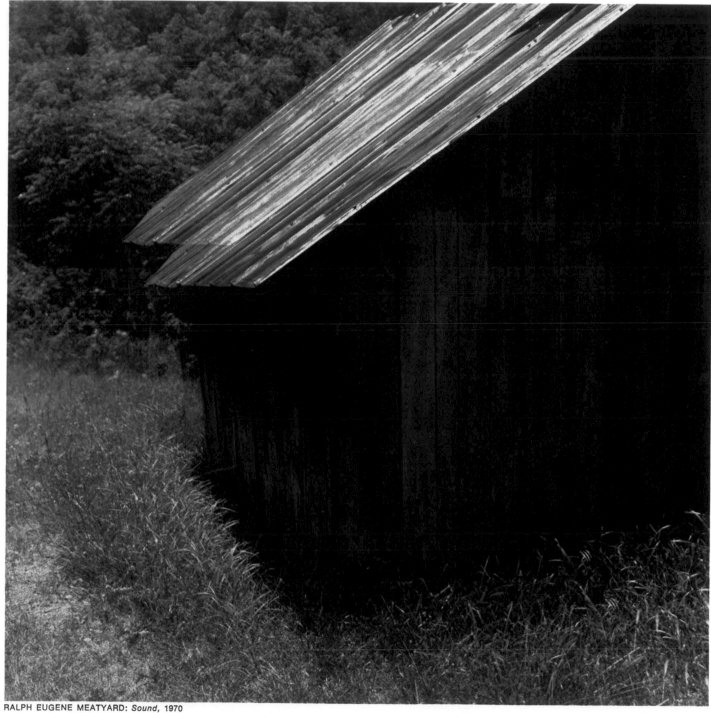

RALPH EUGENE MEATYARD: *Sound,* 1970

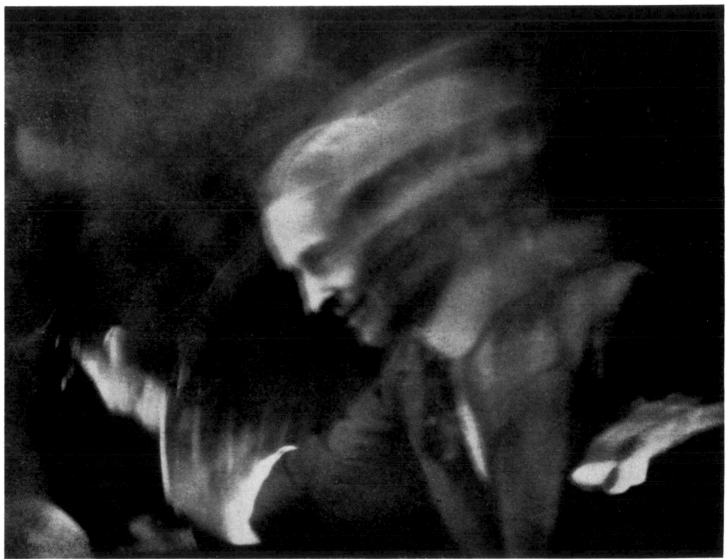

ANTON GIULIO BRAGAGLIA: *Greeting,* 1911

◄ *The concept of photography as a visual recording technique is shattered in a most direct manner by the picture opposite. It consists of two exposures of a shed made from slightly different vantage points. Rather than recording, the camera has been used to set in motion something that never existed. The photographer's term for it is "visual sound"—vibrations created by the overlapping images of the wooden siding and roof, and by the wavelike motions in the grass.*

The principal visual ingredient of the picture above is a shape that the camera could see much better than the eye—the shape of a gesture, captured in a time exposure as a man smiled, bowed and made a sweeping motion of salutation. The photographer, Anton Giulio Bragaglia, originated a photographic philosophy he called "Fotodynamics" (an offshoot of Futurist art), whose esthetic purpose he summed up by saying: "We consider life as pure movement."

207

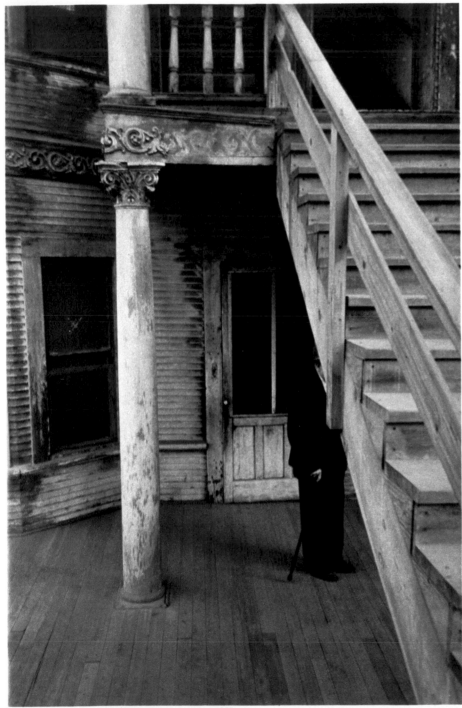

The photographer deliberately avoided catching a visual crest of interest in the picture at left, choosing to expose instead at what seems to be a random instant, with the old man partly hidden under the boardinghouse stairs. Such depiction of "random" time conveys an ordinary, uncontrived sort of perception. And by leaving out something expected—the head of the subject, in this case—it jolts the viewer awake, just as sudden silence can disturb a city dweller used to constant noise.

In a portrait of the novelist Aldous Huxley, the ▶ subject is again half-hidden—but not, as at left, in an effort to convey casual perception. Here, the cleverness and pithy statement are paramount. Huxley, a scathing satirist, is shown spying on the world with one bespectacled eye—and quite ready to dive back into hiding. The photographer placed a light behind Huxley so his shape could be seen through the thin curtain, suggesting that he will be there watching and listening even when the curtain is closed.

ROBERT FRANK: *Rooming House in Los Angeles*, 1955

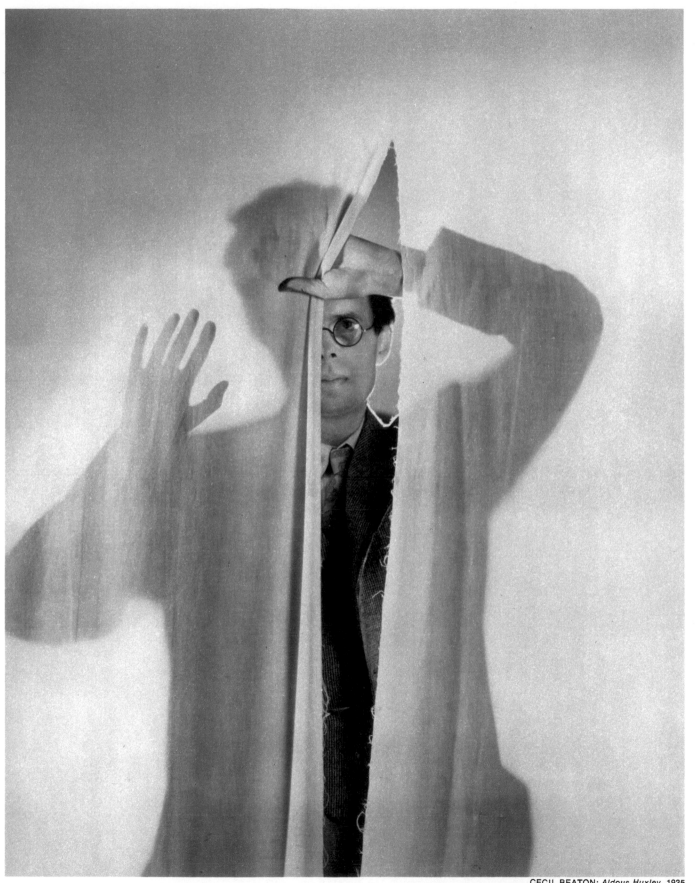

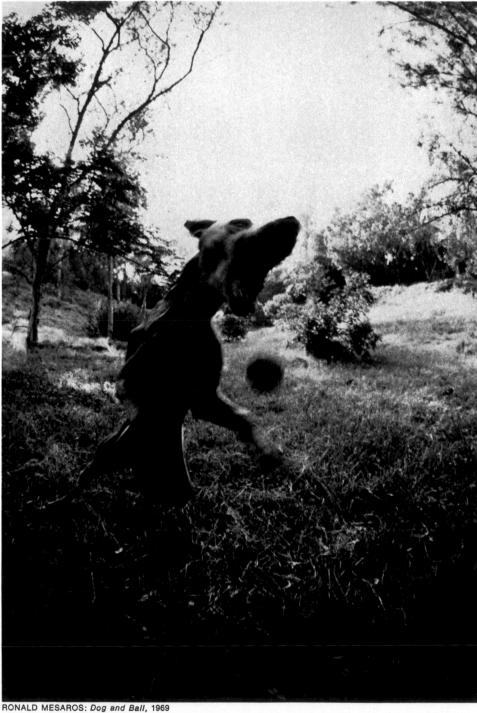

Lunging with snapping jaws and taut muscles at a tossed ball, this dog seems an embodiment of violence even in its moment of play. Two design decisions were crucial to the meaning of the picture: the photographer's use of a wide-angle 18mm lens on his 35mm camera to make the muzzle disproportionately large and terrifying; and the selection of a rather slow shutter speed (1/60 second) to blur the motion somewhat, suggesting the animal's inescapable quickness.

A portrait of the actor James Dean, made in ▶ the year of his death, is brilliantly composed to suggest a personality full of contradictions —boyish and manly, polite and wild, sensitive and tough. Although Dean is dressed in rough clothes and the setting seems to be a gloomy alleyway, the organization is formal and almost symmetrical, with the subject placed in the center of a diamond-shaped frame of light and shadow. Two other dualities: his face is halved into light and darkness; and his head is shown both straight on and in profile—the shadow cast on the wall.

RONALD MESAROS: *Dog and Ball*, 1969

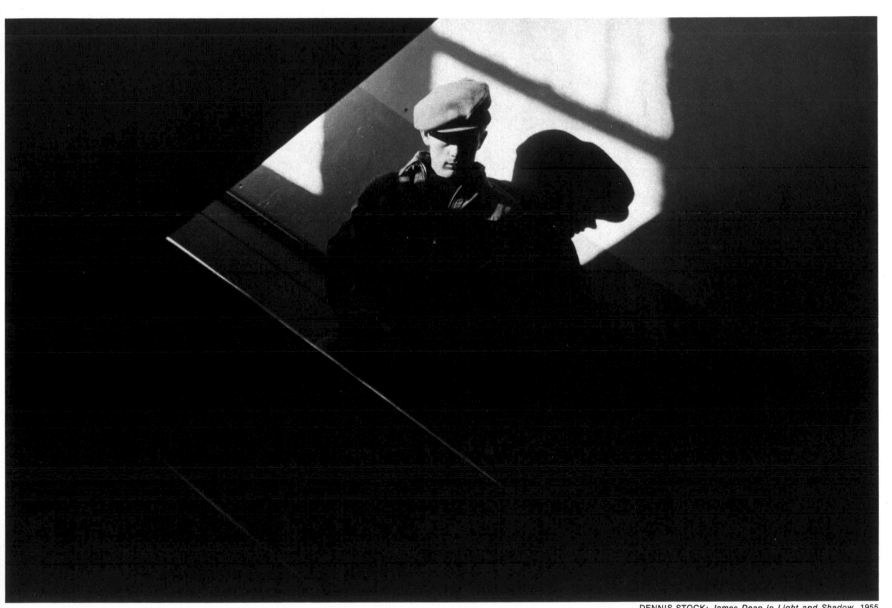

DENNIS STOCK: *James Dean in Light and Shadow*, 1955

A seemingly cursory glimpse of a London street generates a powerful sense of isolation. There is no dominant center of interest, nor is any comprehensible event shown. The photographer has established three more-or-less-equal points of interest with no real connection between them. One is the girl inexplicably running down the sidewalk; the eye is drawn toward her by the strongly stated perspective of converging lines. A second focus of interest is the trash collector, brought to the viewer's attention by being framed in the rear window of the hearse. And the third is the hearse itself, which disturbs the viewer by its implication of death—though it is almost callously ignored by the two living people in the picture.

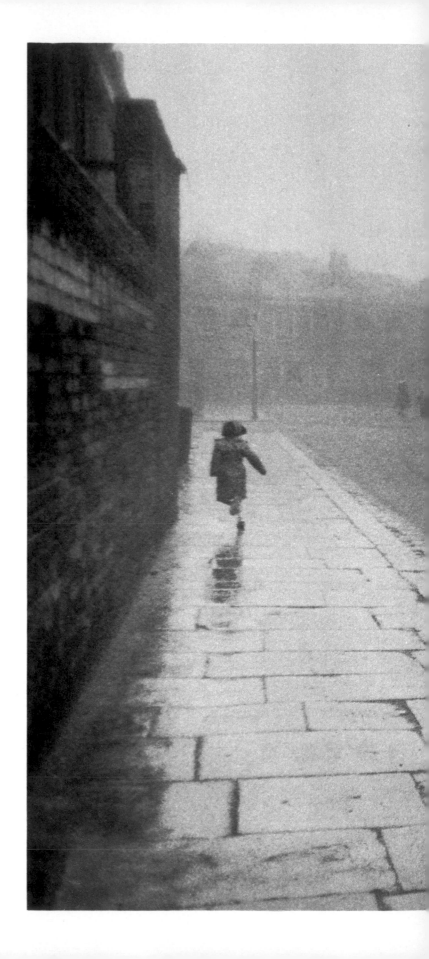

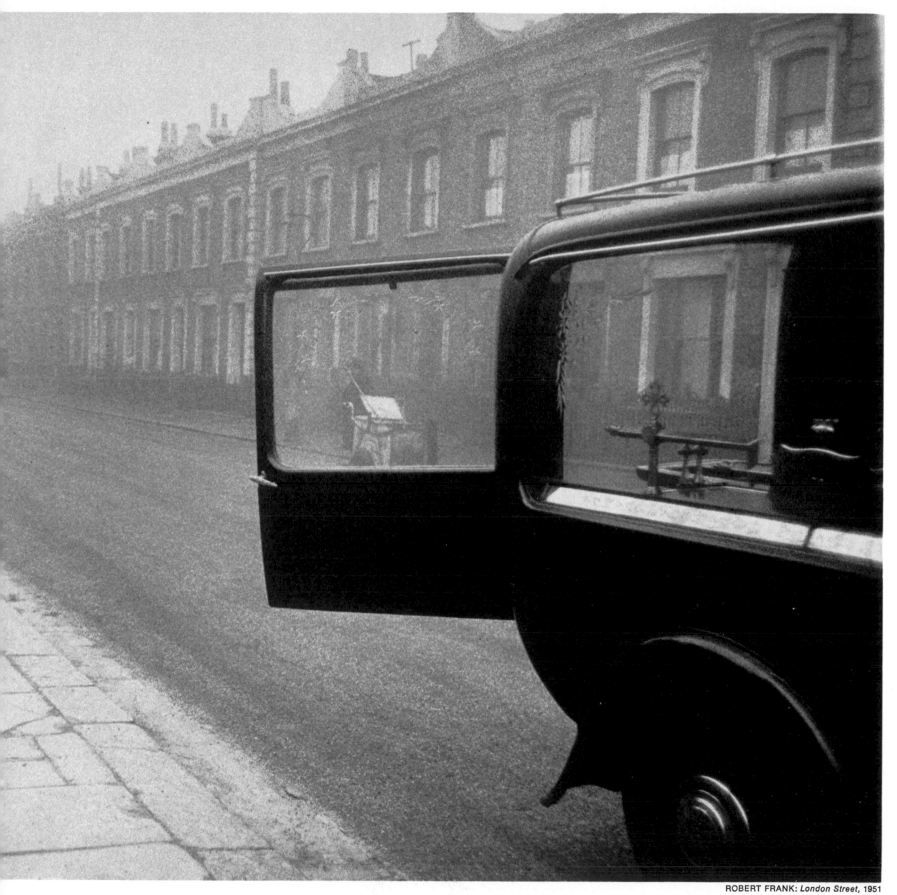

ROBERT FRANK: *London Street*, 1951

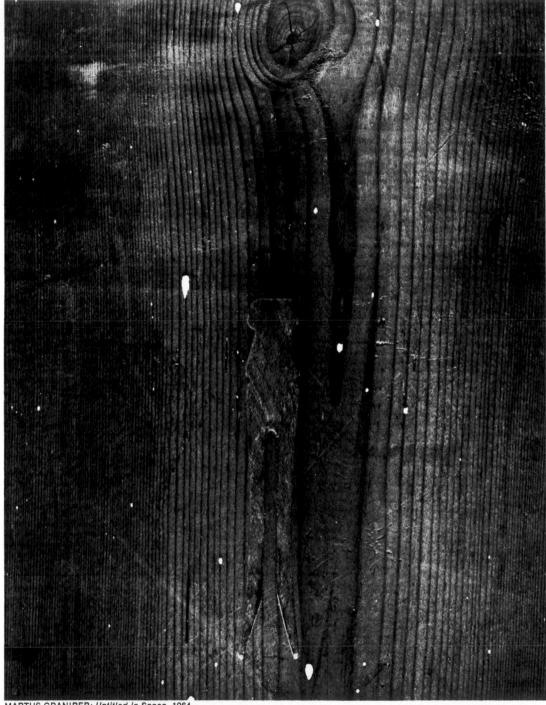

An effort to force the viewer from casual glimpse to a realization that all things are not what they seem, this photograph at first is reminiscent of the portrayal of the tree trunk on page 47. It appears to be another straightforward study of texture and pattern. Yet, while it relies for its identity on similar efforts to capture "woodiness," it is not so simple. The viewer discovers on close inspection that there is a clothespin at center, its own grain and line camouflaged by the grain of the wood.

Celebrating the majestic look of a lake high in ▶ the Sierra Nevada, the picture opposite presents a remarkable array of textures—the craggy, roughhewn cliff, the soft sand, the crystalline ice and the mirrorlike smoothness of the water. It also displays impressive shapes and great tonal range —further testimony to the bounty of perceptual ingredients to be found in the natural world.

MARTUS GRANIRER: *Untitled in Space*, 1964

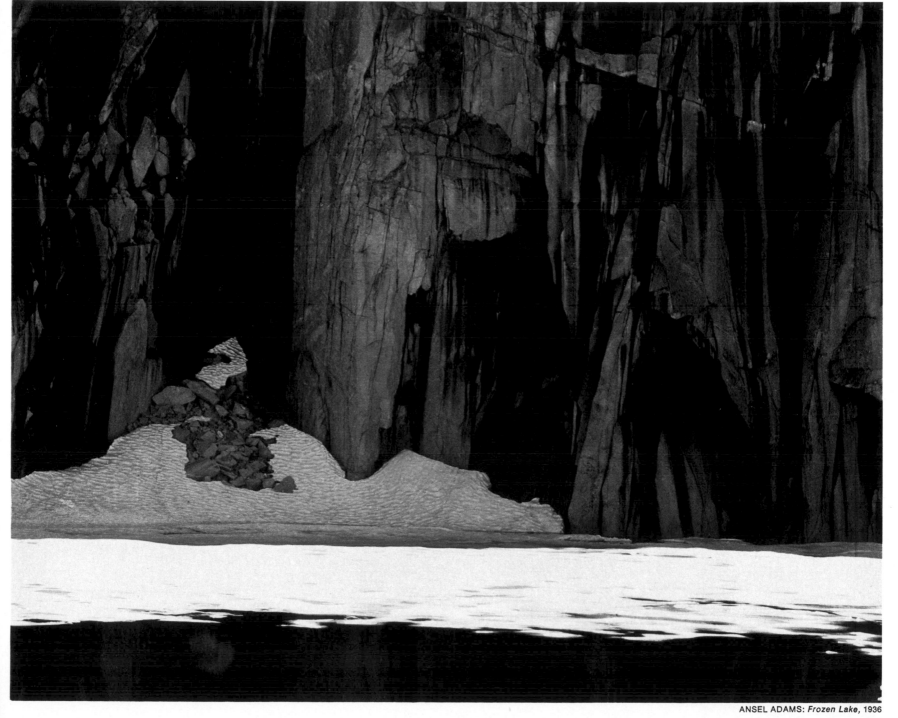

ANSEL ADAMS: *Frozen Lake*, 1936

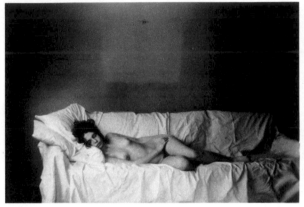
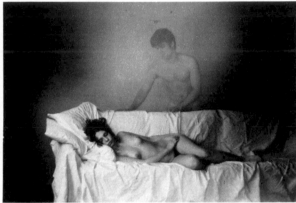
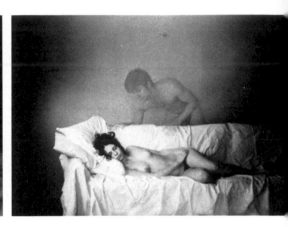

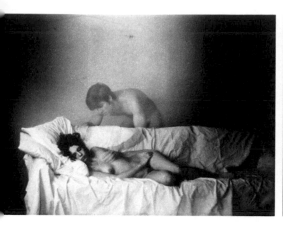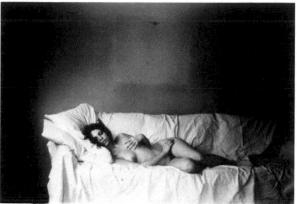

Exploring realms of fantasy and the supernatural in these sequences, Duane Michals traced the comings and goings of ghostly figures by multiple exposures and blurring of motion. The upper row of images represents a sleeping girl's erotic dream: a lover appears, touches her—and she awakens, with kindled desire. The lower sequence is a myth of dying: death, personified by a sedate elderly man, calls upon an old woman; after delivering his summons, he fades away—and suddenly the woman starts to dematerialize too. Both sequences possess a deceptively simple quality, but are full of technical skill and such subtlety as the use of progressively more intimate framing in the fantasy about death.

DUANE MICHALS: *The Young Girl's Dream*, 1969

DUANE MICHALS: *Death Comes to the Old Lady*, 1969

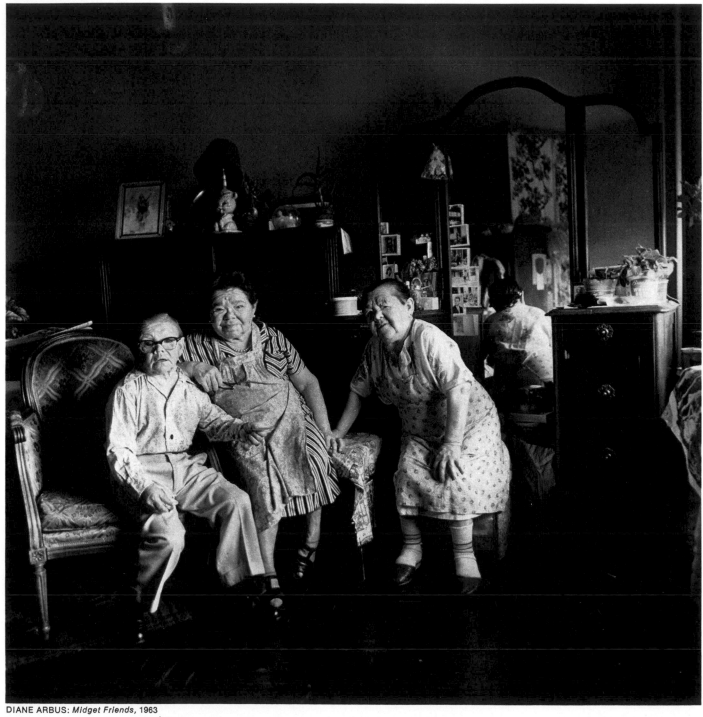

DIANE ARBUS: *Midget Friends*, 1963

The woman midget at center rests her hand on the man's shoulder, leaning confidently toward him, while the woman at right inclines toward them. By this artful arrangement of forms, the photographer clearly established her response to the subjects. The viewer senses at once that there is a relationship between the people (and they are, indeed, good friends—all belonging to a troupe of midgets who first came to America in 1923 with a circus). The sense of warmth indicated by the pose overrides any inference of freakishness; these are human beings who happen to be small.

Entitled Madonna, the picture of a mother and child at right gains an iconlike quality from the rigid stances and silhouetted profiles. There is even a halo of sorts around the woman's head, formed by the curved top of the window. The photographer has highlighted and framed the picture—and accentuated the rigid pose simply by bending some of the Venetian blinds.

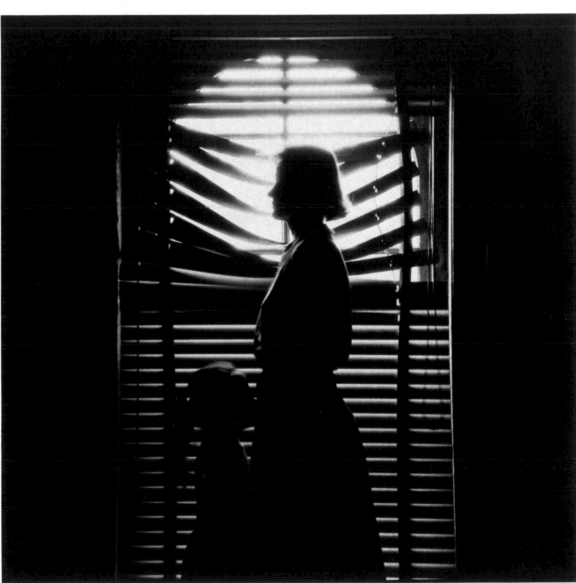

RALPH EUGENE MEATYARD: *Madonna,* 1969

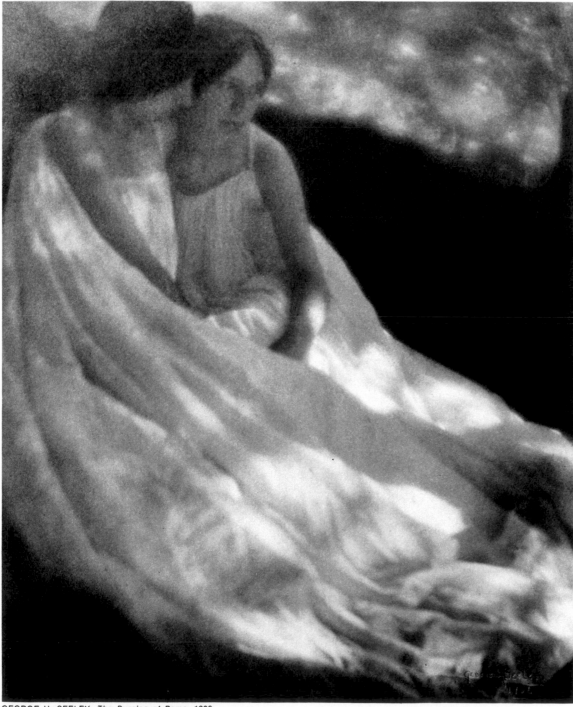

Soft focus and subtle gradation of tone aid in the expression of a classical subject—two women photographed to suggest they are watching the burning of Rome. In the pictorialist tradition of simulating 19th Century painting, the photographer's response to the subject is highly romantic—and is expressed in the languorous pose of the women, the almost liquid flow of their gowns, and the lambent light (presumably from flaming houses) playing over the scene.

At the opposite pole from romance, the picture of ▶ Welsh coal miners is all grit, grimness and hostility. The grouping of the men against the background of their row houses seems to belong to a traditional sort of timeless portraiture. Yet the restlessness of their mood, indicated by the defiant cigarette and the averted eyes, marks the miners as prisoners of their time and place.

GEORGE H. SEELEY: *The Burning of Rome, 1906*

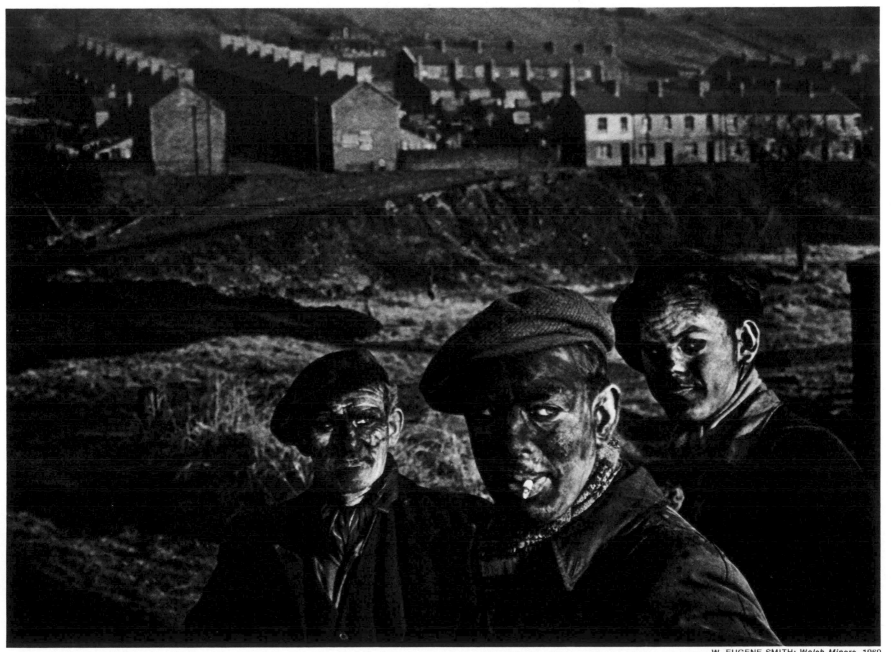

W. EUGENE SMITH: *Welsh Miners*, 1960

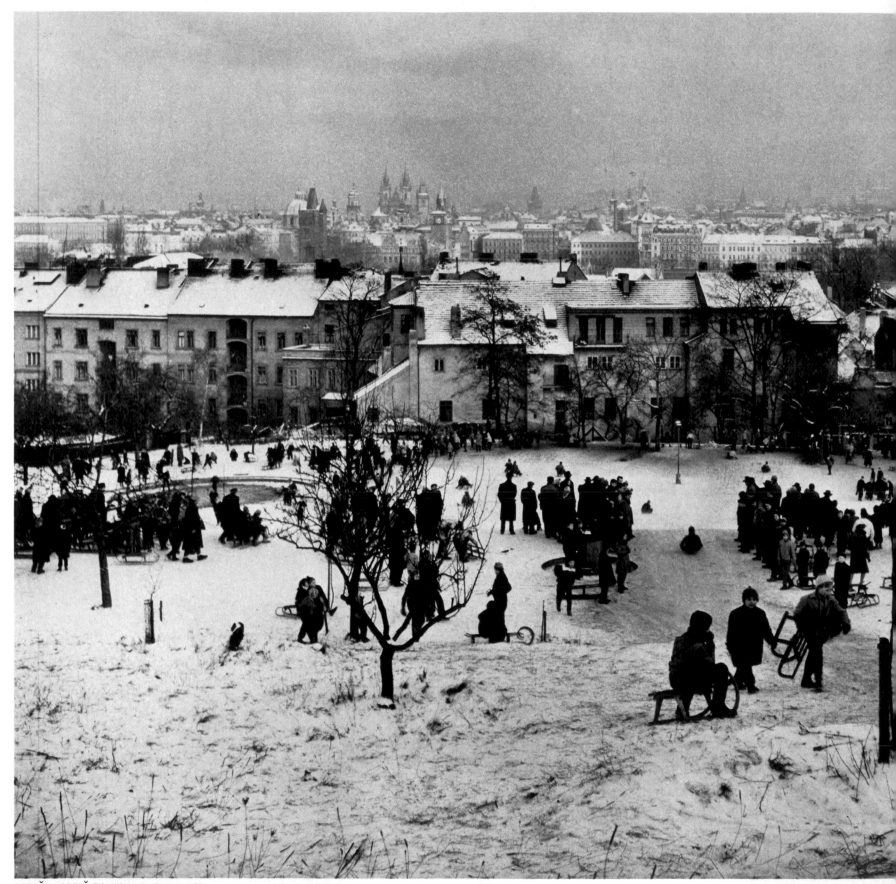

ZDENĚK VOZENÍLEK: *Winter in Prague*, 1961

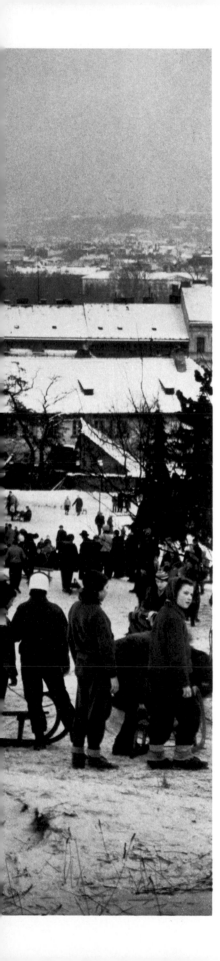

The photographer's affectionate response to the city of Prague suffuses his happy sledding scene. In an expansive photographic embrace, he encompasses a panorama of architecture and dozens of human episodes. Except for the contemporary dress, this could almost be the peaceful Prague of good King Wenceslaus, who reigned here in the 13th Century.

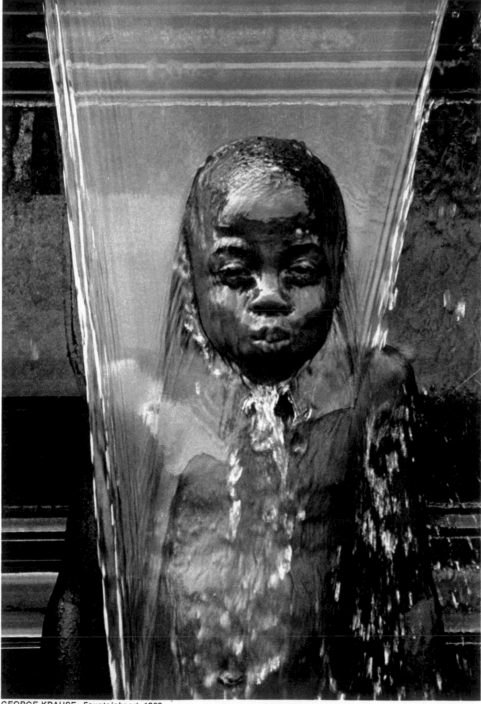

A vision of summertime delight is offered by this picture of a boy cooling off under the overflow of an outdoor fountain in Philadelphia. But the texture of the water has been used to imply wider meanings. The cascading sheet of water, coating the boy's face with its own sheen, creates the illusion of a bas-relief head carved on a wall. This photograph becomes more than a simple depiction of boyish play; it proclaims the presence of art in life, as well as life in art.

GEORGE KRAUSE: *Fountainhead,* 1969

Bibliography

Visual Elements and Principles of Design

*Anderson, Donald M., *Elements of Design*. Holt, Rinehart and Winston, 1961.

†Arnheim, Rudolf, *Art and Visual Perception*. University of California Press, 1967.

Croy, O. R., *Design by Photography*. Focal Press, 1963.

Feldman, Edmund Burke, *Art as Image and Idea*. Prentice-Hall, 1967.

Garrett, Lillian, *Visual Design: A Problem-Solving Approach*. Van Nostrand Reinhold, 1967.

Kepes, Gyorgy:
—ed., *Education of Vision*. George Braziller, 1965.
Language of Vision. Paul Theobald, 1967.
—ed., *Module, Proportion, Symmetry, Rhythm*. George Braziller, 1966.

†Lyons, Nathan, *Photographers on Photography*. Prentice-Hall, 1966.

*Taylor, John F. A., *Design and Expression in the Visual Arts*. Dover, 1964.

Welsmann, Donald L., *The Visual Arts as Human Experience*. Prentice-Hall, 1970.

Photography and Time

Cartier-Bresson, Henri:
†*Photographs by Cartier-Bresson*. Grossman, 1963.
The Decisive Moment. Simon and Schuster, 1952.

Frank, Robert, *The Americans*. Grossman, 1969.

Newhall, Beaumont, *The History of Photography from 1839 to the Present Day*. The Museum of Modern Art, Doubleday, 1964.

Challenging the Traditions

Bennett, Steichen, Metzker: The Wisconsin Heritage in Photography. Milwaukee Art Center, 1970.

Contemporary Photographs. UCLA Art Galleries, 1968.

Evans, Ralph M., *Eye, Film and Camera in Color Photography*. John Wiley and Sons, 1959.

Goodman, Nelson, *Languages of Art*. Bobbs-Merrill, 1968.

Into the 70's: Photographic Images by Sixteen Artists/Photographers. Akron Art Institute, 1970.

Jerry N. Uelsmann. Philadelphia Museum of Art, Aperture, 1970.

Lyons, Nathan, ed.:
Aaron Siskind: Photographer. George Eastman House, 1965.
The Persistence of Vision. Horizon Press, George Eastman House, 1967.
Vision and Expression. Horizon Press, George Eastman House, 1969.

*Ward, John L., *The Criticism of Photography as Art: The Photographs of Jerry Uelsmann*. University of Florida Press, 1970.

The Principles at Work

Ballo, Guido, *The Critical Eye: A New Approach to Art Appreciation*. G. P. Putnam's Sons, 1969.

Gernsheim, Helmut, *Creative Photography, Aesthetic Trends 1839-1960*. Faber and Faber, 1962.

Hook, Sidney, ed., *Art and Philosophy, A Symposium*. New York University Press, 1966.

Steichen, Edward, *A Life in Photography*. Doubleday, 1963.

†Szarkowski, John, *The Photographer's Eye*. The Museum of Modern Art, Doubleday, 1966.

Vivas, Eliseo, and Murray Krieger, *The Problems of Aesthetics*. Rinehart, 1957.

Magazines

Aperture, Aperture Inc., New York City.

Camera, C. J. Bucher Ltd., Lucerne, Switzerland.

Camera 35, U.S. Camera Publishing Corp., New York City.

Creative Camera, International Federation of Amateur Photographers, London.

Infinity, American Society of Magazine Photographers, New York City.

Modern Photography, The Billboard Publishing Co., New York City.

Popular Photography, Ziff-Davis Publishing Co., New York City.

U.S. Camera World Annual, U.S. Camera Publishing Corp., New York City.

*Available only in paperback.
†Also available in paperback.

Acknowledgments

For help given in the preparation of this book, the editors are particularly indebted to Martus Granirer, New City, New York, who served as a special consultant. The editors also express their thanks to the following: David Attie, New York, New York; Wynn Bullock, Monterey, California; Peter Bunnell, Curator, Department of Photography, The Museum of Modern Art, New York, New York; Wolf von dem Bussche, New York, New York; Walter Clark, Rochester, New York; Raymond Baxter Dowden, New York, New York; Marcia Kay Keegan, New York, New York; Harvey Lloyd, New York, New York; Charles Mikolaycak, New York, New York; Allan Porter, Editor, *Camera*, Lucerne, Switzerland; Walter Rosenblum, Professor, Department of Art, Brooklyn College, Brooklyn, New York; Joel Snyder, Chicago, Illinois; Harald Sund, Seattle, Washington.

Picture Credits
Credits from left to right are separated by semicolons, from top to bottom by dashes.

COVER—Ken Kay; Jack Schrier.

Chapter 1: 11—Ralph Weiss. 14—Jesse Birnbaum. 15—Tony Ray-Jones. 23 through 31—Sebastian Milito. 32—Paul Caponigro. 33—Bill Brandt from Rapho Guillumette. 34, 35—George A. Tice. 36—Paul Caponigro. 37—Joseph Dankowski. 38—Minor White. 39—Ann Warrington. 40—Aaron Siskind. 41—© Barbara Morgan. 42—Sebastian Milito. 43—Imogen Cunningham. 44—Albert Renger-Patzsch, courtesy George Eastman House. 45—Sebastian Milito. 46, 47, 48—Minor White. 49—Edward Steichen, courtesy The Museum of Modern Art, New York. 50—Paul Caponigro. 51—Paul Strand, copied by Paulus Leeser. 52, 53—Ralph Weiss; Sebastian Milito. 55—Richard Beck, London, courtesy *Twen.* 56—© Pete Turner; Lilo Raymond—Martin Schweitzer (2). 57—Nicholas Foster; Terence Naysmith, courtesy Kodak A.G. Photograph taken with Kodak Color Film.

Chapter 2: 61—Wolf von dem Bussche. 66 through 76—Wolf von dem Bussche.

Chapter 3: 79—Harold Zipkowitz. 83—Marcia Kay Keegan. 84—Richard Noble. 86, 87—Dean Brown. 88, 89—Pete Turner. 90—Richard A. Steinberg. 93—John Senzer. 95—Neal Slavin. 96, 97—Duane Michals. 99—Norman Snyder. 100—George Krause. 102—Laurence Fink. 103—Inge Morath from Magnum. 104, 105—Leonard Freed from Magnum. 106—Tony Ray-Jones. 107

—Bill Binzen. 109—Leslie R. Krims. 110—Diane Arbus.

Chapter 4: 113—Paul Strand. 116, 117—William Gedney. 118—August Sander. 119—Neal Slavin. 120—Emmet Gowin. 121—Bruce Davidson from Magnum. 122—Thomas Brown. 123—Lewis Baltz. 125—Henri Cartier-Bresson from Magnum. 126—Michael Semak. 127—Henri Cartier-Bresson from Magnum. 128—© André Kertész. 129—Mario Giacomelli. 130, 131—Mary Ellen Mark; Henri Cartier-Bresson from Magnum. 132, 133—© Bruce Davidson from Magnum; Jack Schrier. 135—Robert Frank. 136—Lee Friedlander. 137—Bruce Davidson from Magnum. 138, 139—Garry Winogrand. 140—Robert Frank. 141—Murray Riss. 142, 143—Reed Estabrook. 144—Murray Riss.

Chapter 5: 147—Donald Blumberg and Charles Gill, courtesy George Eastman House. 148—Aaron Siskind. 150—Thomas Petrillo. 151—Lawrence Bach. 152—Tom Porett. 153—Jerry N. Uelsmann. 154—Thomas F. Barrow. 155—Eileen Cowin. 156, 157—Henry Grossbard. 158—Andre Haluska. 159—Edmund Teske. 161—Robert F. Heinecken, courtesy Mrs. Barbara St. Martin, Los Angeles, California, copied by Martus Granirer. 162—Ken Josephson. 163—John Wood. 164, 165—Reed Estabrook. 166—Ray K. Metzker. 167—Alice Wells—Gerd Sander. 168, 169—Eric Renner. 170—Ray K. Metzker. 172, 173—William G. Larson. 174—Keith A. Smith.

Chapter 6: 177—André Kertész. 180—Richard Avedon. 181—Jerry N. Uelsmann. 182—Alen MacWeeney. 183—Edward Weston. 184—Harry Callahan. 185—Gary Prather. 186—Bill Brandt from Rapho Guillumette, courtesy The Museum of Modern Art, New York. 187—Jacques Henri Lartigue from Rapho Guillumette. 188—Otto Steinert, courtesy The Museum of Modern Art, New York. 189—© Lennart Olson/Tio. 190—Harry Callahan. 191—Romano Cagnoni from *Report.* 192—André Kertész. 193—Richard Avedon. 194, 195—Michael Di Biase; Wynn Bullock. 196, 197—Egons Spuris. 198—Frederick Evans, courtesy Library of Congress. 199—Philip Trager. 200—Heinrich Kühn, courtesy Folkwangschule, Essen. 201—Emmet Gowin. 202—Edward Steichen, courtesy The Museum of Modern Art, New York. 203—Bill Brandt from Rapho Guillumette, courtesy The Museum of Modern Art, New York. 204—Minor White. 205—George A. Tice. 206—© Ralph Eugene Meatyard. 207—Anton Giulio Bragaglia, courtesy Archivo A. V. Bragaglia of Centro Studi Bragaglia, Rome. 208—Robert Frank. 209—Cecil Beaton. 210—Ron Mesaros. 211—Dennis Stock from Magnum. 212, 213—Robert Frank. 214—© Martus Granirer. 215—Ansel Adams. 216, 217—Duane Michals. 218—Diane Arbus. 219—© Ralph Eugene Meatyard. 220—George H. Seeley, courtesy The Metropolitan Museum of Art, New York, gift of Alfred Stieglitz, copied by Anthony Donna. 221—© W. Eugene Smith. 222, 223—© Zdeněk Vozenîlek. 224—George Krause.

Text Credit

Chapter 1: 12, 16, 17, 18, 19, 20, 21—Marginal quotes from *Photographers on Photography,* edited by Nathan Lyons, copyright 1966 by Prentice-Hall, Inc., Englewood Cliffs, New Jersey, in collaboration with George Eastman House, Rochester, New York.

Index
Numerals in italics indicate a photograph, painting or drawing of the subject mentioned.

 xx

Printed in U.S.A.